PHANTASMATIC INDOCHINA

Asia Pacific:
Culture, Politics, and Society
Editors: Rey Chow, H. D. Harootunian,
and Masao Miyoshi

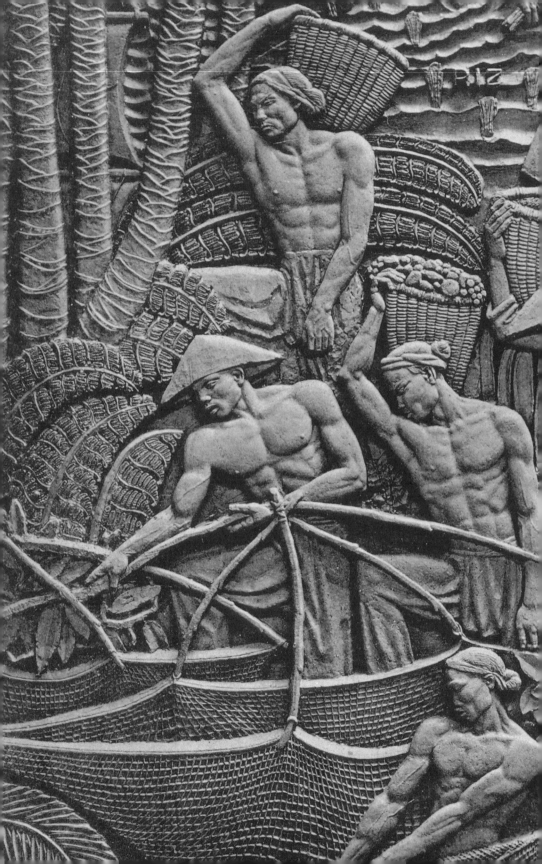

Panivong Norindr

PHANTASMATIC INDOCHINA

French Colonial Ideology in Architecture,

Film, and Literature

Duke University Press Durham and London 1996

© 1996 Duke University Press

All rights reserved

Printed in the United States of America on acid-free paper ∞

Library of Congress Cataloging-in-Publication Data appear on

the last printed page of this book.

To my parents,
Kongseng Sananikone and Pheng Norindr

CONTENTS

ACKNOWLEDGMENTS

Many individuals and institutions have contributed to making this book a reality. A special word of thanks goes to the librarians who assisted me in locating obscure primary sources and whose knowledge and expertise often go unrecognized: Mary Clare Altenhofen of the Harvard University Fine Arts Library, Sommala Nouguérède of the Saint-Maur Bibliothèque Municipale, Jean-Pierre Ranoux-Butté of the Musée des arts d'Afrique et d'Océanie, and Sharon Hill and Jovanka Ristic of the American Geographical Society Collection at the University of Wisconsin–Milwaukee. Jacques Boivin and director/producer Patrick Jeudy very generously provided me with copies of their work.

Parts of this book originated in conference papers and seminars. I thank Dudley Andrew and Steven Ungar who selected me as a participant in their 1991 N.E.H. seminar, "Film, Literature, and the Cultures of Interwar France," which provided an ideal collegial forum for the critical exchange of ideas. I am also grateful to the audiences at the institutions where I initially presented my work: Emory University, Smith College, the University of Iowa, the University of Nevada–Reno, and the University of Wisconsin–Madison. Special thanks go to my first public audience, the students—Beatriz Anton and Sarah Harley in particular—who participated in my class "Indochina in French Cinema and Fiction."

Over the years, I have benefited from the support of a number of institutions. A graduate school research grant from the University of Wisconsin–Milwaukee allowed me to travel to France and conduct research in archives in Paris and Aix-en-Provence. The Center for Twentieth-Century Studies, under Kathleen Woodward's leadership, has fostered an intellectual community that has always supported my endeavors. A fellowship at the Institute for Research in the Humanities

at the University of Wisconsin–Madison provided me with the intellectual space to write without interruption and to complete a first draft of this book.

I must also acknowledge friends and family members who facilitated my research in France and the United States: Panisouk, Somphavong, and Somphavonne for sharing their computer knowledge and hardware so that I would have access to the Internet; Somsavang, who taught me the basic rules for becoming a successful "chineur"; and Kongseng, Menay, Pheng, Alejandro, Josette, and Amaya for providing daily sustenance and material comfort. Carol Cook, Leyla Ezdinli, Mary Harper, Elizabeth Houlding, Paolo Iazzi, David Thurn, and Phil Watts offered encouragement and were always there when I needed them. I also thank Jean Brady and Reynolds Smith of Duke University Press for being such thoughtful and patient editors.

My greatest thanks go to the following individuals: Suzanne Nash of Princeton University for teaching me the rigor of scholarly analysis; Dalia Judovitz for engaging me theoretically and taking an early interest in my work; Robin Pickering-Iazzi who offered instructive comments and labored through the entire manuscript in an attempt to make my prose more elegant: Rey Chow for being such a steadfast champion and stimulating supporter and for suggesting that I send the completed manuscript to Duke University Press. My greatest debt goes to Marina Pérez de Mendiola, who convinced me to bring these dormant essays into the public realm and whose critical insight improved the work immensely; I am forever indebted to her intellectual support and generosity.

Three chapters of this book have appeared elsewhere, in slightly modified form. Chapter 1 was published in *French Cultural Studies* 6.16 (February 1995) and Chapter 5 in *differences* 5.3 (Fall 1993). Chapter 6 originated as a talk given at the Tenth International Colloquium in Twentieth-Century French Studies and will be published as part of a collection of essays edited by Dina Sherzer. I want to thank the editors and publishers of these journals and books for permission to reuse this material.

INDOCHINA AS FICTION

"Indochine" is an elaborate fiction, a modern phantasmatic assemblage invented during the heyday of French colonial hegemony in Southeast Asia. It is a myth that has never existed and yet endures in our collective imaginary. As a discursive construction that supported financial and political ambitions, and as a particularly fecund *lieu de mémoire* (site of memory) heavily charged with symbolic significance, Indochina continues today to arouse powerful desires. Its luminous aura sustains memories of erotic fantasies and perpetuates exotic adventures of a bygone era, while appealing to the French nostalgia for grandeur. It is my contention that Indochina is a concept at the intersection of myth and phantasm, an imaginary structure and an idea that can be located, in Catherine Clément's words, "in the register of the phantasm, of the imaginary mise-en-scène, indeed of the dream" (17). Indochina also has the power to rearticulate and transfigure the image of history.

Such a bold claim and one that goes against current trends in historical analysis may baffle, even generate sharp criticism, especially from those expecting yet another diachronic history of the region. Critics will undoubtedly challenge and dispute the notion of "Indochina as fiction" on both conceptual and methodological grounds. Historians, for instance, skeptical of work in cultural analysis that draws on postcolonial theories and intertextual readings informed by poststructuralism, regard such speculative pronouncements as far too disengaged from material reality to be of any significant value. They can point to a large corpus of historical material gleaned from archives as proof of the existence of Indochina. Cartographic surveys and maps, ethnographic accounts, geological studies, journalistic reports, travel accounts, private letters, official reports, tourist guides, iconographic representations, personal mem-

oirs, financial reports, and so on can be summoned to produce a coherent textual narrative on French Indochina and an intelligible image of the French colonial possession. Scholars have relied traditionally on this vast corpus for writing what can be regarded as a genealogy of the French colonial presence in Southeast Asia.[1]

Narrating the history of the region, however, also means inventing and postulating a coherent political identity for a region once conveniently regarded by scholars and politicians as a void or a desert. If the name "Indochina" was first coined as a geographical marker to describe the Southeast Asian peninsula situated between India and China, in a relatively short period of time that coincided with the almost century-long French occupation of sovereign territories in the region, it was identified and confused with a political entity, the Union Indochinoise, which was created to bring together dissimilar nations and kingdoms under one centralized colonial administration. The name "Indochina" became synonymous with this new federation of states, whose geopolitical borders could be mapped out and a detailed inventory of its economic resources taken, its arts catalogued—in short, every facet of its "cultural identity" refigured and reproduced. With these concrete scientific data offered as proof of its existence, how can the "reality" of French Indochina still be denied or disputed? At issue is not simply the fictional or real existence of Indochina but, perhaps even more important, the question of how factual truths have been used and manipulated to construct an identity for Indochina. What also needs to be foregrounded is the emergence of Indochina as a subject of historical reflection; in other words, we must turn to the question of writing as "'modern' historical practice" (de Certeau, *The Writing of History* xxvi), what the French philosopher Michel de Certeau dubbed "l'écriture de l'histoire," the writing of history.[2]

De Certeau argues that historical accounts articulate a vision or memory of other worlds as a blank space on which Western desire is written (xxv). They transform "the space of the other into a field of expansion for a system of production" (xxv–xxvi), initiated by a type of "writing that conquers" (xxv). This study builds on de Certeau's proposition and demonstrates the extent to which Indochina became, for the French, a space of cultural production. While ostensibly fulfilling their mandate to civi-

lize backward nations, the French produced a coherent image of Indochina to sustain the myth of its colonial edification.

My aim, in this study, is not to restore or correct the "true" image of Indochina, nor to provide a more valid version of its "authentic" history. Essentialist notions of history have no place here. More modestly, it traces the process of assimilation of the idea of Indochina in the French imaginary while debunking the myth of Indochina in its multifaceted figurations, as it has been, and continues to be, constructed through the exoticizing project of various historical, literary, cinematic, and political discourses. In short, this inquiry into the cultural topography of Indochina examines what Paul Valéry calls the "échafaudages imaginaires," the imaginary scaffoldings on which Indochina as a fictional place, a lieu de mémoire, and a vision of an exotic utopia were erected and against which the fantasies of artists, writers, filmmakers, architects, political figures, and others emerged.

Many myths of Indochina have been elaborated since 1585, when Father Georges de la Mothe, a French missionary, first landed in the Mekong Delta. If his name and those of Francis Garnier, Francis Rivière, and Auguste Pavie have today receded from our memory, the story of their conquest, of heroic *faits d'arme*, has been woven into tales of courageous struggle against "exotic," if barbaric, native populations. Rarely read colonial writers modeled their fictive protagonists after these men, creating prototypical figures such as the heroic soldier of the *troupe coloniale*, the bold and enigmatic adventurer who would be king, the selfless man of science or of the clergy who dedicated his life to improving the fate of the natives, the naval officer whose amorous adventures with the native women, the *congai*, brought erotic exoticism to new levels, and so on. But more importantly, they transformed this imaginary location where many of these fantastic adventures took place into a familiar and readily identifiable terrain.

The advent of new techniques in mechanical reproduction and, particularly, improvement in coloring techniques that culminated in chromolithography bolstered the prestige of what became emblematic colonial figures and prestigious sites. Rather than chronicling the dreary life of *La Vie quotidienne des Français en Indochine* (Meyer), the increasingly popular illustrated journals such as *Le Tour du monde*, *Le Petit Journal illustré*, and

L'Illustration chose to disseminate and circulate their fantastic accounts, displacing and replacing a less heroic version of colonial life with compelling fictions and exotic fantasies.

Graphic art,[3] from colonial propaganda posters to trade signs, contributed rather effectively to the idea of an exotic Indochina along with publicizing their goods and services. They promoted products such as tea from the *Compagnie Coloniale;* coal from the Hongay coal mines; coal from the same basin occupied by Rivière in 1883 before he was killed on May 12, 1883, and where Garnier had also fallen; as well as travel, with such companies as the prominent Messageries Maritimes and Air France. These iconographic representations restyled Indochina in glossy colors and inviting terms. For instance, one slogan proclaims: "Young people, go to the colonies, fortune awaits you." They thus transformed the Indochinese colony into an alluring and commodified object, a familiar icon or sign to be desired or possessed. The power these iconographic lures exerted on the French is difficult to measure accurately. Their enduring impact, however (only superseded by the emergence of the moving image), should not be underestimated, as the narrator of Marguerite Duras's novel, *Un Barrage contre le Pacifique,* suggests.

During the colonial era, Indochina, also known as "la France d'Asie," was said to be "a region of transition" (Brenier and Russier 19) that possessed no distinct identity of its own because its art and culture were considered to be derivative of those of India and China. The great Khmer, Siamese, Cham, and Laotian civilizations that had fought for the domination of the region appeared to have vanished mysteriously. Although monumental traces of their culture have survived—Angkor Wat, the twelfth-century funeral temple, comes immediately to mind—they have been neglected or forgotten by the natives. Left to decay in the jungle, Angkor would have to wait until the nineteenth century to be "rediscovered and rescued from oblivion" by members of the Ecole française d'Extrême-Orient. Angkor would become one of the privileged reference points in the French literary imaginary on the Far East, soliciting the interest of such diverse authors as Villiers de l'Isle-Adam, Pierre Loti, André Malraux, and Michel Butor, among many others.

In the absence of comparable important architectural monuments built in the modern period and in light of the natives' disinterest in the

preservation of what the French regarded as the epitome of their civilization, French political figures considered these ruins and vestiges to be telltale signs of the peninsula's cultural and political decline. For them, colonizing Southeast Asia also meant salvaging the cultural vestiges of a vanished world, one that had been reconquered by nature and could now be salvaged through their concerted action. As will be discussed below, Malraux articulated in problematic ways this desire to recover Khmer works of art from the Cambodian jungle in his 1930 novel, *La Voie royale*. The French would even go as far as to claim that they were the sole and rightful heirs to these great civilizations.

The historical forces that shaped and authorized such a smug assertion are far too numerous and complex to be discussed here fully; they can only be alluded to in this introduction. As will be examined in the following chapters, the French colonial will to power manifested itself in numerous ways, from the physical domination of native space in cartographic practice to a slightly more subtle form of cultural subjugation elaborated in the policy of "acculturation." As with Great Britain, France believed in its sacred mandate to civilize and educate the world. Convinced of its cultural ascendance over all colonized peoples, the French promoted almost exclusively their own history and culture at the expense of the indigenous culture.[4]

During the golden age of French colonialism, modernity and progress were the absolute standards against which these "backward" nations were measured and compared, so that their very existence as sovereign nations could simply be denied. The Indochinese peninsula was therefore regarded as an empty space, a void that could be exploited and colonized (Daney 60–61). It is also against this lack, this absence of a proper name, that an official mythology had to be created and on which public and private fantasies came to be imagined. To supplement this aporia, an identity for the region had to be invented, one that would conjure up fantasies of colonial life and promote the benevolent role of an enlightened France.

Behind its civilizing façade, however, lies a much less charitable France, consumed by its desire to compete with the British Empire and to contain its penetration into the Far East. The colonization of Southeast Asia was dominated by the world of commerce and finance, by greed and

profit (see Meuleau, Marseille). The philanthropic façade France presented to the world was a thin disguise to justify its expansionist ambition and consolidate its presence, to bring under its economic and political tutelage a region rich in natural resources, replete with cheap and skilled labor.

The tableau the French poet and career diplomat Paul Claudel painted of Indochina in the 1920s is symptomatic of the prevalent tendency to assess the success of the French colonization on the Indochinese peninsula solely in economic and material terms, glossing over native "reality" in order to highlight French achievements in the peninsula. Claudel focuses on the infrastructure built by the French, the network of roads and railroad tracks laid out in Indochina. He boasts of the agricultural and industrial development of Indochina, its increased capacity to produce: "Rice export which is Indochina's raison d'être keeps on increasing: Last year, export amounted to more than a million ton" (334). He gloats over the increased production level, pointing to 800,000 tons of anthracite produced, a capacity that will be increased to 1,300,000 tons when new equipment is installed. He foresees the opening of Laos when the network of roads is completed.

But even more disturbing than the catalogue of beneficial actions of French colonization is the phantasmatic quality of Claudel's lyrical description: "It seems that one crosses the borders of a kingdom at peace where all outside noises come to expire, where all the bustles of a world at work do not succeed in wrinkling the surface of an ocean made of paddy" (333). Claudel seems to have encountered in his journey to Indochina a dreamlike world completely disengaged from reality, a world where the inhabitants live in complete and perfect harmony: "Never in Indochina has the collaboration between the indigenous and European populations been more intimate and peaceful. We are witnessing the impulse of an entire people whose sole and most profound desire is to adopt our culture and, indeed, our language" (333). Claudel's language betrays his desire to make his Indochina conform to an ideal imaginary world where an imagined colonial community of like-minded and tolerant men could live together peacefully. His words could well serve as a caption to Alfred Janniot's didactic bas-relief of the French colonies that adorns the façade of the Palais Permanent des Colonies, built as a perma-

nent reminder of the golden age of French colonialism at the Exposition Coloniale Internationale, held in Paris in 1931.

Curiously absent from Claudel's idealized account, however, are references to the suffering and hardship endured by the native peoples. Also missing are reports of forced labor, indentured servitude, famine, and epidemics that French colonialism was supposed to eradicate but that it instead exacerbated. When the indigenous peoples appear in his report, they are completely assimilated into the landscape and presented as part of an aesthetically ravishing exotic system, the disposable bits and parts of a well-oiled machine designed to efficiently work the rice paddies, the rubber plantations, and the open-air mines: "Nothing is more curious," he exclaims, "than to see these slices of mountains being demolished by thousands of workers and rows of small wagons on superposed terraces" (335).

Like Claudel, many French politicians from a wide political spectrum and different political affiliations wanted to hold on to the idea of Indochina as a model colony. The June 1930 debates on the Indochinese question, placed on the agenda of the Chambre des députés at the request of incensed French politicians after the Yen-Bay rebellion, are mandatory readings not only for those interested in analyzing colonial ideology and *l'histoire des mentalités* (intellectual history), but more broadly, for all those who want to have a better understanding of the history of culture.

Advocates of French colonialism in Indochina wanted at all costs to preserve the image of an idyllic world untouched by political cataclysms. Reports of peasant unrest, army rebellions, workers' strikes, and student demonstrations did little to convince the political leadership that the golden age of French colonialism in Indochina was rapidly drawing to a close. The only acknowledgment of the situation's gravity was the discussion of what was then believed to be the principal cause of these forms of unrest. The French right interpreted the concerted actions of a nascent nationalism and liberation struggle as a descent into anarchy, blaming these "evanescent disruptions" on "Moscow's agents provocateurs" and their naive Indochinese followers schooled in Marxist theory. It was believed that the elimination of brainwashed activists would restore a kingdom at peace. The Claudelian notion of a "kingdom at peace," however, represents other types of images revealed by his own contemporaries.

Roland Dorgelès, in *Sur la route mandarine* (1925), attempted to look beyond official propaganda and popular stereotypes to explain the peculiar attraction Indochina exerted on the French: "There is the attraction of the unknown, the hope of one day becoming rich. There is the strange and complete seduction of a country that one cannot forget when one has lived there. There is also, for many, the charm of a life less mediocre than the life one would have led in France, in suburban housing or some provincial shack. One has his chalet, his servants, his rifle hung between two elephant tusks, the shared car that takes you to Catinat street. One is obeyed, one is somebody . . ." (187). To live in Indochina or in any other French colony meant leading the life of a "colonizer" who aspired to all the trappings of an illusory bourgeois existence. Dorgelès also paints without any sentimentality the everyday life of the "planter among his heveas, the scientist in his laboratory, the archeologist in the middle of his ruins, the doctor in his hospital room, the industrialist in his manufacturing plant, the resident inspecting the villages" (202). For him, "it is they who have made Indochina what it is" (202).

Dorgelès, however, also does not hesitate to highlight the ravages of industrial and capitalist progress, demystifying the effects of colonization and modernization on the local population, and particularly on the Moï, the "unpacified tribe" fantasized by André Malraux in *La Voie royale.* Because they had neglected to systematically exploit their land, and hence increase output and maximize profit, the colonial administration simply dispossessed them of their fertile red earth, subdividing it into 30,0000- or 40,000-hectare concessions long coveted by French colonizers, to make room for larger plantations and more lucrative business concerns. As attested by colonial officials, these dispossessions were not seen as spoilation, but "development, colonial expansion . . . Civilization" (260). If the Moï dared to remain on their ancestral land, they would have to pay "taxes," be forcibly enrolled in statute labor (*la corvée*), or they would simply be forced to serve in "the native auxiliary militia" (260).

Other writers such as Georges Garros in *Forceries humaines* (1926) and Andrée Viollis in *Indochine S.O.S.* (1935) also discuss the exploitation of native coolies during the heyday of French colonial occupation in Southeast Asia. Viollis describes the Hongay mine as the "immense coal wall" where forty thousand workers toiled to extract "opencast coal" for 3F50

to 4F50 a day. Laws forbidding child labor in France do not apply here in the colonies as the children are paid a meager salary of 1F50 to 1F80 a day (73). Perhaps the most forceful indictment of colonial practices in the French colonies is to be found in *Le Procès de la colonisation française* (1925) written by Nguyen Ai Quoc, better known as Ho Chi Minh.

In spite of these public condemnations, Claudel still argues for an obsolete notion of an altruistic France: "It is France, alone, which has given Indochina its geographic and political unity" (338). The federation of states that was to be known as the Union Indochinoise was established only in the modern period, in 1887, when the colony of Cochin China and the protectorates of Cambodia, Annam, and the Tonkin were federated and placed under the leadership of a governor-general. In 1893, the Union annexed Laos, and in 1900, the Chinese territory of Kwang-Chau-Wan was also integrated into the Union (Ajalbert 15).

This study examines the elaboration of the idea of "Indochine," an imaginary "Indochina," the construction and refashioning of its image and modern history. It deals with the identification of the imaginary Indochina with the political union, its conflation and confusion, its absorption into the French imaginary, and its internalization into the political unconscious, a process Serge Gruzinski refers to as the "colonization of the imaginary."

First, my analysis of the Exposition Coloniale Internationale de Paris, held in Paris in 1931, foregrounds and frames many of the issues that will be developed further in subsequent chapters, in particular the issue of how discursive formations, such as Western exhibitions, reconstruct Indochina's cultural identity while defending and perpetuating the ideology of colonialism. The colonization of the imaginary, indeed, operates on different levels and registers and takes on different forms. The Exposition was perhaps the most comprehensive attempt by official France at promoting the *idée coloniale* (colonial idea). A didactic and apologetic showcase, the colonial fair required experts in all fields to contribute their knowledge and expertise, raising the issue of the complicit role played by scholars during the colonial era. This chapter also calls attention to the ways the Exposition reconstructs through architecture a phantasmatic identity for Indochina, rewriting at the same time its history through a "mise-en-scène of built space" (Palà 19).

Beyond the picturesque representation and behind the innocuous façade dreamt up by the organizers of the Exposition, a more belligerent political image of Southeast Asia begins to emerge and assert itself—one that French officials attempted to contain by repressing dissent, resorting to such radical measures as jailing and deporting those who dared voice their opposition to French colonialism in Southeast Asia. Incidentally, many of the Vietnamese student militants later became North Vietnamese officials. As students, they participated in a number of demonstrations. The most resounding one was staged in July 1930, in front of the Elysée Palace, to show support for their comrades jailed or sentenced to death for having participated in the Yen-Bay rebellion. Taking their demands to the streets and making them public signaled the resolve of the students whose reputation no longer fit the sanctioned image of the docile student and resigned worker once disseminated by the press. The students had staunch supporters in the Surrealists, among them Louis Aragon and André Breton, who endorsed their actions. Denouncing France's colonial presence in Southeast Asia in their tracts, newspapers, and journals such as *l'Humanité* and *Le Surréalisme au service de la révolution*, they too called for a complete French withdrawal from the colonies.

The Surrealists' most coherent and concerted action regarding the "colonial situation" was the organization of a counter-exposition entitled La Vérité sur les Colonies (The truth about the colonies). Organized by the Anti-imperialist League, whose members included André Thirion and Louis Aragon, the counter-exposition, as its name suggests, strove to demystify "the French civilizing mission," to reveal the most heinous aspects of French colonialism, to shed light on the abuses perpetrated in the colonies and crimes committed to subject the natives, and to divulge the discrepancy between official discourse and reality in the colonies.[5] One particularly disturbing aspect of La Vérité sur les Colonies is that the artworks exhibited were largely drawn from the personal collection of Surrealist figures such as Louis Aragon and André Breton. As Mieke Bal, James Clifford, Donna Haraway, Susan Stewart, and others have clearly demonstrated in their works, the relation between collecting and colonial domination is a particularly contentious issue. Collecting and exhibiting native works of art in this particular context raise as many ques-

tions as the official exposition at the Musée Permanent des Colonies entitled "The Exotic and Colonial Influence in French Art," a direct forebear of the 1984 "Primitivism in Twentieth-Century Art" exhibit at the Museum of Modern Art (see Rubin, Torgovnick).

In their tracts denouncing the Exposition, the Surrealists not only condemned the physical violence perpetrated on the indigenous people, they also questioned the nature and provenance of the displayed artifacts, which they described as having been "arraché par la violence [uprooted through violence]" from their country of origin, and used as an "objet de réclame [advertisement]" to promote the colony. Denouncing this type of commodification of native artifacts, they berated what they considered to be the "scandalous swerving away from an original, native signification." Because avant-garde practice also incorporates and appropriates "primitive" artifacts, transfiguring them into a modernist aesthetic objet d'art, a legitimate question to ask is whether the Surrealists themselves corrupt native meaning. Thus, they too could be said to exert, to a degree, a type of cultural violence and hegemony over colonized nations.

The questions I explore in the chapter "Indochina as 'Rêves-Diurnes' and Male Fantasy" concern the *détournement* of native artifacts, the subject of a contemporary work of fiction written by the young André Malraux. Loosely based on Malraux's Indochinese adventures in the 1920s, *La Voie royale* narrates the story of two adventurers: Claude Vannec, a young French archeologist, and Perken, a Danish adventurer whose main ambition is to leave "a scar on the map of Indochina." Having pacified the mountain peoples inhabiting the Dang Rek region, the border area between Laos, Siam, and Cambodia, and in need of hard currency to buy arms to defend the territory he controls against the encroachment of modernization and colonial progress, Perken agrees to join Claude in his expedition to salvage bas-reliefs and sculptures from the nefarious grasp of the Indochinese jungle. Malraux's archeological novel reveals a particularly striking masculinist vision of Indochina. Thus, my analysis also probes the aesthetic and ideological ramifications of Malraux's archeological representation of a feminized Indochina.

I then focus on Marguerite Duras's Indochinese trilogy, published over four decades: *Un Barrage contre la Pacifique* (1950), *L'Amant* (1984), and

L'Amant de la Chine du nord (1991). Duras's novels reconfigure an imaginative geography of Indochina, while retaining its historical specificity. Unlike Malraux's novel, her novels transform and radicalize the ways we understand *histoire* as both a story and history. Duras's memory of colonial space and her protagonists' "errance" in the city are read against the containment strategies of colonial urban planners. These novels allow us to examine and interrogate the complex process by which subject locations are linked, in Homi Bhabha's words, to "the questions of the effects of power, the inscription strategies of individuation and domination in those 'dividing practices' which construct colonial space" ("Signs Taken for Wonder" 170).

Among other issues of concern is how today Indochina has made an enthusiastic return on the French scene. The elated reception of Régis Wargnier's movie *Indochine*, the popular and critical success of Jean-Jacques Annaud's adaptation of Marguerite Duras's *L'Amant*, and the quasi-official endorsement of Pierre Schoendoerffer's docudrama war movie, *Dien Bien Phu*—not even taking into account the profusion of publications of war memoirs—bear witness to the reemergence of Indochina in French consciousness. Although Indochina or, more accurately, the political entity known as the Union Indochinoise, was dissolved as a result of the French debacle at Dien Bien Phu in 1954 and the ensuing Geneva Peace Conference agreement, "Indochine" today still has the power to conjure languorous memories of colonial life in the tropics.

Because memory's motivations are never pure and should be regarded with suspicion, one must question the reasons underlying the current French *engouement* (passion) or nostalgia for Indochina in contemporary French cinema. The filmic resurrection of an exotic Indochina raises a number of questions that go beyond the strictly formalistic inquiry into filmic signification. Why the sudden interest in Indochina at this particular historical juncture? What role did the French government play in the edification of a "filmic memorial" on Indochina? Is there a link between a director's filmic vision and the political phantasms that sustained the myths of the legitimacy of the French colonial presence in Indochina?

Answering these questions may tell us more about the process of identification of Indochina with familiar tropes (i.e., the arrival trope)[6] and stereotypical images ranging from the seductive and available native

(the latest transfiguration of the congai), to the opium smoker, which includes familiar landscapes such as the blue-green Bay of Halong and the temples of Angkor, images betraying the resilience of a feminized representation of Southeast Asia first encountered and deployed in travel accounts and now perpetuated very effectively by the cinematic industry as well as by the tourist and fashion industries.[7]

The persistence of these images reveals the extent to which the West continues to desire Indochina as a phantasmatic object while commodifying its aura. Writers for *Rev' vacances*, a French tourist brochure, for instance, still rely on the evocative power of the name "Indochine" to incite travelers to visit the independent nations of Southeast Asia: "Indochina is finally opening up to the traveler bewitched by a world filled with history and mysteries" (19), they proclaim unabashedly more than forty years after the fall of Dien Bien Phu, considered by some to have signaled "the end of a dream."

Probing the resilience of the French nostalgia for Indochina amounts to elucidating the enduring appeal of Indochina as a series of different discursive formations that rearticulate an aesthetically and ideologically constructed representation of a belle époque of French colonialism in Indochina. If absorbed and consumed uncritically, the current wave of popular material on Indochina threatens to submerge all serious attempts at interrogating French colonial involvement in Southeast Asia under the ebb of phantasmatic images that perpetuate the myths of its foundation, promoting a fin de siècle resurrection of the mythologized images of an exotic and erotic Indochina.

REPRESENTING INDOCHINA

The French Colonial Phantasmatic and the Exposition

Coloniale Internationale de Paris

"Indochine" as Phantasmatic

In his latest book, Edward Said reexamines the relationship between culture and empire as a complex engagement with and "struggle over geography" (*Culture* 7). He considers the novel to be "*the* aesthetic object" par excellence, of particular significance for the "formation of imperial attitudes, references and experiences" (*Culture* xii; emphasis in original). Other critics such as James Clifford, Clifford Geertz, Eric Hobsbawm, and Terence Ranger include in their studies of colonized cultures other types of cultural forms: museographic and ethnographic displays, rituals and ceremonies, traditions. They argue that cultural representations of exotic nations and their people are complicated processes that involve various strategies that differ from those that depend on mimetic representation, transparence of representation, and immediacy of experience. Clifford reminds us that cultural accounts are intentional creations, not solely caught up in the representation of other cultures but, more radically, in their translation, invention, and reconstruction (21–54). One of the aims of this chapter is to shift our understanding of colonial conquest from a purely "geographical inquiry into a historical experience" (Said, *Culture* 7) to imaginary/conceptual ones.

While I acknowledge the influence of Said's seminal studies on my own work, Said can be criticized for overestimating the impact and power of the novel and of scholarly discourse in shaping public opinion on the colonies. He fails to consider the multiple mediations and translations, and the power of the unconscious, in the reorganization and transformation of scholarly knowledge into individual and collective phantasms for the Orient. I therefore propose to examine Indochina as a

phantasmatic construct essential to the containment strategies of suc-
cessful imperialism, a thesis put forth and analyzed in the context of
World's Fairs and, more specifically, in the framework of the Exposition
Coloniale Internationale held in Paris in 1931. The focus is not only on
the performative function of the Exposition, that is to say, on the Exposi-
tion's role in disseminating imperial ideas and beliefs. Rather, the Exposi-
tion will be seen as the paradigmatic site of an elaborate mise-en-scène or
staging of the "idea of Indochina," where the conquest of the imaginary is
inextricably linked to both the act of naming and the act of representa-
tion, and where complex mechanisms of cultural production are at work.

To underline the processes of naming, translation, and representation
as the central modes of production of strategies of containment, one must
locate the emergence of Indochina in French consciousness or the French
imaginary as a modern and model colony. We could begin by reviewing
accounts written by travelers and explorers to the region (see Garnier,
Pavie), a corpus of texts that participates "in the *fixing* of colonized cul-
tures, making them static and unchanging rather than historically con-
structed" (Niranjana 3). We could also proceed by studying the genesis of
modern colonial cities and assessing the politics of French colonial ur-
banism (see Leprun and Sinou, Wright). These two approaches would
undoubtedly illuminate many aspects of the logic underlying French
colonial expansionism and expose, for instance, the link between French
colonial architecture and the policy of "association," or French architec-
tural aspirations and their destabilizing effects on traditional indigenous
forms. However, in order to interrogate more forcefully the processes of
"invention" and "reconstruction" that subtend the relations between me-
tropolis and colony, colonizer and colonized, I have chosen to concen-
trate on the Exposition Coloniale Internationale, a cultural event that
brings to the fore different strategies of representation and practices of
"containment" and allows for a rigorous analysis of the elaboration of
exotic fantasies.

Conceived as a stage upon which to enhance the prestige of Imperial
France and thus to justify and promote the ethos of colonialism, the
Exposition Coloniale Internationale de Paris delineates a space within
which various systems of representation and different discourses on the
Other come together to "materialize" exotic cultures. Experts and schol-

ars in all fields were asked to contribute their knowledge and expertise to
this project. Anthropologists selected cultural artifacts to represent and
chronicle aspects of indigenous life. Archeologists, geographers, and
economists collaborated to catalogue, inventory, map, and accurately
assess French colonial possessions and their wealth, using, for instance,
exploration reports and findings of the Société de Géographie or of the
École française d'Extrême-Orient.[1] The curator of the Louvre chose art-
work inspired or influenced by the colonies. But one of the most impor-
tant roles was played by architects, who not only planned and conceived
the mise-en-scène of the exotic spectacle, but who also, and more con-
cretely, designed and reproduced native buildings and monuments. All of
these experts' contributions, as sources of retranslated objective truths,
coalesce in and around the Palais d'Exposition (exhibit hall) and partici-
pate in the elaboration of *la féerie coloniale* (the colonial phantasmagoria).

L'Exposition Coloniale Internationale de Paris did not simply strive to
give a unified vision and complete inventory of exotic (i.e., colonized)
reality, but was also designed to "ravish" and arouse desires for the colo-
nies. It is, therefore, a privileged point of entry into what I call the French
colonial phantasmatic. By colonial phantasmatic—a term I borrow from
psychoanalysis—I mean the ideological reality through which colonial
fantasies as the support of desire[2] emerged, operated, and manifested
themselves. It also refers to the psychic process, the structuring action,
which shapes and orders the subject's life as a whole. The modern use of
the term "fantasy" was first conceptualized by Freud in his many essays on
the function and nature of fantasy.[3] My own understanding of the com-
plexity of this concept is largely mediated by the work of the French
psychoanalysts Jean Laplanche and J.-B. Pontalis, who first unveiled their
views on fantasy in their original 1964 essay "Fantasme originaire, fan-
tasme des origines, origine du fantasme." They defined it more succinctly
in their *Language of Psychoanalysis* as "an imaginary scene in which the
subject is a protagonist, representing the fulfillment of an (unconscious)
wish" (314). Elaborating on Freud's analysis of the relation of art to
fantasy, Laplanche and Pontalis link desire to unconscious fantasies
which structure and shape the subject's psychic life: the claim is "to
unearth the phantasies which lie behind such products of the uncon-
scious as dreams, symptoms, acting out, repetitive behavior, etc. . . .

(317). Kaja Silverman puts it more succinctly; she calls the phantasmatic this "unconscious fantasy or group of fantasies which underlies a subject's dreams, symptoms, repetitive behavior, and day-dreams" (161). I argue that the colonial phantasmatic elaborates a complex restructuring of both psychical and cultural reality.

To appeal to a psychoanalytic concept like the phantasmatic and extend it to include a nation's discursive practices and, more precisely, colonial fantasies at the Exposition, may seem at first antithetical to cogent analytical research. But, as feminist critics such as Elizabeth Cowie and Cora Kaplan have elegantly shown, fantasies are not only a "crucial part of our constitution as human subjects" (Kaplan 146), they are also imbricated in the discourses on sexuality and race.[4] They caution us against seeing fantasizing as "a female specialty," a particularly important injunction in the light of our postulate that the entire colonial enterprise hinges on a masculine imaginary of conquest. The myriad discursive forms these male colonial fantasies assume are thus the object of critical scrutiny in this study. I suggest that the colonial phantasmatic may also give new insight not only into the underlying premises of French colonial discourse of the 1930s, and its enduring appeal, but also into the identificatory and libidinal forces of what Jameson calls its "political unconscious." The desire for exotic and other sensual and cognitive experiences manifested itself in concrete fashion, in the design of the Palais d'Exposition, the decorative façade, and so on. This desire was impressed upon the imagination of these fairgoers by collapsing the aesthetic with the real in order to elicit support for French colonialism and, ultimately, to solicit a political endorsement. Apprehending the Exposition as *fantaisie*, both as creative activity and imaginative process as well as the products of this activity, sheds light on the ways *la France officielle* represented its colonies and imagined Indochina, its relation with the colonized nation and its people.

To test and illustrate this notion of colonial phantasmatic, I posit the following hypothesis. I contend that "Indochine" is a nineteenth-century French fiction, a fantaisie or geographic romance, created by France to elicit desire for its Far Eastern colonies. It is an imaginative territorial assemblage *calqué* (traced, copied, translated) from the political boundaries fixed by the French government when it created the Union Indo-

chinoise in 1887, in an attempt to consolidate the French presence in Southeast Asia and contain Great Britain's progress there. The phantasmatic Indo-Chine is difficult to locate precisely or represent accurately because it extends beyond the purely administrative and political boundaries of the Union Indochinoise. This uncharted territory has for markers cities like Hué, Saigon, Angkor-Thom, Vientiane, or Phnom Penh. These are not places mapped by geographers and cartographers, excavated by archeologists, or studied by the experts of the École française d'Extrême-Orient. Hué, Saigon, Angkor Thom, Vientiane, and Phnom Penh are represented, translated, and mediated—what the French call the process of *vulgarisation* (popularization)—by more "popular" media. The Indochinese fantasies, in other words, are elaborated and disseminated, arguably more effectively, by means other than through the work of experts. In *Orientalism*, Said believes that "to get at the Orient [the reader] must pass through the learned grids and codes provided by the Orientalist" (67). Said's work leaves out popular sources. In this newly modern age of mechanical reproduction, the *journal illustré*, such as *Le Tour du monde*, *L'Illustration*, or *Le Monde illustré*, which made their first appearances in the 1860s, featured heroic accounts of French military advances in untamed regions, reports of important archeological discoveries like Angkor Wat and Angkor Thom, and records of daily indigenous life in the colonies. These journals brought the vicarious traveler in contact with exotic lands, their strange customs and peoples. These phantasmatic images circulated via other media as well: stylized posters, designed by well-known artists like Capiello and others, for the Messageries Maritimes, cajoled the would-be traveler; advertisements boasted of the easy life in the colonies and urged the French to leave their drab life behind—a dream no longer out of reach for most French with the advent of new technical advances in steam travel (and later, air travel). Postcards also played an important role in promoting French colonial possession. In the political arena, the Tonkin expedition (1883–85) sealed the fate of Jules Ferry. His colonial policies were widely debated and commented on by the daily press. Ferry had to resign from the Présidence du Conseil after the French debacle at Langson (March 1885). By the last decade of the nineteenth century, the spectacle or "theater" of the colonies, to borrow Sylviane Leprun's words, had become an integral part of French life.

The emergence of French colonial fantasies of Indochina reveals an attempted identification and conflation of this phantasmatic Indochine with the political Union Indochinoise. Indeed, it is the very failure of that identification—the discrepancy between the imagined ideal and the political reality—that must account for the logic, motivations, conscious and unconscious desires. Its location between India and China explains its christening and original orthography, Indo-Chine.[5] The swerving away from its strictly cartographic meaning to signify a new political geography, or *physionomie politique*, was designed to erase from the collective memory the bloody history of its foundation (i.e., events like the death of Commandant Rivière or that of Francis Garnier). The French will to fashion an innocuous image and a new and coherent identity for Indochina meant endorsing the pseudo-scientific belief that these independent kingdoms and nations and their cultures were derivatives of those of India and China. In numerous accounts of its "elementary geography" written during the belle époque, Indochina is regarded as "a region of transition," "a meeting point," "the cross-roads of maritime routes between the Orient and the Far-East" (Brenier and Russier 20). It is an empty space where traces of a glorious past can only be excavated with the knowledge and expertise of the French. By promoting the idea that Indochina is merely the "hinge [charnière] between the Indian and Chinese civilizations" (Marseille, *Empire* 21), we might come to fully appreciate the power of Orientalist discourse in legitimizing the political will of the nation. For now, it suffices to say that the spelling used by the École française d'Extrême-Orient becomes the one adopted officially by the French government (Brenier and Russier 19). What once was its sole defining mark, the graphic trace of the hyphen, the linking *trait d'union*, disappears at the very moment French fantasies of Indochina take hold of the French popular imaginary.

To consolidate these myths of Indochina as lack, void, or absence, a new history of the region had to be written, one that would fit the new political identity assigned to it and accommodate new phantasmatic images like those of Angkor Wat, long forgotten by the natives, and "rediscovered" and promoted by the French. The history of the Union Indochinoise served to legitimize the French administrative construction of "Indochine" as the "cadre territorial et étatique de la colonisation

[territorial and state boundary of colonization]" (Hémery, *Ho Chi Minh* 24) which imposed French colonial rule on a number of independent kingdoms and states, bringing them together under the aegis of one central general government. The creation of a federation of states paradoxically meant carving and dividing a region, under the suzerainty of the Vietnamese and Chinese empires, into three provinces (Cochin China, Annam, and Tonkin), wrestling territories from the Thai that constituted part of the ancient Khmer empire, and unifying the three kingdoms of Laos into one colonial state. Transforming these occupied territories in the Southeast Asian peninsula into a single administrative, economic, and political space and identifying it under the name "Indochine" meant not only ignoring boundary disputes between historically rival nations, absorbing heterogeneous populations, and drawing new political boundaries without any regard to ethnic composition. More importantly, it also meant inventing a stable and unified identity based on a lack, the absence of a proper name, and supplementing it with a colonial phantasmatic.

The Exposition Coloniale Internationale de Paris homogenizes and consolidates the heterogeneity of Indochina's history and geography through a variety of representations. As mentioned earlier, the Exposition constructs and disseminates these representations to an impressionable public already acquainted with the exotic colonies through the press, political discourse, literary writings, and cinema.[6] By framing the popular and political images of Indochina within this new geographical space of the Exposition, these Indochinese fantasies (e.g., those invented to promote Saigon or Angkor Wat as the cradle of an ancient "Indochinese" civilization) become identified as the real markers of that new French colonial possession triumphantly named "Indochine," destroying in the process both the region's cultural specificity and its diversity. The Exposition is therefore the site where strategies of containment and identity formation are at their most effective. What is at stake in these representations of other cultures and their peoples, and what do these representations tell us about French colonial ideology? How effective were these cultural manifestations in assigning a cultural identity to Indochina? What allowed the French to speak of a sexualized and feminized Indochina? What were the modes of identification conceived to stimulate and satisfy these desires and phantasms for the exotic? My aim is not

so much to contest these representations nor to simply relocate the position of the native/woman/Other but to deconstruct these fantasies by bringing together and juxtaposing conflicting discourses of colonization on Indochina. To achieve this process of defamiliarization, I focus more specifically on architectural discourse and on the ways the Palais d'Exposition becomes a paradigmatic model of the true representation of French colonial empire.

L'Exposition Coloniale Internationale de Paris

World's Fairs have been the subject of numerous studies (see Allwood, Demy, Poirier), but rare are the works devoted to French colonial expositions (Hodeir and Pierre). When they are the focus of scholarly attention, these singular exhibits designed to anchor and promote *l'idée coloniale*, are subsumed, unproblematically, under the category of "World's Fair." In his classic study, for instance, René Poirier traces the genealogy of the colonial exposition by examining its emergence at the World's Fair of 1867. The Paris Exposition Universelle is said to have inaugurated the tradition of building indigenous pavilions in their traditional architecture. The Tyrolian village, Egyptian caravanserai, Oriental minaret, Turkish bath and mosque all made their appearance in the capital of France (Poirier 12). Fairgoers, however, would have to wait until the Paris 1889 Exposition to get a glimpse of life in the colonies. A colonial city complete with indigenous people installed in native villages had been recreated in the *section coloniale* of the 1889 World's Fair. These "native reconstructions" were more often than not grotesque and humiliating exhibitions of, for example, an "African village in a primitive state," resembling a "zoological curiosity." Visitors could also barter in Tunisian and Algerian souks and bazaars. For others, the "colonial city" became synonymous with erotic display. Under the guise of folkloric presentations, veiled Algerian women danced before a titillated French public, a spectacle said to have greatly shocked Jules Ferry (Poirier 150).

The legacy of the section coloniale at World's Fairs can be found in its most elaborate form at the Exposition Coloniale Internationale de Paris (1931). Although other great colonial powers of the time (Great Britain,

the United States, Belgium, and Holland) also used national and international expositions to promote their colonial empire—Wembley became the site of the Exhibition of 1924 and Chicago hosted the World's Columbian Exposition of 1893—it can be argued that the French surpassed them in scope and in their ambition to sustain the myth of the colonial era beyond its heyday.

Walter Benjamin stressed the link between the representation and consumption of exotic cultures and the commercialism of world exhibitions, which he considered to be nothing less than "the sites of pilgrimage to the commodity fetish" ("Paris" 151). For Benjamin, "The world exhibitions glorify the exchange value of commodities. They create a framework in which commodities' intrinsic value is eclipsed. They open up a phantasmagoria that people enter to be amused. The entertainment industry facilitates this by elevating people to the level of commodities. They submit to being manipulated while enjoying their alienation from themselves and others" (152). The large number of tickets sold (33 million for the duration of the Exposition) seems to bear this out. Benjamin's insights into the Exposition raise a number of interrelated issues. The first one deals with what Benjamin calls "the enthronement of merchandise" with the aura of amusement surrounding it.

The organizers had a complete understanding and thorough knowledge of the public's expectations. They knew that an exhibit that would merely showcase colonial products would leave fairgoers largely unsatisfied. To lure them, they found it necessary to combine these didactic displays with more popular forms of diversions, the underlying aims of which were still to inform, educate, and seduce. Visitors could ride an electrocar that would allow them to tour the entire world in an hour. After a stroll among the ancient ruins of Angkor Wat or the "primitive" African village, they could restore themselves by sampling food from many different regions. Later, they could take their children for a camel or elephant ride. Young couples could spend their day observing the exotic fauna in the newly constructed Vincennes Zoo or go for a pirogue ride on the lake. At night, light shows would transform the landscape of this colonial world and insert the fairgoer in a phantasmatic world. In short, organizers had recourse to different types of *séduction du pittoresque,* which ranged from popular amusement to more high-brow forms of

pleasure. The vicarious experience of participation in the exotic life of the colony offered to the fairgoer did not simply indulge the senses and offer pleasure, nor did it simply "elevate people to the level of commodities." It also attempted to transform the visitor and make him or her into a French colonizer.

Although one cannot deny the influence of capital and merchandise and the promise of riches they held for the French, to consider "commodity fetishism" in classic Marxist terms is to stay within the binary logic of representation and misrepresentation (Mitchell 225). I therefore will not investigate colonial fairs within the continuum of World's Fairs— i.e., the heretofore privileged method of inquiry—but will rather address the poetics and politics of exhibition in order to determine the extent to which colonial expositions and, more specifically, L'Exposition Coloniale Internationale de Paris came to embody in the French imaginary l'idée coloniale. To understand what is meant by the poetics and politics of exhibition, one must turn to an essay written by Heidegger entitled "The Age of the World Picture." Heidegger considers "the conquest of the world as picture" to be "the fundamental event of the modern age" (134). The world as picture refers to man's capacity to produce a structured image which "secures, organizes, and articulates itself as a world view" (134). This notion can be extended to the process of exhibiting at colonial World's Fairs. Timothy Mitchell, in his brilliant study of Egypt at the exhibition, calls this reordered world "the age of the world-as-exhibition." "World exhibition," he adds, "refers not to an exhibition of the world, but to the world conceived and grasped as though it were an exhibition" (222). My analysis also builds on the studies of historians who see the Exposition as a pivotal moment in French colonial history (the apotheosis of the "colonial idea" [Girardet, *L'Idée* 175–99], the site of a struggle between Republican and imperial ideas [Ageron, "L'Exposition" 565–70], the locus of an emerging French cultural identity [Lebovics 51–97]). It also investigates the complex interplay between historical and geographic imaginations, the phantasmatic and the real. The Exposition allows us to rethink the historical, aesthetic, and sociopolitical construction of identities, self and other relations, and to examine ways in which various colonial discourses—in particular architectural discourse— reinscribe the colonized subject within a framework that answers to the

political and aesthetic needs of an imperialist's appropriation of exotic worlds. At issue is not simply the oppressiveness of the colonial exposition, but also its totalizing ambition, its claims to authenticity, and its will to account for every form of exotic experience.

The Palais d'Exposition

In the 1930s, architecture was considered to be l'art par excellence because it was said to embrace (and even subsume) all arts. As "total art," it displaced painting as the favorite medium for representing other worlds. Members of the organizing committee of the Exposition believed that architecture, as a "mirror of reality" or "mirror of the world" (Maigrot 23), should mediate the encounter with exotic and strange civilizations so as to effectively draw support for French colonialism. They had complete faith in the role of mimetic art in representing a colonial reality that was thought to be accessible and transparent. Thus, they entrusted architects with reproducing native monuments that would appeal to the French sense of visual immediacy and satisfy their desire for exotic representations. The Palais d'Exposition was also intended as an architectural marker of "la plus grande France," the slogan used by members of the French Parti colonial to describe and promote France and its overseas possessions.[7] Architecture, then, can be said to have been invested with the authority and power to champion l'idée coloniale.

The Palais d'Exposition was conceived as an architectonic colonial manifesto, a public and official display of French colonial policies, which determined its discourse, circumscribed its space, and revealed its ideology. The integrity of indigenous buildings and native architectural space was altered to make way for a transfigured vision of indigenous buildings that conformed better to French aesthetic and political ideals. In an effort to emulate the principles of Haussmannian city planning, particularly when it came to the *tracé* (layout or plan) of the city, architects and planners designed a colonial microcosm by constructing an exotic village along a large avenue, appropriately called la grande avenue des colonies françaises, which represented French colonial possessions. Algeria, Guadeloupe, French Guyana, New Caledonia, Cochin China,

Laos, Reunion, Senegal, and Tonkin all had their pavilions, reconstructed in the native fashion. Representing the world by reordering and reconstructing it was meant to create a new identity for France, "la France des cinq continents." The culmination of this "new" exotic French world was a reproduction of Angkor Wat, one of the world's most colossal religious monuments, complete with its complex of temples. Considered to be the highlight of the Exposition, it was chosen because it embodied the exotic most vividly in the imaginary of the French. Indochina was to be seen as the jewel in the crown of the French colonial empire.

The ruins of Angkor Wat were reconstituted at a cost of 12.5 million francs. It was the single most expensive "native" complex of buildings. The façade and the exterior of the structures with their elaborate carvings, sculptures, and bas-reliefs were reproduced in minute detail. The Parisian architect Charles Blanche, responsible for the whole ensemble, sent his son, Gabriel, to Indochina to secure and bring back exact dimensions and molds of the carvings. The operating assumptions were that native referentiality could be copied, molded, transported, and recontextualized, and that architecture was capable of conveying the essence of a civilization.

To that end, the interior of the main building was completely redesigned to present French Indochina as a "great modern state with the body of its political organization, the exact representation of its economic power, and the complete tableau of its social, intellectual, and artistic activity" (Beauplan n.p.). Emptied out of its original native signs, Angkor Wat was restored to accommodate a prescriptive series of exhibitions. Samples of Indochinese economic resources were displayed on the first and most important level: industrial goods, agricultural products, foodstuffs, samples of mineral resources, various textiles, raw industrial materials, products from commerce and banks; in short, all the goods France was to appropriate for itself. The second level documented the services of métropole provided to the colony in exchange for these goods: public instruction, medical aid, science, books, French art, the École des beaux-arts d'Hanoi. The third and last level narrated the history of the region using archeological and ethnographic artifacts. The hierarchization of levels with commerce as the basis—or foundation, so to speak—of French colonial policies demonstrates, in unequivocal fash-

ion, the primary role played by commerce in delimiting the boundaries of French colonial expansionism.

The complex link between territorial appropriation and architectural representation is of particular interest because it exposes the logic of processes of reproduction and reterritorialization. In other words, a scaled-down or miniature version of French colonial empire comes to represent a model of empire. More precisely, the spatial reterritorialization of native buildings—which are powerful signifiers of that culture—produce a knowledge or "understanding" of French colonial empire, even when a sacred complex of edifices like Angkor Wat is but a fragment of Khmer civilization and, more importantly, a "temporary" reproduction, constructed only for the duration of the Exposition, meant to be demolished at its closing. The reproduction of a native building is obviously not the thing in itself but a decontextualized representation, removed from its native environment, displaced in both time and space. Although the Palais d'Exposition was not built to last, it was designed to evoke, paradoxically, the permanence of an autochthonous culture.

On the microcosmic level, the replication of Angkor Wat shows how native objects and space can be used and manipulated to serve French colonial ideology. On an anagogical level, this "restructuration" of native architectural design must be inscribed within the framework of an official colonial policy, what the French call euphemistically the *aménagement du territoire* (national and regional development), a process that displaced, if required, entire populations of indigenous inhabitants. To better gauge the scope of Western manipulation of native signs, we must also look at the political discourse implicit in this type of reconstruction. What are the ideological implications of selecting a monument in ruin, which allegedly is capable of expressing, in the words of a critic, "the essence of an entire nation," at a specific moment of its history? To the French, Angkor seems worthy of comparison only because it measures up to the Western construction of prestige: "the temples of Angkor were the mirror of the world for the Khmer of a thousand years ago, just as the cathedrals were for Christians of the Middle Ages, the Parthenon for the Greeks of the Golden Age" (Fougères 71). Marshall Lyautey, the general commissioner of the Exposition, called it "this marvel of the Far East, this Persepolis of the Khmer" (442). Thus, Angkor is judged strictly from a Eurocentric point of view, which never questions the "positionality" of

the comparing subject who relies unproblematically on unexamined notions of permanence, greatness, and similarities.

But what is perhaps even more disturbing is the claim made by many Frenchmen, and among them, the writer and Académicien Claude Farrère, that France is the legitimate heir of the Khmer civilization: "Indochina for the Indochinese means the slaughter or enslavement of all Cambodians, Laotians, Mois, Hmongs, and others! . . . We, the French from Asia, we, the Western peacemakers of the Far-East [nous, Française d'Asie, nous pacificateurs occidentaux de l'Extrême-Orient], are the legitimate heirs of the ancient Khmer civilization, [we are] better than anything that succeeded it until our arrival on those distant and sacred shores. We have prohibited, wherever we have established our presence, civil wars and the destruction of the past, natural preceptor of the future" (n.p.). This self-nomenclature of a Français d'Asie (or Français d'Afrique) will become the slogan adopted by French nationalists to justify their continued presence in Indochina or Algeria in the 1950s and 1960s. In this passage, Farrère claims that France, as the *nation protectrice* (guardian nation), has the moral obligation to prevent further bloodshed in the region. The French mandate to civilize these warring primitive peoples must be linked to the greater goals of the "civilizing mission." Angkor Wat stands for more than a symbol of the golden age of the great Khmer civilization that once dominated the entire region;[8] half a millennium later, it signifies a "new" Angkor, symbol of a new Indochina that can be reborn from its ruins, a rebirth made possible by France, which would validate France's claim to be its legitimate and powerful heir. The French cast themselves not simply as archeologists/architects, whose duty it is to preserve the past. They also suppose themselves to be direct heirs of a great civilization.

This should not come as a great surprise. In 1931, it was widely believed that architecture was not only "l'art par excellence parce qu'elle cumule tous les arts [the art par excellence because it combines all the arts]" but also provided "la trace la plus excellente des civilisations disparues [the most valiant trace of lost civilizations]" (Bayard 2). Architecture was also regarded as a gauge of sophistication of an indigenous civilization. "The technique in construction indicates the degree of intelligence and ingenuity of the builders, the style of the façade betrays the refinement, the strength or naïvety of a race," proclaimed an architecture

critic at the Congrès de l'urbanisme colonial, held at the Exposition (quoted in Palà 21–22).[9] The (asserted) symbiosis between architecture and racial ideology offered the French powerful justification for longstanding racial and cultural prejudices. The construction of native buildings and monuments could not be entrusted to indigenous architects. Autochthonous artisans were called upon solely to decorate these buildings.

Thus far, we have seen how the Palais d'Exposition was designed to give a coherent vision of the colonies and seduce the French. To make these palais appear still more "real," the indigenous people were used as *figurants* (extras)—as props or live mannequins to perform native tasks and rituals. The indigenous people delimited the "animated space," thereby constituting a tableau vivant or phantasmagoria, while native buildings were part of the "constructed space."[10] Buddhist rituals were held by bonzes, classical Khmer dances were performed by the Royal Khmer Ballet, and craftsmen carved decorative objects. An exotic world, complete with native practices, emerged before the eyes of the fairgoer. The appeal of the vision vivante was quite successful in drawing the French to the Exposition Coloniale. Thus, the spectacle of the Exposition depended also on the cooperation of the silent native figurants in their assigned and confining roles of "adopted children" under the various guises of exotic dancer, artisan, or student. The Palais d'Exposition was constructed, therefore, as a powerful "context" that conferred an identity upon the objects and peoples it circumscribed and thus reinforced and perpetuated certain cultural idées reçues about the other. It leveled material differences, and codified and perpetuated created and desired differences as truths. But these palais were not designed to last. They were to be demolished at the end of the Exposition. Only one palais would stand after the end of the Exposition, Le Musée Permanent des Colonies.

Le Musée Permanent des Colonies

If the Trocadero, the Eiffel Tower, and the Petit and Grand Palais were built to bear witness to the Paris World's Fairs of 1878, 1889, and 1900, the Musée Permanent des Colonies was designed, as its name suggests,

to be a permanent testimony to the Colonial Exposition of 1931. It was to account for all of France's colonies, but the problem arose of how to choose from so many different types and styles of architecture. It was decided that a building "French" in style and spirit would be built. The French architect Albert Laprade turned to the Greco-Roman architectural tradition as his source of inspiration. The architecture of the Musée signals, then, a return to a more canonical Western model, its basic structure resembling a classic temple. The palais is imposing without being grandiose. Its style is distinct from the "classic nineteenth-century grand style, with historical and allegorical decoration, at the service of imperial nationalism" (Hobsbawm 175), in part because it was not designed as a triumphant ode to French conquest and also because its architecture is that of a "neutral and modern" building (Maigrot 23).

Unlike the 1900 World's Fair, where the architect Alexandre Marcel built the Panorama du Tour du Monde as a composite Palais d'Exposition upon which different native styles of architecture were juxtaposed rather incoherently (Beautheac and Bouchart 40), it would be the Musée's decorative scheme and not its design that served French colonialism. The "Gigantic tapestry representing the colonies' economic contribution to France" (Goissaud 279), said to be the most colossal bas-relief of the time, was executed by the French sculptor Alfred Janniot, recipient of the Grand Prix de Rome. Janniot succeeds in giving coherence to very different and disparate elements which constitute la plus grande France by relying almost exclusively on naturalized, that is, imagined and idealized, images of the colonies and their inhabitants. The content of the form, as Hayden White put it, "entails ontological and epistemic choices with distinct ideological and even specifically political implications" (ix). Janniot participates in the elaboration of a colonial memory and succeeds in promoting a particularly idealized history of French colonialism.

By concentrating on Janniot's elaborate sculptural composition, we can see how his bas-relief transforms French colonialism into a work of art.[11] In all, 250 figures of men and animals are represented in a space of 1,128 square meters—covering almost the entire façade measuring 88 meters by 14 meters. The bas-relief is divided into two panels, with the main door as its center. Images of the African colonies, on the left side of the central door, are opposed to those of the Asian colonies, situated on the right.

The colonies are depicted as the source providing the metropolis with all of its raw materials. Above the center door, the figure of Abundance is enthroned next to the figures of Peace, Liberty, and Sun. All of the raw materials plundered from the colonies converge in this allegorical group (and the center door), transported via cargos, transatlantic liners, and sailboats that will reach the most important French ports—Marseilles, Bordeaux, Saint-Nazaire, Le Havre—as well as Le Bourget, the airport. Each colony provides France with export merchandise. Goods from the federated states of the Indochinese Union figure prominently: silk, cotton, and rubber from Cambodia; coal, coffee, and cinnamon from Tonkin; from Annam, fish and precious wood; from Cochin China, rice and pepper; from Laos, coco oil. These representations are carefully composed to give a sense of order and unity. But if the symmetry of the composition appeals to the viewer's aesthetic sense of order, the mystification cannot be ignored.

The mystification enacted by the sculpture is thematized most blatantly in the figures of the African and Asian natives. These figures are naturalized to give an aura of innocence to the French colonies of Africa and Asia. The scenes portrayed evoke a golden age when the people still lived in a state of nature. The grace, elegance, and strength of the African men, for instance, are conveyed by memorable and beautifully etched hunting scenes which oppose man to exotic animals (crocodile or hippopotamus). Details of their well-carved, athletic bodies accentuate the vigor and resilience of these men, who seem happy to engage in manual labor, carrying elephant tusks or wood. The African women are depicted as engaged in traditional chores such as milling the grain, milking animals, collecting the cotton in bales, picking fruit, and caring for the children, all of which emphasize their feminine voluptuousness. The Asian men are represented as busy harrowing paddy fields, casting hoop or fishing nets, while the women are bleeding rubber trees or gathering the pepper crop.

Most striking is the complete harmony in which these people and wild animals inhabit a perfectly domesticated space and mythified world. This particularly attractive representation of life in the colonies has displaced the more cruel tales of exploitation and domination. In fact, a kind of sexual materialism dominates these representations of Indochina and

the French colonies. The African and Asian flora, their jungles and forests, do not pose any threat to the people. They provide more material goods that can be exploited. The predatory nature of French colonialism has been adroitly displaced and reimagined onto a battle royal which opposes the panther and the python or the lion and the gazelle—scenes that simply illustrate the violence of the law of nature. Janniot's bas-relief restores to "'realist' art that principle of play and genuine aesthetic gratification" (Taylor 205). It reflects and reinforces French cultural stereotypes of exotic life in the colonies—the glowing [ardente] joie de vivre which arouses the whole African continent, the thousand-year-old torpor of the Asiatic world. The bas-relief encodes and frames the colonial subject in an "other" world that supports the sentimentalizing and populist myths of Asia and Africa.

Modern technologies are nowhere to be seen in these two panels (except in the center), which underline the idea that these exotic and traditional societies remain uncontaminated by progress. The implicit subtext is that these "backward" nations need the guidance of the civilized West. Indeed, France is represented by a group of allegorical figures that occupies the center of the bas-relief. At the top of the central tableau sits Terra Mater, in all her glory. On her right, Liberty raises the torch, sign of light and guidance. On the left, branches of an olive tree enlace the figure of Peace, both figures rooted in the earth (Boudot-Lamotte 239). The sublimation of la plus grande France into these heroic figures invites the fairgoer to enter this colonial world.

Inside, the fairgoer finds a colonial universe ordered and sorted. Organized into two divisions—the retrospective section and the *section de synthèse* (the empirical section)—the Musée boasts an important ethnographic collection. Among the cultural artifacts to be found are examples of women's indigenous art, a mask collection, many fetishes, jewels, fabric, and pottery from Africa, Asia, and Oceania. The attempt to represent native art coherently, that is to say, in a systematic and logical fashion, created the fiction that "ordering and classifying, the spatial juxtaposition of fragments can produce a representational understanding of the world" (Donato 223). Like the juxtaposition of architectural elements of native buildings in the space of the Exposition, the accumulation of heterogeneous native artifacts in a museum homogenizes—rather

than highlights—cultural differences. Janniot's bas-relief participates in the same process.

Thus architecture and decorative art had the power to displace, reproduce, and appropriate native art forms. Janniot's bas-relief aestheticizes colonial history by naturalizing and allegorizing social realities. His *poème en pierre* (stone poem) is a monolithic *grand récit* (grand narrative), the function of which was to legitimate, totalize, and unify a phantasmatic vision of the colonial world. The Palais d'Exposition shows how the reconstruction of native architectural buildings on the outskirts of Paris did not simply showcase indigenous culture, but "reinvented" native traditions and constituted the colonial subject within an imperial logic of power and domination.[12] Janniot's elaborate fresco adorning the Musée Permanent des Colonies leads us to the question of the inscription of the colonial subjects in another space—an immutable, atemporal, transparent space—not only in the decorative and didactic space of the museum, but also in the reconfigured space of the Exposition itself. The colonized native, in addition to being an aestheticized object, was also reconstituted as a subordinate subject, cast in the role of the docile student, industrious worker or craftsman, or exotic performer. The resignification of the colonized subject as a figurant in the féerie coloniale reveals the force of this framing process in a space of domination and power which is coterminous with the logic of French colonial policies and France's mandate to civilize backward peoples. Because the Exposition was designed not only as a *"tour de force* of cultural or historical totalization" (Clifford 46) but also as a colonial "fantasy" created to "ravish" and elicit an individual or collective phantasm, it transformed the Western self, who now had "real" if "simulated" markers to experience what had been only dreams of escaping *l'emprise de la réalité* (the ascendancy of reality), the grasp of the economic depression of the 1930s. For the French, visiting the Exposition did not simply mean moving freely in a contained and phantasmatic world where they could fulfill their desire for the colonies and imagine themselves leading the exotic life of the colonizer, but, more importantly, it meant grasping the colonial world as a picture, a representation.

The delight of the French in this type of representation was accompanied by a different type of ravissement, that of the plundering of native

artifacts by private collectors and the state and their exhibition at the Exposition and in museums. This was followed by the expulsion of "unruly natives" who threatened to undermine those fantasies. During the Exposition, Indochinese students and workers demonstrated against the French Republic on the very grounds of the Exposition. Because they contested the representations elaborated at the Exposition, these unruly natives had to be removed from this new colonial Eden. Otherwise they could have exposed the whole exoticizing project of the fair. At the same time, the student militants emerged transfigured. They acquired a new identity, that of the déclassé, which no longer coincided with the image of the docile, shy, and gentle being attached to ancient ancestral customs and traditional values invented and popularized by the French press in the twenties (Roubaud, quoted in McConnell 141). Nor do they belong or fit in the fictive world depicted in Janniot's beautiful façade of the Musée Permanent des Colonies. The demonstrations by militant Vietnamese students and workers at the Exposition and other public places, calling for the end of French colonial rule and the independence of Vietnam, had a jarring effect on the idealized and authoritative construct of the Indochinese subject as craftsman, student, or exotic dancer, and provide a counterdiscourse to the phantasmatic. Unlike acquiescent native figurants who collaborated with the French organizers of the Colonial Exposition, the dissident natives unsettled the identity invented for them by placing themselves on the margins of the Exposition, literally and figuratively putting themselves outside the law, even when they realized that such defiant gestures would be punished with imprisonment or deportation. Their tale of resistance is one that needs to be told today.[13]

UNRULY NATIVES

The Indochinese Problem

As was made explicit in the previous chapter, the use of silent native *figurants* (extras) in such figurative roles as exotic dancer, artisan, or "adopted children" appealed to the French sense of the exotic and contributed to the success of the Exposition Coloniale Internationale. The complete triumph of the Exposition was nevertheless marred by a number of demonstrations staged by militant Indochinese students, the "unruly natives" who refused to be included in a scenography that reinforced the image of the docile and compliant native, popularized and disseminated by the official colonial propaganda and the French press. These "unruly natives" sought to disengage and free themselves from an elaborate discursive system of surveillance and containment which attempted to fix an ideal and phantasmatic collective identity onto a disparate "Indochinese" population. Rather than work behind the scenes, these men and women dared voice their opinions and make their demands public. The emergence of a native student discourse of resistance, which opposed not only French colonialism but also resisted and challenged discursive cultural constructions that aestheticized them, is the focus of this chapter. Native resistance practices will be examined in the light of an analysis of a nostalgic French political discourse.

In early May 1931, five thousand copies of a Surrealist tract entitled "Ne Visitez pas l'Exposition Coloniale" (Do not visit the Colonial Exposition) were circulated. Attacking "la foire impérialiste [the imperialist fair]," the tract begins with what the writers called "a nice raising of the curtain," the abduction of the Indochinese student Tao by the French police:

The day before the first of May 1931 and two days before the inauguration of the Colonial Exposition, the Indochinese student Tao is abducted by the French

police. Chiappe, to compromise him, uses forgery [le faux] and the anonymous letter. One learns, in the time necessary [for the French government] to ward off any unrest, that this arrest, described as a preventive measure, is only the prelude to an expulsion back to Indo-China. What is Tao's crime? Being a member of the Communist party, which is not in the least an illegal party in France, and to have dared to demonstrate in front of the Elysée against the execution of forty Annamites. (Pierre 194)

This news item or *fait divers* would have gone unnoticed, perhaps, had André Breton, Louis Aragon, Paul Eluard, Benjamin Péret, André Thirion, and others among the twelve Surrealist signatories of the tract and, even more important, *L'Humanité*, not brought this situation to the fore. The tract alludes to events that had been widely commented on in the press and in parliamentary debates, but which today have receded from our memory. Who was this "Indochinese student" Tao and what was he really guilty of?

Roger Gaillard, writing in *L'Humanité* of May 7, 1931, calls attention to Tao's predicament with the headline "Tao's Life Is in Danger!" He goes on to describe the police abduction and the events surrounding his deportation back to Indochina in these terms:

In the morning of April 30, Tao is seized when he comes out of his home, thrown in a taxi. For many days, the police feigns [*sic*] to ignore what it is all about. And, a week later, a radio communiqué [un bref radio] informs us that he has been carted away without even being able to take with him a few items of clothing or money, or to shake a friendly hand. Why resort to purely fascist behavior? Except because these imperialist governments are determined to get rid of all those who hinder them, and by all available means.

Tao's being in France means that, in order to prosecute and condemn him, one is under an obligation to respect certain ways of proceeding, above all the workers who keep a watchful guard around him. They know and love him because he personifies the heroic Annamite movement.

Tao's being in Indochina means that the member of the central committee of the party is given over to the base vengeance of the colonialists who, in the last year, tremble at the very thought of the revolutionary upsurge. It means the summary jurisdiction of criminal court—so well named!—the ancient barbaric tortures put back in practice [remises en honneur] by the police of the "civilized." (1)

For Gaillard, Tao embodies "the heroic Annamite movement" of national liberation whose oppositional (but legitimate) actions on French soil have been harshly repressed. He also exposes the common colonial practices of torture, summary executions, and so on, practices that, he fears, await Tao upon his return to Indochina.[1] Both the Surrealists' tract and *L'Humanité's* account suggest that Nguyen Van Tao was deported back to Indochina for being a central committee member of the French Communist Party and inciting subversive activities.[2]

To better understand the context of these governmental measures, it is necessary to trace Tao's exemplary and increasingly "deviant" political trajectory. According to a biographical "file" prepared for the Indochinese government, Nguyen Van Tao arrived in Marseilles surreptitiously, as a stowaway, in October 1926.[3] The French authorities had kept a very close watch on him ever since, at eighteen years of age, he was expelled from the Collège Chasseloup-Laubat, one of the French lycées of Saigon, for leading a student strike-boycott. The years 1924 to 1928 marked the beginning of a wave of student unrest in Indochina. The funeral of Phan Chau Trinh, one of the founding fathers of Vietnamese nationalism, triggered concerted student action. The main form of student mobilization consisted of boycotting their own schools. Tao joined the rapidly growing patriotic student movement which, in the short time from May to June of 1926, mobilized thousands of students. In Cochin China, for instance, sixteen different schools had been deserted by their students; by May 1926, more than five hundred students had been expelled, among them the young Vo Nguyen Giap (who would later rise through the Vietnamese Army ranks and defeat the French at the infamous Battle of Dien Bien Phu in 1954) and Dang Xuan Khu (Truong Chinh), a future Communist leader of the reunified Vietnam (Hémery, "Du patriotisme" 24–25).

Enrolled as a student at Aix-en-Provence, Tao never completed his degree, perhaps because he had to support himself working as a study monitor (*surveillant*) at the Collège de Brignoles in 1927. His political activities, however, never ceased. He became involved in the liberation struggle in France and took part in important meetings that eventually determined the direction of the Vietnamese anticolonialist struggle. Significantly, he was one of the two Vietnamese delegates to attend the

Sixth Congress of the International in July and August 1928, intervening with a long declaration on August 17 (Hémery, "Du patriotisme" 38). As the French historian Daniel Hémery has shown, Tao played, with Ta Thu Thau, the Trotskyist leader, a crucial role in steering the Vietnamese students toward Marxism. He adhered to the French Communist Party in early 1928, worked at its section coloniale, and was a member of its central committee. He was the main organizer of Vietnamese communism in France until his expulsion in 1931. Upon his forced return to Saigon, he wrote for *La Lutte*, the most successful Vietnamese newspaper published in French and, therefore, not subject to censorship.[4] Although he was elected in 1933 to one of the six Vietnamese seats on the Saigon municipal council, his election was declared null and void because of an unfulfilled age requirement (he was not old enough to hold office) (McConnell 147). Later, in his quest for a democratic and self-governing Vietnam, he led the "legal communist organization," becoming minister of work of the Democratic Republic of Vietnam in 1946 ("Du Patriotisme" 38).

My use of biography here is deviant. If historians and cultural critics are now capable of reconstructing Tao's political genealogy, it is in part because the French had become masters in the gathering and collecting of information, recording it painstakingly in police files.[5] The efficiency and control of the French surveillance apparatus was truly extraordinary. Of the 5,000 Indochinese living in France in early 1929, 3,675 had a dossier at the Ministry of Colonies (Hémery, *Revolutionnaires* n.p.). Other means of surveillance that involved different French government agencies were also used. The Contrôle postal read private correspondence, the police recruited and sent informants to meetings to record public debates and private conversations. All of the information gathered on private individuals found its way into these infamous *fiches*. A parallel can be drawn here with the totalizing ambition of the Exposition and its strategies to detail and account for all aspects of indigenous life. Under close watch and "exposed" by an invasive surveillance apparatus, the colonial natives were literally "catalogued" for future reference.

The same system of surveillance activities was also deployed in Indochina, but on an even larger scale. The French journalist Andrée Viollis, who visited the headquarters of the Sûreté in Hanoi, reported that

"20,000 political dossiers and 50,000 files were catalogued there in perfect order, in a large library where employees, as numerous as they are zealous, worked. Others are in charge of the deciphering of coded telegrams, from China and other parts, of the surveillance of letters, opened, photographed, and glued together properly" (127).

I do not resort to Tao's sketchy biography in order to build the image of a native leader who has not yet found his rightful place in the historical narrative on Indochina but to problematize the fact that the biographical Tao is also a textual construction, a collage, whose identity has been reconfigured with the help of information gleaned from many different sources—letters, police files, informant reports, and intergovernmental notes.

By evoking the political engagement of a committed Communist nationalist and examining the reverberations of his actions in the French press and in parliamentary debates, I also want to draw attention to the strategies used by the Annamites who wanted not only to establish political self-representation at a time when voicing such ideas was regarded as being subversive and a revolutionary activity, as well as to break from the political naturalistic classification assigned to them. I contend that the performative quality of these "unruly practices" shattered the French fantasies of the Indochinese people as gentle and amenable subjects.

The June 1930 parliamentary debates on the Indochinese question provide perhaps the best forum for an analysis of the discourse on colonialism and "the most striking reflection on the effect of Yen-Bay and the student demonstrations on the French polity" (McConnell 136). Many French deputies, among them Ernest Outrey, seized this opportunity to interpellate the French government as to the measures taken by it: "in order to stop and sanction, as they deserve to be, these intolerable and improper [inconvenantes] demonstrations of certain extremist Annamite students living in Paris, who, at the inauguration of the Indochinese Cité Universitaire, and in the presence of the President of the Republic and H.R.H. the Emperor of Annam, have interrupted publicly, using injurious shouts, one of the Annamite orators by throwing tracts in the room, demanding the liberation of the thirteen Yen-Bay condemned and all of the political prisoners in Indochina" (Chambre des députés 2440). Ou-

trey speaks here of the first Indochinese "public" demonstration against France. Tao and other Vietnamese militants, students, and workers boycotted the Maison de l'Indochine at the Cité Universitaire and disrupted its official inauguration attended by French President Gaston Doumergue and Emperor Bao Dai of Annam, distributing thousands of tracts to break the official silence on the repression in Indochina following the Yen-Bay rebellion.

The Yen-Bay rebellion, as is well known, is the site of a mutiny where a garrison of Vietnamese troops killed their French officers and seized the town on February 10, 1930 (McConnell 132). It stands as the most significant marker in the emerging history of insurrections and revolts in Indochina during the interwar period. Its significance, I would argue, can be traced in part to the scope and intensity of the French retribution, the reprisals and bloody repression that followed the short-lived mutiny. The French executed the mutinous soldiers, bombed the village of Co-Ham, said to have been the place of refuge for mutinous soldiers, gave prison and death sentences meted out by a specially formed criminal commission to members of the Vietnamese Nationalist Party, known as the Viet Nam Quoc Dan Dang. Moreover, it assumes great significance for the violent fracture it produced in the French imaginary on Indochina.[6]

The Yen-Bay episode rallied and radicalized the Vietnamese student émigrés, transforming many nationalists into radical Communists. But not everyone wanted to pursue a hard line. In fact, the spectrum of student responses reflected the divisions along political lines (nationalist, moderate, Communist, radical), which splintered the Vietnamese while anticipating the armed conflict between nationalist and Communist, and the division of the eastern part of the Indochinese peninsula into North and South Vietnam. But the most important, immediate effect of Yen-Bay was the radicalization of the Communist anticolonialists among the Vietnamese.

The target of the second Vietnamese student and worker demonstration was rather symbolic. On May 22, 1930, 150 Vietnamese students and workers staged a surprise, "illegal" demonstration in front of the Elysée Palace, distributing leaflets demanding the liberation of the Yen-Bay comrades (Hémery, "Du Patriotisme" 45; McConnell 134).[7]

The student demonstrations in Paris shocked the right-wing and moderate press because they signaled a leftward turn in the students' political journey and revealed for the first time in France the force and seriousness of their demands. The Indochinese students could no longer be viewed exclusively as "pupilles de la nation" (wards of the state) or "des enfants en tutelle" (children under guardianship) (Chambre des députés 2431). They emerged transfigured as ingrate *insurgeants* who dared attack the highest symbol of French authority.

Piétri, the minister of colonies, justified the sanctions imposed in the following fashion:

Sirs, as the delegate, in France, invested by the power of my governors-general, I have decided to initiate repatriation proceedings of all those of these young men whose residence in France I regard as undesirable.

As subjects, and even as French protégés, it is true that, at least in practice, they can not be expelled. But they are subject to a similar regulation as those with a residency permit [autorisation de séjour]. And this regulation includes a sanction, the withdrawal of the residency card and their return to Indochina, a sanction the Interior Minister and myself have not hesitated to impose.

If one argues that it is dangerous to send them to Indochina, I will answer that, in a comparably dangerous situation, what matters is that, over there, one does not get the impression that Paris is a refuge for amateur troublemakers [amateurs de trouble].

It would be easy to reply to Mr. Berthon; the issue, in compliance with the law and de facto [en droit comme en fait], is unassailable; the sole aim of granting an exit visa to these natives is, precisely, to ensure that, during their sojourn, they show themselves to be worthy of the authorization which has been given to them. (2498)

André Berthon, the Communist House member, who had questioned the legality of such measures, presented these events in a rather different light:

Sirs, on May 22, a demonstration took place on Saint-Honoré Street, in the vicinity of the Elysée. A number of Indochinese students and workers gathered to protest peacefully against the condemnation handed down by the Yen-Bay criminal court, the executions already carried out, and the maintenance in prison of

Indochinese revolutionaries, who, at the moment, are jailed in the hundreds, I should say, thousands. . . . This demonstration was very peaceful. It was rigorously legal and, if we are to believe the police reports themselves, these young men placed, at the head of their march, groups carrying placards with only these in-scriptions: "equality," "fraternity" "Save the condemned men of Yen-Bay." (2490)

According to Berthon, the "unruly natives" merely exercised their civic rights as "protégés français" and made their demands by protesting against the condemnation given out by the colonial court.

The "Indochinese question" was seriously debated over three different sessions of the Chambre des députés in June 1930. Communists and Socialists, members of the Parti colonial and the Parti radical, all voiced their opinions on the Indochinese problem. François Piétri, the minister of colonies, voiced his concerns and indignation in the following terms: "My indignation extends towards the conduct of these students, who solicit and receive the hospitality of our laws, our customs, and our ideas, who take advantage of our intellectual and social life, and who have the audacity to insult our chief of state and to proclaim, in France, that those who assassinated French officers and soldiers are heroes" (2501). Yet he also wanted to protect France from becoming a "refuge for amateur trou-blemakers." Once described as "childlike" and passive, the students are now seen as "audacious," "insulting," provocative profiteers, revealing an incommensurable discrepancy between their actions and their erstwhile reputation as silent and self-effacing natives. By refusing their assigned place as they dare to voice their opposition and make public proclama-tions, they no longer conform to the idea of the "good native/student."

Defined and fixed by their position as recipients of the "hospitality of our law, our customs, and our ideas," the Vietnamese students are admon-ished primarily because their actions are seen as being disregardful of the opportunities provided to them by France, as summed up rather precisely by the all-encompassing concept-metaphor of hospitality. Piétri believes that the students are bound by a contract, if not legal at the very least a moral agreement of some sort, that implies obedience to authority and should have prevented these types of eruption and "illegal" activities.

The notion of hospitality extended to Indochinese students is a prob-lematic concept fraught with tensions that demand to be unpacked, its

genealogy and politics unveiled. The issue of hospitality in this particular context is not simply a rhetorical figure used in a political discourse, but part of the surveillance apparatus deployed to contain and isolate the radical Vietnamese student movement.

French hospitality took a very concrete shape, in a form as elementary as basic shelter. The Maison des Étudiants Indochinois was built to provide students with affordable housing in the heart of the Cité Universitaire in Paris. But behind its philanthropic façade, the hospitality ostensibly offered screens a much more disturbing logic. The Maison was part of an elaborate apparatus of surveillance designed to monitor the students, their movements, and political activities.[8] In fact, Ta Thu Thau, as a founding member of the Comité de réception des étudiants vietnamiens, founded in September 1928, attempted, with some success, to "shield the student émigrés from the supervision of police agencies [soustraire l'émigration étudiante à la tutelle des services de police]" (Hémery, "Tha Thu Thau" 208).

The symbolic importance attached to a concept such as "home" can be seen by the presence of important French colonial figures at the two official commemorations. At the first Indochina House inauguration, Minister of Colonies Léon Perrier placed the need for such a building in the context of what France had done to bring the spirit of modernity to the young minds of Vietnam: "As soon as he enters the French schoolroom, the young school boy has the impression of entering another world, which is bathed in a seductive glow. One speaks to him of France as a *divine guardian;* one liberates his soul from ancestral terrors, one communicates to him a confidence in the future and a sense of progress to replace the tedious effort at memory which had paralysed the intellectual activity of his race" (*La Presse coloniale*, 21 July 1928, quoted in McConnell 81). Perrier's speech is exemplary of the official discourse of the time. Here, in the most reductive and racist terms, Perrier refers to a number of issues that have embroiled Vietnamese society: the Hué court's resistance to change; its inwardness and reliance on a traditional mandarinate hostile to modernization and progress; its eagerness to preserve its privileges, which adamantly rejected the modernization of its political and economic institutions. In short, the Hué court was confident of the superiority of its intellectual and moral knowledge and tradi-

tions over Western notions of modernism and technical progress, and disdainful of all that fell outside Confucian thoughts.

However, for obvious reasons Perrier neglected to mention the catalysts to change and the emergence of the transformation of Vietnamese traditional institutions into a new civil society. The agents of change included the "unruly natives," the young intellectuals who studied in France, the Soviet Union, or China. Ho Chi Minh benefited from this broad cultural and political experience, summarizing his political knowledge in these terms: "Thus, I was able to acquire some experience as far as the edification of the Party is concerned in the USSR, in the matter of the struggle against capitalism in France and against the colonialists and the feudal lords in China" (271); "Ainsi, j'avais pu acquérir un peu d'expérience en matière d'édification du Parti en URSS, en matière de lutte contre le capitalisme en France et contre les colonialistes et les féodaux en Chine" (Hémery, "Du Patriotisme" 3). Like Ho Chi Minh, the students rejected not only these traditions and a type of "intellectual opposition to progress and change [immobilisme intellectuel]" (Le Thanh Khoi 361). They also denounced and struggled against a mandarinate that collaborated with the colonial power and took an active role in exploiting their own people.

In both Indochina and France, the students played an integral role in the movement that rejected traditional mandarinate studies, which rewarded the privileged few with the right to hold public office. Although they were educated in overseas metropolitan centers, as we will see below they were not cut off from Vietnam and were well informed of the material conditions that continued to oppress peasants, workers, and students.

In January 1929, Vietnamese students living in France published a manifesto in the *Journal des étudiants annamites*, declaring: "We seize this opportunity to proclaim once again our profound attachment to our beloved country so unhappy under foreign domination and to affirm that the aim of our studies will be its liberation. . . . We are happy to note that the Annamite workers share the same feelings" (Hémery, "Du Patriotisme" 30). Acknowledging the support of the Vietnamese workers, they reasserted their desire to see their country liberated from colonial domination. This proclamation contrasts sharply with the one made public by

François Piétri, the new minister of colonies, two years later at the inauguration of the Maison.

Piétri claimed that the central doctrine of the French Republic was to *"raise all peoples to an equality of mind."*

The experience of study in France, Piétri argued, would demonstrate to the youth of Vietnam that France contained much more than productive factories and that "despite the magnificence of France's technical accomplishments" the Vietnamese would be more deeply touched by "the ideal of reason which has illuminated the world for centuries." Students, who had first learned "respect for tradition" in Vietnam would learn from France the need for "organized work, and positive effort." When they returned, they would communicate "to their own parents, friends, and later their children what is the nature of the greatness of the people which watches out for you, what is the worth of this *family*—the French collectivity, which today regards you as its *most treasured children.*" (*Annales Coloniales*, 23 mars 1930; my emphasis; quoted in McConnell 81–82)

Beneath the rhetoric of paternalistic benevolence, which merely confirms the unequal relation of power that characterized colonialism and the relation between France and the native students, who were placed once more in the position of "children," lies a much more problematic and paradoxical situation. How can the French government legitimize or rescue its reputation as a nation that aspires to "raise all peoples to an equality of mind"? How can such a lofty ideal not be used against France and its colonial policies? The danger education presented was not lost on all the parties, particularly among those staunchly defending French colonialism in Southeast Asia. The inherent contradiction between an enlightened France with a strong history of Republican ideals and an imperial France must be laid bare. The only solution was to provide the natives in the colonies with a different type of education, one that would not foster liberal ideas.

The French colonial education system, inherently discriminatory, was designed to deny the natives access to French education: "At the conclusion of the 'complementary' education, then of the 'local secondary' education [A l'issue de l'enseignement 'complémentaire' puis de l'enseignement 'secondaire locale']," writes Hémery, "one could only enroll in the University of Hanoi, this 'closed box for the manufacturing of dwarfs

[boîte close pour la fabrication de nains],' in Paul Monet's words. The secondary school certificate [le certificat d'études secondaires], still called 'local baccalaureate [baccalauréat local],' did not give access to metro-politan universities; once in France, one still needed to obtain a special dispensation [*dérogation*] or prepare the offical baccalaureate" (Hémery, "Du Patriotisme" 22). The University of Hanoi conferred diplomas that were not even recognized by universities in France. To pursue advanced degrees, students had only one choice: to expatriate themselves. In the words of a student leader, they felt compelled to go to France in order to "conquer the instruction that is denied to us in our country" (Ta Thu Thau, quoted in Hémery 24).[9]

To get an authorization to leave the country (*une autorisation de départ*) proved to be a very difficult task in itself, in the light of the restrictive colonial policies and the draconian administrative measures enacted to curtail the number of student émigrés. The decree of June 20, 1921, required all applicants to ask the general government for an authoriza-tion to enroll in a French university. The decree of December 1, 1924, doubled the number of official supporting documents (*pièces officielles à réunir*) to be submitted for review. The tenor of the remark addressed to the young patriot Nguyen An Ninh by Cognac, the governor of Cochin China, is revealing of the official position: "Des intellectuels, nous n'en voulons pas! [Intellectuals, we don't want them!]" (Hémery, "Du Patri-otisme" 5). Expatriation, then, is a necessity, an obligation. The question of exile must also be linked to the notion of "militancy," and understood not in terms of "loss" of native traditions, but as a perfect illustration of a "populist situation" (Hémery 34) that favors contacts between heretofore incongruous groups. Exile brought together students, workers, and *ti-railleurs* (native soldiers) who were marginalized by a discriminating edu-cational system.[10]

Under Governor-General Varenne's administration, the "unruly na-tives" benefited from a relatively liberal issuing of authorization to leave the country. The Indochinese who were allowed to study in France had been carefully screened, even though, in the end, those measures proved to be ineffective, as illustrated by the student demonstrations in France.

What particularly infuriated the French was not so much the actions of the students—the demonstrations were in themselves peaceful and

relatively benign activities—but the students' knowledge and mastery of French Republican ideals, the assimilation of the concepts of freedom and self-determination that were used to challenge and oppose colonial France. As "guests" who had benefited from the hospitality of French laws, customs, and ideas, the students had given their "host" unmentionable sorrows in return. Following this line of colonial logic, France was being treated by these ungrateful students like the "father manhandled by his ingrate children" (Taine, quoted in *Le Petit Robert* 1003). Underlying this paternalistic and condescending admonition is the belief that education can indeed be a dangerous supplement. Piétri's staff warned of the possible ill-effects of unchecked education: "The Indochinese who come to Europe are very young people who sometimes undergo a rapid transformation because of the propaganda which is directed at their milieu. When they are not content to absorb the . . . education which is given them and make themselves guilty of acts against public order, it is in their interest that they be returned to their natural milieu, where familial influence and the influence of their ancestral tradition can aid them to emerge from a crisis which will most probably be temporary" (quoted in McConnell 141). The natives were to be returned to their "natural milieu," as if this mythic place had existed or had never been transformed by colonial practices and laws. Education was unquestionably a double-edged sword. The French believed that the Indochinese students sent to Europe to be educated would later return to their native countries to occupy important (native) leadership positions so that a whole class of Western-educated natives would support the imperial administration. This assumption, and goal, formed the basis of the later colonial policy of association, a policy that was still endorsed in the 1920s by the self-styled anticolonialist writer André Malraux.[11] Education would therefore transform these backward natives and make each of them into a "citizen of Greater France [un citoyen de la plus grande France]," in whom French colonialism would find trusted collaborators. But it could also turn the student into a radical nationalist, or worse, a Communist.

As the debates on the "Indochinese question" reveal, a good French education is one that does not foster ideas that could be used against French colonialism. Pierre Taittinger, the leader of the Jeunesses Patriotes, summed it up particularly well during his speech at the Chambre. Taittinger harks back to a golden age of colonialism:

In bygone days, Indochina was a tranquil nation, pleasant and welcoming. When a civil servant traveled, he was welcomed with a propriety, a kindness which all travelers in the Far East can recollect. There was a naive and touching trust extended by a major part of these populations.

What are the causes of the complete and abrupt reversal of the situation we face today? (Chambre des députés 2435)

He simply blames "the agent of the Bolshevik propaganda," "the man from Moscow," or "the call for hatred from Moscow," for this revolutionary unrest and the sudden reversal of French colonial fortune.

Because he estimated that over two-thirds of the Vietnamese students in France were Communists or pro-Communists, he proposed the following solution. The Vietnamese were to be returned to a mythical (and passive) ancestral past, a golden age of French colonialism when education was not even an issue:

Our intentions, in principle excellent, as far as education is concerned, were perhaps misguided in the Far East. It would have been better to encourage professional education [l'enseignement professionnel], to safeguard, so to speak, the ethnic originality of our subjects [administrés] and this would have quite often led the Annamite to reveal himself.

The Annamite has marvelous gifts as an art worker [ouvrier d'art], as a carver [ciseleur]. He has original conceptions of real artistic value. It is proper to encourage his development rather than to make him a "déclassé," a philosopher, an intellectual who harbors in his heart and mind only rancor and bitterness. (Chambre des députés 2437–38)[12]

The only kind of education for the Vietnamese would be a "professional education"; Piétri concurred and argued for a more important role for "education in Indochina" and, particularly, for a new and expanded role of the Université de Hanoi. Marius Moutet objected, arguing that the Université de Hanoi was "a university for simpletons [une université pour primaires]" that thus merely produced "assistant-physicians, (male) nurses, assistants to the court [médecins-adjoints, des infirmiers, des commis-greffiers]" (Chambre des députés 2500), an entire underclass of professionals. But Piétri answered that soon it would confer "the same degrees as French universities." In his mind, this would solve the entire student crisis and prevent the creation of a dangerous class of subversive

"déclassés": "The Annamite students could thus remain in the milieu of their traditions and customs, without having to face the contact of an attitude of mind whose shock is too sudden and too tough for theirs [sans affronter le contact d'une mentalité dont le choc est trop soudain et trop rude pour la leur]. There are, at present, 3000 of these students in France, of which 1000 to 2000 are in Paris. It is really pointless, and it behooves us to alert the parents of the dangers that such an exodus poses" (Chambre des députés 2506–7).[13]

Much indeed was made of the concept of *déclassé* or *déraciné*, labels used as buzzwords by conservative critics who opposed sending more Indochinese students to France for their education to describe the "acculturated natives" (see Shils 405–6). Taittinger's racist colonial beliefs were representative of the time for many an ideology that also transpired, as we have seen, in Alfred Janniot's pictorial representation of the hardworking Indochinese subjects as artists and wood carvers in his elaborate bas-relief adorning the Musée Permanent des Colonies. Etched in stone, these phantasmatic images of the Indochinese betray the French desire to hold onto the dreams and fantasies of a golden age of French colonialism, revealing the arrogance of a nation that refused to acknowledge the end of their domination in Southeast Asia.

The issue of the déclassé or déraciné intellectual was being addressed by the students themselves, who sought to radically redefine and rearticulate their relation vis-à-vis France, the *mère patrie* (mother country): "The young generation of which we belong must seek to escape, by all possible means, the Indochinese prison, to exile ourselves in foreign parts [à l'étranger] to find the means to fell [abattre] the colonial regime. . . . The concerted action from inside and from outside is the necessary condition for all liberation," writes Nguyen Huu Ninh in the March 1, 1928, issue of the Toulouse student newspaper, *L'Avenir de l'Annam* (quoted in Hémery, "Du Patriotisme" 26). The Vietnamese students' self-conscious efforts to resolve these issues demonstrate what Gayatri Spivak has called the "subaltern consciousness as emergent collective consciousness": "It is within the framework of a strategic interest in the self-alienating displacing move of and by a consciousness of collectivity, then, that self-determination and an unalienated self-consciousness can be broached" (14).

To be exiled in France was, paradoxically, the necessary condition for escaping French colonial rule. For the first generation of Vietnamese émigrés, emigration was a necessary step to take for national liberation. Studying in France did not mean being cut off from one's country of origin and its traditions, as French government officials like Taittinger and Piétri would have us believe in order to support their claim of the "unruly natives" as déraciné or déclassé. The flow of information circulated back and forth between France and Indochina through an informal network which succeeded in disseminating forbidden or seized newspapers in Indochina. Events taking place both in France and Indochina were therefore known to student leaders on both continents.

Indochinese students and workers also kept abreast of events in their native country via mail and collective or personal subscriptions to local newspapers. Hémery reports that the Association des étudiants indochinois de Montpellier placed at its members' disposal *"la Tribune indochinoise* of Saigon, the *Ngo Boa* of Hanoi, the *Tieng Dang* of Hué—papers that were seized in Indochina" (Hémery, "Du Patriotisme" 26). In 1929, copies of *Bua Lien*, the Indochinese Communist Party paper (or more accurately a "ronotype leaflet [feuille polycopiée]") found their way to France, smuggled out by Indochinese seamen (26). The French government could not stop the flow or the exchange of Marxist ideas and theory. With the help of the Vietnamese personnel working for the Messageries Maritimes, in 1930 hundreds of newspapers were smuggled back and forth. A letter by the French governor-general dated February 17, 1927, gives the tenor of this problem: "In 1927, not one month passes without the Sûreté seizing hundreds of newspapers and tracts coming from France. Thus, in January 1927, 345 copies of *Phuc Quoc* are seized in Cochinchina, and 242, in Tonkin" (19).

Through the newspapers, the students found a powerful forum where they could express their concerns on such contested issues as the conditions of emancipation and of national regeneration.[14] They also discussed and tried to define their role in the liberation struggle, voicing innovative ideas about the responsibilities and duties of the elite and intellectuals: "You will return with a bachelor's degree, a lycée's degree not to exploit our people, but to inculcate in our youth the knowledge you acquire with difficulty during your stay in France," states a woman

writer in April 1927 in the first issue of the student paper, *L'Annam scolaire*, published in Aix-en-Provence (quoted in Hémery, "Du Patriotisme" 28). The degree of political sophistication and awareness displayed by many of these youthful writers seems to have greatly surprised many a Frenchman.

Although Piétri claims that the students did not assimilate the lessons of French Republican ideals, even a cursory analysis of their writings shows otherwise. The Indochinese students did not simply idealize or emulate Western institutions but adapted them specifically to the Indochinese context. In fact, as Hémery has argued, the extent of their attraction to the French political model may have been limited to the "observation of its functioning which contributed to renew the nationalist referential frame" ("Du Patriotisme" 27). Much was learned from analyzing the French workers' movement, in particular, strategies used in mass trade unionism and in the workers' press and in the participation in electoral elections (27).

The emergence of a number of student newspapers reflected a flurry of student activism.[15] Better organized than ever before, the students also engaged in a number of other oppositional practices, using every means at their disposal to liberate themselves from the French political and cultural *tutelle* (supervision). They not only wrote in student newspapers, but organized themselves in an *association mutuelle* (mutual benefit association) or *comité de lutte* (committee for the liberation struggle) and addressed *réunions publiques* (public forums) (Hémery, "Du Patriotisme" 18) to denounce the repression in Indochina and to call for a complete French withdrawal from the Indochinese colony. Likewise, they launched opinion campaigns to denounce Franco-Vietnamese collaboration.

The events of spring 1930 must be understood within this particular context of student activism. Whereas the Exposition attempted to recontain the students' image, to resubmerge them within a French imaginary that wanted to preserve the notion of the docile colonial subject, their actions ruptured these old colonial fantasies. The Indochinese students emerged from these demonstrations transfigured from the colonial pupils and déclassés to become full-fledged agents of change, a new role that did not coincide with the image invented and disseminated for them by the French press. Louis Roubaud, for instance, writing in *Le Quotidien*,

helped shape the first clichés about the Vietnamese as the docile, shy, and gentle being attached to ancient ancestral customs and traditional values in France in the 1920s (see Roubaud [1924], quoted in McConnell 141). As we have seen in the preceding chapter, it was this particular representation of the Indochinese that was being rearticulated for the Exposition Coloniale. Less than a decade later, Roubaud began to see the change in his perception and wrote with empathy about militant students who committed their lives to the liberation struggle in his book *Viet-Nam: La Tragédie indochinoise*. After the Yen-Bay insurrection, a small minority of French intellectuals—André Malraux, Paul Rivet, Andrée Viollis, Francis Jourdain, and Léon Werth among them—constituted themselves into a Comité de défense des Indochinois in support of their claims and demands. But, ultimately, it was the actions of these committed "unruly natives" who wrote their own narratives of colonial resistance, that brought these French intellectuals to take a stand on their behalf.

THE "SURREALIST" COUNTER-EXPOSITION

La Vérité sur les Colonies

L'Exposition coloniale
L'anneau dans le nez de la religion catholique
Les hosties de la Défense nationale
Fétiches fétiches on te brûle si tu fais
la nique à des hommes couverts de sabres et de dorures
et l'outrage aux magistrats dans l'exercice de leurs fonctions
L'anneau dans le nez de la Troisième République
l'enfantement obligatoire
Il faut des soldats à la Patrie
L'Exposition coloniale

. .

Les bourreaux chamarrés parlent du ciel inaugural
de la grandeur de la France et des troupeaux d'éléphants
des navires des pénitentiaires des pousse-pousse
du riz où chante l'eau des travailleurs au teint d'or
des avantages réservés aux engagés volontaires
de l'infanterie de marine
du paysage idéal de la Baie d'Along
de la loyauté de l'indigénat chandernagorique

. .

Il pleut il pleut à verse sur l'Exposition coloniale
 (Aragon 214–16)[1]

While bearing in mind the emergent Indochinese discourse of opposition to the dominant colonial fiction, in the following analysis I want to focus specifically on the Surrealists' anticolonial initiatives, as exemplified by the "Surrealist" Counter-Exposition.[2] Although scholars frequently men-

tion this intriguing exhibit, the critical questions it invites have not received the attention they merit. As the name Contre-Exposition clearly suggests, the Surrealists wanted to delineate and mark their opposition and hostility to the Exposition Coloniale Internationale de Paris with their own subversive display of colonial documents and ethnographic objects. The avowed aim of the Counter-Exposition was to undermine the prestige and political significance of Marshall Lyautey's colonial phantasmagoria, in the words of one of the organizers, "to react against the intense colonialist propaganda elaborated by the government, especially at the Vincennes Exposition" (*Notes sur l'Exposition anti-colonialiste* n.p.). It strove to shed light on unsettling aspects of colonial "truth" and "reality" put forward and affirmed by the Exposition Coloniale by fracturing the bourgeois vision of colonial order with its own surreal assemblage of disparate installations, which included, under the same roof, the ethnographic exhibit organized by Aragon and a wide array of anticolonial propaganda materials, ranging from pictures and drawings to maps, political cartoons, and captions.

Because naming the Counter-Exposition La Vérité sur les Colonies (The truth about the colonies) suggests explicitly the didactic lesson— "the exposition as an education instrument, a teaching device" (Eco 303)—designed to discriminate "truth" from myth, fact from fiction, it appears to unproblematically submit itself to the rules and parameters governing the realm of factual and moral edification. La Vérité sur les Colonies did not, however, limit itself to conveying information on the colonies, denouncing the crimes and abuses committed by the West on the colonial peoples in the name of civilization, and to making manifest the "truth" of the colonies with all of its attending suffering. Even though the concept of "truth" may indeed evoke the opposite notions of untruth, lie, distortion, and misrepresentation, particularly with regard to such a contentious issue as French colonialism, it also transcends the realm of pure knowledge. The French Surrealists, as James Clifford has argued, transformed and radicalized the notion of truth by linking it to that of "ethnography." Thus, "ethnographic truth," in this specific context, does not aim to describe "colonial reality" mimetically; it refers to a new "cultural reality," one in which avant-garde practices deploy "ethnographic documents" in order to circumscribe a different reality, one "restlessly

subversive of surface realities" (Clifford 128) seen to be constitutive of the bourgeois world.

Tracing the convergence of ethnographic practices with Surrealist inventions and experiments, Clifford claims that "ethnography . . . shares with surrealism an abandonment of the distinction between high and low culture" (130), transforming "what is called reality by means of non-adapted hallucinations so as to alter the value hierarchies of the real" (Einstein 95, quoted in Clifford 130). "The task of ethnographic surrealism" is to reveal "the full human potential for cultural expression" (Clifford 129). Hence, his privileging of what he calls an "ethnographic attitude," one that "compos[es] and decompos[es] culture's 'natural' hierarchies and relationships" (132), and an ethnographic perspective, which "function[s] in the service of a subversive cultural criticism" (129).

La Vérité sur les Colonies illustrates, perhaps even better than *Documents*, Georges Bataille's short-lived glossy review, "a semiotic conception of culture," one "composed of artificial codes, ideological identities, and objects susceptible to inventive recombination and juxtaposition" (Clifford 132). Like *Documents*, which Clifford compares to "a kind of ethnographic display of images, texts, objets, labels, a *playful* museum that simultaneously collects and reclassifies its specimens" (132; my emphasis), the Counter-Exposition also works to defamiliarize common perceptions by juxtaposing incongruent images, objects, and texts. The unexpected conjunction of photographs, "primitive" objects and fetishes, maps, texts by Lenin and other Marxist leaders, reports, and so on reorganize the visitor's understanding of "colonial reality," rendering it more complex. Unlike *Documents*, it repoliticizes the cultural formations by resituating them in a new historical and cultural frame.

My purpose in this chapter is to examine the Surrealists' cultural and political intervention on the colonial question, and the claims made on behalf of "ethnographic surrealism," using the Counter-Exposition as the privileged terrain for mapping out the aesthetic and ideological impact of their actions, as well as the limits of Surrealist cultural politics. Within the larger problematic of the book, I will also be investigating the motivations behind the omission of Indochinese "objects" from the ethnographic exhibit. What does this omission tell us about the status and location of the "primitive object"? The Counter-Exposition also allows

me to raise the following questions: What kind of relation exists between "primitive" artifacts and fine art in the mid-twenties to the mid-thirties, that is to say, during a period of French colonial domination that is marred by indigenous rebellions and revolt from the Rif War of 1925 to the Yen-Bay revolt of 1930? What does it mean to "collect" an object, remove it from its original context, and recontextualize it under other material conditions? "What is involved in the expropriation (theft or pillage) of objects from actors in a particular context of space, time, and meaning," as Georges Stocking asks, "and their appropriation by observers in another? Who owns this 'cultural property'?" (Stocking 5). What are some of the ethical questions raised by the acquisition, through barter, trade, or purchase, of native artifacts? What and who is involved in the changing status of the artifact, its transformation into fine art? In other words, I will be concerned with the aestheticization and politicization of the "primitive" and its commodification. I also raise a number of less abstract, but certainly no less important questions: What role did the Surrealists play in the conceptualization and organization of the exhibit? To what extent can it be justifiably called a "Surrealist" counter-exposition? What strategies did they use to confront the social and artistic environment that was stifling and repugnant to them? To what degree does their attraction to the primitive still operate within a colonialist framework?

It is not inappropriate to begin my analysis of the Counter-Exposition with the study of an iconographic representation of the world, a peculiar map, the Surrealist Map of the World, first published in *Variétés* in 1929. This will lead us to a more extended discussion of the status of the "ethnographic object," its transfiguration into a work of art, which should shed light on the interactions and divergences, tensions and convergences, between ethnographic, museographic, aesthetic, and colonial (and anticolonial) conceptions of the "primitive object." As can be expected, the Surrealist map does not obey any cartographic rules. It never provides a legend. The geopolitical boundaries of nations and states have been whimsically redrawn. Representations of the Easter, Hawaiian, and Marquesas Islands do away with scale and scientific rules. As a result, an entire continent like Australia appears to be much smaller than Easter Island. There are also strange and, ultimately, revealing omissions. Indo-

china is nowhere to be found. In fact, none of the nations of Southeast Asia dominated by the French appear on the map, whereas Bali, Borneo, and Java, as well as China, India, and Russia are all dutifully named and marked out. How are we to read and make sense of this map?

This Surrealist map may be decoded, I believe, by examining other sites of Surrealist interventions and by weighing the role they attached to certain political and aesthetic movements. The revolutions in China and Russia, the liberation struggle in India struck a responsive note among many Surrealists, who covered these events extensively in their review, *Le Surréalisme au service de la révolution*. Africa, Alaska, Easter Island, and New Guinea, on the other hand, are considered important cultural locations since they accommodate the Surrealists' fascination for "tribal" objects and satisfy their desire for the "primitive," justifying their inclusion on the map. What I am suggesting here is a reading of the Surrealist world map that takes into consideration the convergence of their aesthetic ideas and political concerns. Thus, on closer examination, it appears that many of the nations where so-called primitive or tribal art can be found were deemed worthy of being included by the Surrealists and were mapped out.

One also could have expected Egypt, Japan, and Cambodia to have been included. But, in the 1920s, as the art historian William Rubin notes, "Japanese, Egyptian, Persian, Cambodian and most other non-Western court styles ceased to be called [and considered] Primitive" (3). The Surrealists, like their modernist predecessors before them, found "archaic arts" to be "too monumental, hieratic, and seemingly repetitious," privileging instead "the perceived inventiveness and variety of tribal art [which] was much more in the spirit of the modernists' enterprise" (3). This vanguardist attitude espoused by the Surrealists betrays the modernist appropriation of "primitive" objects for a modernist aesthetic, one that can still be seen at work at the Counter-Exposition.

Ethnographic Objects

To delineate the complex relation between the "ethnographic object" and modernist art, we turn to an important "prescriptive" document. In

May 1931, Paul Rivet, the director of the Musée d'Ethnographie du Trocadéro, and Georges-Henri Rivière, the assistant director, published detailed guidelines and instructions on collecting ethnographic artifacts, to be used by members of the Mission Dakar-Djibouti. The guide was to be disseminated along the journey from Dakar to Djibouti and distributed to potential collectors of ethnographic objects—untrained *amateurs d'objets africains* (lovers of African objects), which included administrators, governors, merchants, traders, missionaries, and so on. Rivet and Rivière privileged the role of collecting in their "ethnography." This type of collective endeavor facilitated the work of museographers and ethnographers and allowed them to work in the best possible conditions. Ethnography could not be separated from museography in the early thirties. One of the main objectives of the Mission Dakar-Djibouti was to bring back many different collections for the Musée du Trocadéro,[3] and its success was largely measured in terms of the scientific *butin* (booty) it brought back.[4]

The publication of this "prescriptive tool" sheds light on the logic and conceptualization of the mission.[5] It also determines the parameters to be used for the identification of the "ethnographic object," and prescribes the rules for collecting. Rivet and Rivière believed that the object or artifact that would eventually be displayed in a museum was not "a dead object," decontextualized and without any reference, a mode of presentation common in older collections: "It is not enough to collect everything (to be complete en largeur), one must analyze every object (to be complete en profondeur). It is in this that the collector will show how he is not a simple gatherer [un simple ramasseur] but the most precious of collaborators to the ethnographer" (Mauss 9). Implicit is the belief that the helpful collector must eschew the role of simple ramasseur, to become a scientific collector, eager and ready to collect a large number of objects ("to be complete en largeur") and willing to fill out a detailed analytic *fiche descriptive* (descriptive file card) that gives the "history" of the object (how, where, when the artifact was found, in what condition, in short, information that constitutes the collection data) ("to be complete en profondeur").

The brochure adds: "Because of the need that has always driven men to imprint the traces of their activity on matter, nearly all phenomena of

collective life are capable of expression in given objects. A collection of objects systematically acquired is thus a rich gathering of admissible evidence [pièces à conviction]. Their collection creates archives more revealing and sure than written archives, since these are authentic, autonomous objects that cannot have been fabricated for the needs of the case [les besoins de la cause] and that thus characterize types of civilizations better than anything else" (Mauss 6–7). They claim that an "authentic, autonomous" object, supplemented by systematically documented descriptions, drawings, photos, and so on, can be used to narrate the story of a people and constitute a reliable "cultural archive." "Written archives" are distrusted because they can be "fabricated for the needs of the case." Because they subscribe to a "materialist conception of culture," the history and ethnography of the object are of primary importance to them. The authors do not seem to question the concepts of authenticity and autonomy. What, for instance, are the criteria used to determine the authenticity of a "tribal"[7] object? This question is still relevant today, as the debate for authenticating African objects in museums has reached no consensus and continues to elicit informative discussion in Africanist circles.[8]

What emerges from this brochure, however, is the attempt to define a Western scientific notion of the "object" and to divorce it from aesthetic and moral preoccupations—considered unscientific, prejudicial, and biased and thus inconsequential for the collecting process. For the ethnographer, the importance of an object does not reside solely in its purity of style, rarity, originality and beauty, but represents une pièce à conviction of a culture that is nevertheless perceived as static or, in comparison to Western societies, in its infancy on the scale of progress. "To locate 'tribal' peoples in a nonhistorical time and ourselves in a different historical time is clearly tendentious and no longer credible" (Clifford 202). This is what Johannes Fabian calls "denial of coevalness." The ethnographer, if he or she wants to understand an indigenous culture, must examine every facet of native cultural production, even the "humblest of objects," that is to say, even domestic objects that at first appear insignificant. He or she must learn how to collect variations of the same object in series. The information furnished must be able to help the ethnographer decode whatever ethnographic or historical information it would yield (the role

of the object, its use, its technique, etc.).[9] In short, ethnographers like Marcel Griaule are in the pursuit of "objectivity" and "completeness," a way of understanding and conceptualizing the other which would demarcate itself from an aesthetic or colonial point of view. And yet, a convergence between an aesthetic and ethnographic perspective cannot be denied. This is exemplified, for instance, by a remark made by Picasso to this effect: "Everything I need to know about Africa is in those objects" (reported in Rubin 74). Or by Marcel Griaule himself, who was also interested in African arts (see his *Arts de l'Afrique noire*) and said: "In my view, it is as dangerous as it is absurd to separate the object from the thinking [pensée] of those who created it, to look solely for emotions and seductions resting on material forms drawn up by unknown hands [Il me parait aussi dangereux qu'absurde de séparer l'objet de la pensée de ceux qui l'ont créé, de chercher uniquement des émotions et des séductions appuyées sur des formes matérielles dressés par des mains inconnues]" (Griaule, quoted in Perret 112). The contamination (or interpenetration) of ethnographic discourse into the aesthetic realm and vice versa is readily apparent at the Contre-Exposition.

The Counter-Exposition

The "memoirs" of Louis Aragon and André Thirion, two Surrealist authors who were actively engaged in the preparation of the Counter-Exposition, provide us with detailed information. Their contentious relationship also sheds light on the shared responsibilities of its organization, frequently underplayed, if not omitted, by the principal actors. In "Une Préface morcelée. L'An 31 et l'envers de ce temps," Aragon describes his role in the following terms:

On the other hand, I had succeeded in convincing the C.G.T.U. [Confédération Générale du Travail Unitaire] to organize an Anticolonial Exposition in a building situated on a plot of land belonging to this organization [the Union des Syndicats de la Seine], at the bottom of what was once the Rue Priestley, where the headquarters of the Central Committee of the Communist Party is at present located, on Fabian Square. This building was the "constructivist" pavilion of the

Soviets [built by the Vesnine brothers] at the 1925 Exposition des Arts Déco-
ratifs, given to the workers' group [la centrale ouvrière].

The main part, with the abundant explanatory inscriptions which accom-
panied it, was put together thanks to the participation of the major collectors of
the art of the colonized nations, among them many Surrealists (André Breton,
Paul Eluard, Tristan Tzara,[10] Georges Sadoul, and myself). We obtained objects
from the best dealers in Paris, specialized in this area [les grands marchands de
Paris, spécialisés dans ce domaine]. The Pavilion was always full. (180)

Besides considering himself to be the sole and primary agent for its
planning and organization, Aragon highlights the important role played
by the Surrealists at the Counter-Exposition. André Thirion's conspicu-
ous absence from Aragon's account is troubling, though not unexpected
from a rival. In his memoir, *Révolutionnaires sans révolution*, André Thirion
would set the record straight:

I divided my program into three sections. I put Aragon in charge of presenting
cultural problems, Sadoul in charge of proselytizing, and kept the "ideological"
part, Leninist theory on imperialism, for myself. "The Truth about the Colonies"
opened its doors on September 20. I had the ground floor, the least attractive
area in the building. Michelet and a few friends helped me put up posters and slo-
gans. The main room on the second floor, designed by Tanguy and furnished by
Eluard and Aragon with fetishistic and primitive objects and a few of the foolish
devotional ornaments from Rue Saint-Sulpice, looked very becoming. (289)

Today, critics generally regard Aragon as the principal organizer of the
Counter-Exposition. But the moving force behind it was neither Aragon
nor Thirion but a self-effacing German named Kurella, the German
Cominternian éminence grise in Paris, who was also the world head of
the Anti-Imperialist League. According to Thirion, it was Kurella who
first suggested the idea of a counter-fair to him. Kurella was said to have
been "struck by the almost total lack of reaction on the part of the French
Communist party to the demonstrations and eloquence accompanying
the Colonial Fair" (289). He saw the Surrealists' opposition to the colo-
nial fair as the only "intelligent hostility," perhaps referring to the tracts
they wrote against the Exposition Coloniale and the numerous articles
denouncing French colonialism published in *Surréalisme au service de la*

révolution. Kurella was able to provide the location, the Constructivist Soviet Pavilion built for the 1925 Exposition des Arts Décoratifs, and some money. He gave Thirion complete freedom in the substance of the exhibition and choice of collaborators.

André Thirion's testimony is mentioned here because it reveals the behind-the-scenes negotiations, the logic and preparation involved in staging the anti-imperialist fair known as La Vérité sur les Colonies. Kurella's account of the French Communist Party's inactivity is neither entirely accurate nor completely fair since writers for *L'Humanité* denounced la foire impériale in a number of scathing articles during the fair's entire run. Before its inauguration, they also had investigated particularly heinous labor practices which forcibly conscripted impoverished African and Indochinese peasants to work on plantations, roadworks, railroads, mines, and building sites.[11]

L'Humanité, "the central organ of the French Communist Party," even ran several ads demanding contributions from its readers:

La Vérité sur les Colonies . . . is an exposition prepared by the Anti-Imperialist League and will open, in August, at the Maison des Syndicats, 8, avenue Mathurin-Moreau.

Photos and graphics—Drawings—Colonial Art—Luminous Projection [Projection lumineuse] and Conference—Moorish Café—Indigenous Orchestras and Spoken Chorus [Orchestres indigènes et Choeurs parlés]

You can and you must help:

1) By giving the support of your organization, for 20 francs (you will receive the illustrated poster and the catalog-program)

2) By sending photos and interesting documents on the Colonies (they will be meticulously returned).

Send money orders and all information requests to André Girard, 11, boulevard de la Villette, Paris (10e).[12]

This ad, placed in *L'Humanité* of August 10, 1931, is disturbing and problematic for several reasons. Although the anticolonial fair was conceived as a political and cultural platform from which the "truth" about the colonies could be told, at the very heart of its conception lie the very same strategies that made the Exposition Coloniale Internationale de Paris into an "attraction park." The ad for the Counter-Exposition sug-

gests that the visitor will be able to sample native food (Moorish Café) and attend cinematic documentaries ("projection lumineuse") and lectures. The fairgoer would even be treated to different types of indigenous music ("Orchestres indigènes et Choeurs parlés"). The anticolonial fair wants to tell a different story but, in the end, it seems unable to imagine other ways of representing colonized cultures and peoples. Ultimately, it wants to educate the masses by entertaining them and providing them with readily digestible material. Thus, it follows the didactic strategies used by organizers of the Exposition Coloniale, even though La Vérité sur les Colonies presents the obverse side of colonization.

Cultural objects that could have been found at the Exposition Coloniale here are placed in a different system of signification, to give a darker view of life in the colonies in order to report and denounce French colonial practices like forced labor, economic, and political oppression, and so on.[13] Thus, we are not surprised by the revelation that the Surrealists who loaned some of the objects for Aragon's "ethnographic exhibit" were described, in a confidential report, as "friends or members of the Anti-Imperialist League" who had first been approached by organizers of the Exposition Coloniale and who "had beforehand refused to lend their objects to the organizers of the Exposition Coloniale" (quoted in Hodeir 126).

This short gloss into the question of the circulation of native artifacts introduces the equally problematic question of the commodification of native objects and their transformation into works of art to be possessed and collected. Aragon first suggested this when he confessed in his poetic memoirs that the provenance of several important pieces came from "les grands marchands de Paris, spécialisés dans ce domaine [from the best dealers in Paris, specialized in this area]" (180). The reliance on capitalist merchants whose entire business is predicated on the uneven exchange of goods—the ultimate colonial *troc* or barter—reinscribes the anticolonial fair in a market economy and, thus, undermines not only the grassroots involvement of the people but, more importantly, the impact of the whole exhibit itself.

Many critics have examined the ideological foundations of collecting and display and their crucial role in processes of Western identity formation (see Stewart, Haraway, Clifford). Clifford, for instance, believes that

"Gathered artifacts—whether they find their way into curio cabinets, private living rooms, museums of ethnography, folklore, or fine art—function within a developing capitalist 'system of objects.' By virtue of this system a world of value is created and a meaningful deployment and circulation of artifacts maintained" (220). This aspect of the commodification of the "primitive" object operates rather effectively here.

By the early 1920s, the Surrealists were among the first serious collectors of "primitive art," which now included art from African as well as from Polynesian, American Indian, and Eskimo peoples. According to Evan Maurer, an art historian specializing in Dada and Surrealism, "Two outstanding early collections were those of Breton and Paul Eluard" (546).[14] Having exhaustively researched the archives of the Parisian auction house, the Hôtel Drouot, he came across "the auction catalog of their combined collections," which he claimed to have been offered for sale in July 1931, "in response to extremely hard financial times." He concludes: "Out of a total of 312 items there were 30 from Africa, 134 from Oceania, 124 from the Americas, 14 from Malaysia and 7 'Divers.' The Breton-Eluard sale was one of the most important Primitivist auctions held in Paris between the two wars, and its scope is an indication of much-increased availability of material, and the variety and range of the Surrealists' interests" (546). Thus, only a few months before the inauguration of the Counter-Exposition, Breton and Eluard had to part with their collection, which may explain why the organizers of La Vérité sur les Colonies had to advertise in *L'Humanité* to find such objects. This also explains the preponderant role played by Aragon.

In his memoirs André Thirion describes the preparation on the exposition grounds, which may clarify Aragon's role:

The exhibit drew a lot of visitors, although it did not benefit from any strong publicity. The members of the Party's Political Bureau stayed away, except for one syndicalist who came by for other reasons. I had installed loudspeakers to broadcast political commentaries from time to time and to urge passersby climbing to Buttes-Chaumont to stop in at "The Truth about the Colonies." Aragon and Elsa brought records of any Polynesian or Asian music they could find at special shops. Elsa had added a few hit songs, including a nice rumba (or some other Caribbean rhythm that had just become the rage). I worked hard on the

exhibit, organizing the guard. To make sure that all the people were present, I spent long hours on Avenue Mathurin-Moreau. I was often the first to arrive and the last to leave. . . . (289)

The contrived manner in which Thirion frames the story of Aragon and Elsa frivolously buying exotic music (Polynesian and Asian) for the exhibit and contrasts it with his recollection of the hard work involved in organizing and publicizing it is undoubtedly self-serving. But even though this anecdote may not warrant undue critical attention, it nevertheless frames the Surrealists' participation in the exhibit in a different light. Thirion adds:

Aragon, Eluard, and Elsa had been showing a young couple, who had nothing proletarian about them, through the exhibit. They were leaving. Elsa put the rumba on the phonograph herself. . . . I couldn't help noticing the touch of condescension that my two friends had introduced into our relationships. Aragon and Eluard, too, incidentally—had just shown it again while visiting the exhibit of which he was the star. But didn't he owe this stardom to me? I was scarcely more than a porter. The rumba was beating its obsessive rhythm and tantalizing melody. (289–90)

If we are to believe Thirion, his account paints a troubling image of Aragon and Eluard, and of the Surrealists in general. Thirion confesses that the Counter-Exposition was also a means for him to "restore [his] prestige as a militant" (289). And yet, it is Aragon who earned all of the accolades. The Counter-Exposition therefore became the site of Surrealist rivalry, with competing visions and personal aesthetic allegiances which must have reduced its effectiveness. For whom, then, was this exhibit staged? From Thirion's account we can deduce that the intended audience was not solely the "people" but included the art dealers and affluent friends of the Surrealists, intellectuals and artists who could appreciate the aesthetic quality of these "tribal" objects. Beneath the hard-line Communist militant lies the ominous figure of the Surrealist "amateur d'art."

Let us now turn to the content of Aragon's "ethnographic" exhibit. It is made up of "three large sculpture divisions: art nègre, Oceanic and redskin. Among the objets nègres, two pieces are particularly remarkable: a

ceremonial chair from Cameroun whose back is made up of two sculpted figures a 1.75 meter high. And a very beautiful 'Maternity': a woman nursing her baby stretched out on her knees. In addition, numerous statues of men, women, statuettes-fetishes, numerous festive and funeral masks. Everything carved from one solid wood piece" (Hodeir and Pierre 130–31; also in "L'Exposition anti-impérialiste").[15] Among the ritual objects displayed are the ceremonial dancing hatchet from New-Hebrides, a Papuan tam-tam, a chief's baton from Sumatra, fetishes, and masks. It is worth noting that no cultural artifacts from Indochina were present in Aragon's "ethnographic exhibit" even though "primitive" objects from Southeast Asia could also have been included. Of note are the ceremonial chair from Africa and the figure representing an African woman nursing her child; the writer aestheticizes the first African object and naturalizes the second, a strategy we have seen deployed in Alfred Janniot's bas-relief of the façade of the Musée Permanent des Colonies, where he also exploits the figure of African maternity. The function of the ceremonial chair, its symbolic significance or its use, is never discussed. The rich cultural content is abstracted in order to isolate and highlight the aesthetic quality of the object. In other words, the "primitive object" is resituated in the framework of native artistic production to demonstrate that Africans (and Polynesians and so on) are sophisticated peoples not unlike the European men who have come to subjugate them. It is this logic that can be seen at work in various reports devoted to the Counter-Exposition: "Proletarians must go to see for themselves the productions of art that are regarded as 'savage art' [art de sauvages] in the world of capitalism. There are splendid sculptures from the Philippines, Congo, the Sudan, Cameroun, Gabon, Oceania, Indonesia, etc., lent to the League by collectors to whom we must pay homage here" (Cachin n.p.). Marcel Cachin, the writer of this column, also refers to these cultural objects as "splendid sculptures." Like the Surrealists, he confers upon them the status of "art."

To better understand the aesthetic importance of the "primitive object" for the Surrealists,[16] one must also examine the tracts they wrote during the same period. The tract entitled "Premier bilan de l'Exposition Coloniale" (First assessment of the Colonial Exposition) seems particularly interesting for our discussion.

"Premier bilan de l'Exposition Coloniale" was written after the acci-

dental fire on the night of June 27, 1931, that destroyed the Dutch pavilion built for the Exposition Coloniale Internationale de Paris. The Surrealists felt that irreplaceable native objects, dubbed "l'art des peuples opprimés [the art of the oppressed peoples]," had been destroyed:

The pavilion that journalists are not ashamed of calling the "Dutch" pavilion contained indisputably the most precious evidence [témoignages] of the intellectual life of Malaysia and Melanesia. It included, as it was commonly known, some of the rarest and most ancient artistic specimens known in these regions, objects snatched by acts of violence [objets arrachés par la violence] from those who conceived them and whom a European government, as paradoxical as it may appear, was not afraid to use as advertising object [comme objet de réclame] for its own methods of colonization. It was probably not enough of an act of piracy, and hence, this violence culminated in a scandalous diversion of meaning, even though these objects could still have been used by the anthropologist, the sociologist, the artist [Ce n'était sans doute pas assez de piraterie et de ce scandaleux *détournement de sens* par lequel elle semblait se parachever, car ces objets pouvaient encore servir à l'anthropologiste, au sociologue, à l'artiste]. (Pierre 194–95, my emphasis)

This passage raises several important and inextricably linked issues. Since the Surrealists consider native artifacts to be evidence of indigenous "intellectual life," the destruction of objects perceived as the rarest and most ancient implies the loss of an essential part of the natives' cultural patrimony. Work done on the historical and theoretical foundations of anthropological research has shown otherwise; these cultures value and conceive of these objects very differently from what I am tempted to call a Western museographic impulse, a drive or cultural impetus to conserve, collect, and display. And in fact, many "primitive" cultures produce cultural artifacts with nondurable material because they simply are not meant to last for an extended period of time. The art historian Evan Maurer explains this phenomenon thus: "Primitive cultures that produced magico-religious images regarded them in a conceptual context entirely different from that which Europe had traditionally applied to its own artistic production. In a primitive culture, the masks, statues, and other objects that are part of their cultural heritage are seen not as primarily commemorative or aesthetic objects, but rather as em-

bodiments of spirit entities which, during times of ritual, carry an enormous and immediate charge of spiritual power" (549). Maurer places emphasis on the "traditional" context which takes into account the spiritual dimension, whereas the Surrealists attach more importance to the material culture of "primitive" people as aesthetic object. As it is clearly stated in the Surrealist tract, they denounce the expropriation of artifacts ("objets arrachés par la violence"), which they regard as having been "stolen" and devalued because of their use "comme objet de réclame," vulgar commercial signs promoting the colonies. This *détournement de sens*, this swerving away from an original, "traditional" signification, scandalizes them. And yet, they too can be accused of having dispossessed "primitive" societies by appropriating the "primitive" artifact for their own aesthetic, that is to say, to affirm the affinity between the Surrealist and the primitive. For example, André Breton's notion of the "marvelous" was indeed influenced by magic in primitive societies.

The Surrealists also lament the fact that "anthropologist, sociologist, and artist" will no longer be able to "use" these artifacts. How Western scholars and artists could still have made good use of these "artifacts" is never articulated. The tract merely reaffirms that "Modern discoveries in art as well as in sociology would be incomprehensible if one did not take into account the deciding factor brought about by the recent revelation of the art of the so-called primitive peoples [Les découvertes modernes dans l'art comme dans la sociologie seraient incompréhensibles si l'on ne tenait pas compte du facteur déterminant qu'a été la révélation récente de l'art des peuples dits primitifs]" (Pierre 198). "Primitive" culture becomes an inexhaustible reservoir of images and concepts against which modernist aesthetic, cultural, and psychoanalytic theories and practices can be drawn and explained. On a less mundane level is the implicit belief that only the artist and "intellectual" can fully understand and appreciate these objects. Nowhere do the Surrealists mention that these objects can be apprehended by the average citizen.

What is perhaps even more problematic is the fact that the Surrealists do not appear to question their own assumptions as to what constitutes an authentic "primitive" object. For this, as we have seen earlier, one would have to wait until the publication of the thirty-three-page "Summary Instructions for Collectors of Ethnographic Objects" in May 1931,

instructions compiled from the series of classes taught at the Institut d'Ethnologie and designed to help the Mission Dakar-Djibouti devise strict guidelines in their "collecte du monde [collection of the world]," which ultimately was designed to get rid of "two biases, that of purity and that of rarity" (Mauss 8). The purity of style simply does not exist since "everything is mixture [mélange], the product of disparate influences, the results of multiple factors" (8). The Surrealists may have complained that Western powers used "primitive objects" "for their own methods of colonization." But as I have tried to show, the Surrealists, too, appropriated native objects for their own aesthetic practice.

The failure of the anti-exposition does not lie, then, as the French historian Charles-Robert Ageron claims, in its failure to attract a large number of visitors. Much more importantly, it lies in its conventional understanding of "primitive" material culture and the multiple functions of its objects, what I will call the Surrealists' "bourgeois" logic. Thus, the impact and significance of the anticolonialist exposition, La Vérité sur les Colonies, must be seen within a more broadly based anticolonialist campaign, which mobilized militants from the French Communist Party, the C.G.T.U., and the Ligue Internationale contre l'Oppression Coloniale et l'Impérialisme as well as the Surrealists. A confidential and anonymous "Notes sur l'exposition anti-coloniale [notes on the anticolonial exposition]" dated September 29, 1931, from the Section Coloniale, outlined "le travail d'agitation [the agitation campaign]" in the following terms:

a) series of articles in *L'Humanité* on the anti–Colonial Exposition, reports, descriptions, news articles on the colonies in connection with the Exposition, accounts of group visits, calendars, program, notices, etc. . . .

b) series of articles in factory newspapers, the regional press, the union press, auxiliary;

c) organize the distribution of a large number of tracts, stickers, sticking up posters in support of the anti–Colonial Exposition; against the Vincennes Exposition, against French imperialism, for the liberation of the oppressed peoples, the independence of the colonies, especially for the support of the Indochinese revolution;

d) organize collective visit of the masses [des descentes collectives de masse] to the anti–Colonial Exposition (n.p.)

Indeed, the general mobilization of trade union and Communist militants was impressive for the seriousness of their exhaustive approach to the anticolonialist campaign. In this more overtly politicized context, it is very difficult to appreciate the subversive quality attributed to "ethnographic surrealism" and the "Surrealist fetish-object," as Jack Spector (or even James Clifford) have argued. In an otherwise interesting discussion of the "Avant-Garde Object," Jack J. Spector describes the ideological function of the Surrealist primitive object thus:

> Moreover, the Surrealist fetish-object contributed to the political and economic subversion of modernism by attacking its characteristics of invention and quality. One level of the fetishistic character of the Surrealist object consisted of its brazen display of useless and disagreeable things that had no place in galleries beside "good art." The illustration of objects in photographs also served a polemical function; for example, in *Le Surréalisme au service de la révolution*, no. 4, December 1931, the last illustration, a photograph of several objects displayed in the room organized by Aragon, Eluard, and Tanguy for the exhibition "La Vérité sur les Colonies," shows a cogently ironic group of figurines—a bare-breasted native woman, a young beggar with a tablet on his chest that reads "Merci," and a Madonna and Child—before which lies a plaque inscribed "Fétiches Européens." (135–36)

Today the polemical function of avant-garde Surrealist practice appears to have lost its radical edge, particularly in an age of virtual reality and technological innovations. Although I do not agree with Ageron's reductive conclusion as to the nature of the failure of the Counter-Exposition,[17] I acknowledge the importance of discerning the multiple strands that made La Vérité sur les Colonies both a "popular" and an "elitist" manifestation. The "Surrealist" ethnographic exhibit is but one organized component of a significant cultural and political "assemblage" that must be read against the grain.

Paradoxically, the most succinct and sensible analysis of La Vérité sur les Colonies was not written by a historian, but by Marcel Cachin in *L'Humanité*, in an article mentioned earlier, which attempts to acknowledge the limitations of such an exposition. While Ageron ironizes, pokes fun, and is simply dismissive, Cachin recognized, more than sixty years ago, the difficulty of mounting such an exhibit:

Admittedly, it is difficult to assemble in any room the entire history and all the crimes of colonialism, and this because of the difficulties in photographic documentation and also because many aspects of the colonial problem do not lend themselves very well to this type of presentation. . . .

The Pavilion of the Soviets is completely occupied and this gives, already, a good idea of the effort put in. The ground floor is dedicated essentially to various aspects of the colonial problem. On the first floor one can find an exhibit of colonial art, and a large space is devoted to the Soviet Republics. . . .

On the ground floor, large and well-illuminated pannels present photographic sets, drawings, statistics: the Vincennes Exposition, the history of colonial conquests, the great imperialist rivalries, the exploitation of the indigenous peoples and hard labor. Morocco and Indochina, Black Africa occupy a large space. Finally the national movement of the great Asiatic peoples, China, Indias, the economic crisis and the use of colonial troops during the war. On the first floor, a large and soberly decorated room contains truly remarkable art nègre, oceanic, and red-skin objects. . . . (n.p.)

Indochina reemerges only as the site of political and economic oppression. A tract for the Contre-Exposition Coloniale, edited by the Confédération Générale du Travail Unitaire, would make it astonishingly clear. Entitled "The Real Guide to the Colonial Exposition," it begins with a financial statement of accounts and a short summary of the extensive holdings of the Bank of Indochina and its different networks in Indochina:

The Bank of Indochina, with a nominal capital of 72 millions, is worth, at the Stock Exchange, more than a billion!

The shareholder who paid 125 francs-gold or 1000 francs-paper currency can now sell his stock for more than 8000 francs.

This bank controls 16 companies in Indochina and one of its directors manages, alone, 10 other companies.

The famous Homberg group also controls 16 companies, three or four other groups share the rest of the wealth of this country. . . . (Liauzu 234)[18]

The conspicuous absence of Indochinese objects from the Surrealists' ethnographic exhibit reveals their indifference toward objects that resist the process of modernist aestheticization, and its cultural (and physical)

appropriation. To be fair, it must be noted that the scarcity of Southeast Asian art and artifacts and the legislative bills passed to protect them from an aggressive world art market made it rather difficult to begin and sustain a serious collection. André Malraux personally experienced this unfavorable conjuncture in the mid-twenties. As I will be discussing in the next chapter, "stealing" and collecting Khmer artifacts could indeed be a hazardous affair. This said, and financial questions aside, nothing prevented the Surrealists from acquiring and displaying these objects except their complete disregard for the cultural production of a people that could not be easily appropriated and transfigured aesthetically.

By considering the use and circulation of ethnographic objects, and the ideological role of "primitive" objects, we force significant contradictions in avant-garde theory and practice to the surface.[19] The Surrealists wanted to liberate the primitive object from its strictly ethnographic frame and relocate it in a realm that would displace the limits of bourgeois reality. Deploying strategies that defined what they believed to be an oppositional discourse, the Surrealists reinscribed the fetishistic object within a modernist aesthetic that failed to unsettle familiar configurations. Ultimately, like the Surrealist map of the world, La Vérité sur les Colonies did not introduce a new model of visualization nor a new mode of apprehending colonial "reality." It relied on oppositional paradigms that still reconfigured the colonized nations of the world as an inexhaustible reservoir of strange objects and exotic images to be exploited.

INDOCHINA AS

"RÊVES-DIURNES" AND MALE FANTASIES

Re-Mapping André Malraux's

La Voie royale

In the introduction to his *Anti-Memoirs* (1967), André Malraux reflects on the origins and nature of novelistic creation:

In the creation of fiction, in war, in museums real or imaginary, in culture, in history perhaps, I have found again and again a fundamental riddle, subject to the whims of memory which—whether or not by chance—does not recreate a life in its original sequence. Lit by an invisible sun, nebulae appear which seem to presage an unknown constellation. Some of them belong to the realm of imagination, others to the memory of a past which appears in sudden flashes or must be patiently probed: for the most significant moments in my life do not live in me, they haunt me and flee from me alternately. No matter. Face to face with the unknown, some of our dreams are no less significant than our memories. And so I return here to certain scenes which I once transposed into fiction. Often linked to memory by inextricable bonds, they sometimes turn out more disturbingly, to be linked to the future too. (6–7)

In a grandiloquent and elliptical style characteristic of much of his later writings, Malraux attempts to illuminate what Freud described as "the connections that exist between the life of the writer and his works" ("Creative Writers and Day-Dreaming" 151), or more simply, "the problem of the writer's choice of his literary material" (152). Freud popularized the notion that, like the child at play, the imaginative writer creates a world of fantasy (144). While investigating the potential sources on which the creative writer draws his material, Freud compared the "poetical creation with the day-dream" and "the imaginative writer with the day-dreamer" (151), which led him to postulate that "a strong experience in the present awakens in the creative writer a memory of an earlier experience (usually belonging to his childhood) from which there now pro-

ceeds a wish which finds its fulfillment in the creative work" (151). Intent upon recovering the elements of experience that might underlie these daydreams, Freud's analytical model (further developed in his later writings) is founded on the opposition between the real and the imaginary.

In the passage quoted above, Malraux wonders what function unconscious ideas organized into fantasies or imaginary scenarios, and daydreams subject to all forms of distortion, have in the creative process, a question also raised by psychoanalysts. Tracing the transformations of the concept of fantasy in Freud's work, Jean Laplanche and J.-B. Pontalis called attention to the need to distinguish between two significations of the term "fantasy," which for them, refer to "two totally distinct realities" ("Fantasy and the Origins of Sexuality" 11): "On the one hand there is the unconscious *Phantasie*, 'the primary content of unconscious mental processes' (Isaacs), and on the other, the conscious or subliminal imaginings, of which the daydream is the typical example" (11). Identifying the relationship between the two forms of fantasy, the "unconscious fantasy and the daydream" (12), Laplanche and Pontalis explore the difference between "the contingent imagery of daydreams and the structural function and permanence of . . . unconscious phantasies" (1).

Although Malraux appears to have conflated these two significations of fantasy, he grasped the effects of fantasies on the "fundamental enigma" of writing, yet could not elucidate them. For him, fantasies and daydreams shape both the work of fiction and memories of historical events, allowing him to reconcile his story with history as well as to transfigure the real world and that of fiction. Lived experience is no longer privileged as the sole reservoir for imaginative speculation; it must compete with daydreaming as another important source and catalyst to political engagement and individual action. Significantly, Malraux regarded T. E. Lawrence as the exemplary figure who achieved this peculiar awareness of the world, the individual who best possessed "this particular relationship with the world" (*Anti-Memoirs* 8). Malraux writes, "the virus of daydreaming gives rise to action too as T. E. Lawrence asserts" (8). He may have been alluding to a particular passage in Lawrence's *Seven Pillars of Wisdom* which highlights the relation of dreams and action: "All men dream: but not equally. Those who dream by night in the dusty recesses of their minds wake in the day to find that it was vanity: but the dreamers

of the day are dangerous men, for they may act their dream with open eyes, to make it possible. This I did. I meant to make a new nation, to restore a lost influence, to give twenty millions of Semites the foundations on which to build an inspired dream-palace of their national thoughts" (23). These "dreamers of the day" are "rêveurs-diurnes," dangerous daydreamers who are not satisfied with the world of dreams and fantasies. They seek to act out their fantasies, to transform their relation to the world in concrete fashion. Their actions are contingent upon a masculinist view of life as a force to conquer and an imaginary understanding of the world, what Alain Buisine calls "un imaginaire masculin de la conquête [a masculine imaginary of conquest]" (227).[1] I contend that Malraux and many of the protagonists of his Asian novels are prototypical types of "rêveurs-diurnes" whose dreams and fantasies are symptomatic of the imperial dreams entertained by many colonial adventurers such as T. E. Lawrence, a figure who made such a strong impression on Malraux that he planned to write a study of Lawrence entitled *Le Démon de l'absolu* (Frohock vii), which he never completed. Lawrence's lasting influence on Malraux can also be seen in his selection of *Les puissances du désert* as the title of a projected series. Only *La Voie royale* (1930), its inaugural volume, was carried to completion.

To adopt an approach that links Malraux the man of letters to both fictional and real (historical) protagonists does not signal a return to a regressive notion of the novel as a mimetic reflection of the author's life and experiences. Malraux himself rejected this type of biographical approach to his work. However, Asia has played an especially significant role as both the fictional setting of his early novels and the actual terrain where his formative experiences took shape. Indeed, the "place" Asia assumed in Malraux's phantasmatic work prompted Paul Valéry, upon their initial meeting, to ask, first of all, why in the world Malraux had gone to Asia.[2] Likewise, the reader must give pause to wonder about this question, which Malraux himself never answered in a satisfactory fashion.

One of Malraux's first attempts at elucidating this question can be glimpsed in a letter addressed to Edmund Wilson, dated October 2, 1933. There he describes his "activities in Asia" in an uncharacteristic (and deceiving) lapidary fashion: "I went to Asia when I was twenty-three, in charge of an archeological mission [comme chargé de mission].

Then I abandoned archeology, organized the Jeune-Annam mouvement, and later became a commissioner of the Kuomingtang in Indochina, and finally at Canton" (Wilson 573).[3] Malraux did go to Asia as he claims, as an archeological chargé de mission, but, as will be shown below, this archeological mission became a source of contention. The literary critic Isabelle de Courtivron points out that his claims of active involvement in the Chinese Revolution can also be contested.

More than thirty years later, in a 1967 interview conducted by the literary critic Jean d'Astier, Malraux would be much more forthright about his motivations. He remarks, "Asia fascinated me" and adds, "She represented the Other. For me, Asia played the role that the woman plays for most men. She was absolutely different, and I wanted to know her" (d'Astier 59). Malraux explains and justifies his fascination for Asia in erotic terms, establishing unproblematically a direct correspondence between Asia and woman, which only reinforces his views of masculinity, adventure, and eroticism.[4] Perken expresses the same views in *La Voie royale* when he claims that "All my old dreams are in my loins [J'ai tous mes vieux rêves dans les reins]" (62):

"And then—only try to grasp all that this country really is. Why, I'm only just beginning to understand their erotic rites, the process of assimilation by which a man comes to identify himself, even in his sensations, with the woman he possesses—til he imagines *he is she*, yet without ceasing to be himself! There's nothing in the world to match it—sensual pleasure strained to the point when it becomes intolerable, the breaking-point of pain! No, for these women aren't merely bodies; they're . . . instruments. And I want . . ." Claude guessed his unseen gesture, the gesture of a hand crushing out life. "As I once wanted to conquer men." (77)

Whereas in the novel Malraux identifies the "country" with "erotic rites" and the control and power he can exert on these women/instruments, in the d'Astier interview Malraux feminizes and eroticizes Asia by couching this desire for the Other in terms of a thirst for knowledge of difference. Yet, when d'Astier calls attention to the absence of women in his novels, except for May in *Man's Fate*, Malraux gives the following embarrassed explanation: "It's true: women do not enter into my work. I have led, however, a very conventional life [une vie très classique]. I was married

three times. . . . Women also do not intervene in Chateaubriand. The subject of my novels did not lend itself to a feminine presence. I am thinking of *L'Espoir*. But it's a bad explanation. I can say that for me woman is a being so different—I am speaking of difference, not inferiority—that I cannot imagine a feminine character" (d'Astier 60). Although Malraux acknowledges "difference," he admits that it is impossible for him to imagine a woman character. Also problematic is his claim that the subject of his novels did not lend itself to a "feminine presence," a statement neither corroborated by historical evidence nor supported by a close reading of such novels as *L'Espoir* and *La Voie royale*. *L'Espoir*, Malraux's novelistic account of the Republicans' courageous armed struggle against Franco's Falangist army, seems to gloss over the actions of the women who fought alongside men in the defense of the Republic during the Spanish Civil War. Moreover, if *La Voie royale* is based partly on his archeological expedition to Indochina, his journey into the jungles of Cambodia was undertaken with his wife Clara. In these two novels, the conspicuous absence of women characters (except as erotic objects) looms large and raises serious questions which feminist critics are only beginning to address.[5] At issue then is Malraux's conception of masculinity and eroticism. In order to create his phantasmatic masculine world, Malraux removes all traces of significant female presence or denies women characters all agency in his fictional world. In her *Memoirs*, Clara Malraux complains that her "hands have held pages in which I was nothing but an absence, a void" (259).

Malraux displays a nostalgia for a time when traveling to Asia and, more particularly, Indochina in the early twenties meant retracing and emulating the journey of legendary male figures such as Baron von Ungern-Sternberg in Mongolia, James Brook in Borneo, and Mareyna in Annam (Vandegans' "Un Personnage" 579–92), noting that the legends surrounding these men-who-would-be-king were still very much "alive in the Indochina of the 1920s" (*Anti-Memoirs* 258). These men, whose personal ambitions were to rule unsubdued independent native peoples and rescue them from the contaminating influence of Western civilization and progress, carved out large expanses of territories for themselves or in the name of king or country.

I have alluded earlier to the fact that at the very moment Malraux

rejects biography, it returns with a vengeance. And yet, he still asserts that "The *Antimemoirs* rejects biography by resolve. They are not based on a journal or [travel] notes. Starting with certain decisive elements of my experience, I encounter a character, and fragments of history" (d'Astier 58). It is usually agreed that biographies follow distinct genre requirements: the chronology of events must be closely observed; the protagonists must be situated in the appropriate time frame and placed in the proper historical context, and so on. My use of biography transcends its commonplace meaning, most often understood as the "authentic" written history of an individual's life, and includes the author's fantasies reelaborated in his fiction, incorporating recollection, selective memories, and dreams, imaginary and lived experiences that were projected onto different types of writings, from letters and interviews, to writings on art and literature. This phantasmatic corpus is refashioned—altered and augmented—to fit a particular model of living, to represent a particular *mode of life*, one that emulates and captures the fantastic stories of adventurers admired by Malraux.

This blurring of fact and fiction creates a terrain for remapping Malraux's Indochinese adventures with a richness that has not been lost on Malraux critics who generally agree that "The *Anti-Mémoires* [are] Malraux's oeuvre par excellence, where the fusion-confusion of the real and the imaginary, experience and dream, lived raw material and the art which transforms it are fully achieved" (Lacouture 400). However, I consider *La Voie royale* (1930) to be exemplary of that complex process where dreams of conquest are translated and refigured in the text, and where the author's fantasies of Indochina have allowed the subject of writing to be reinscribed in history. *La Voie royale* provides the basis for discussing three basic sets of interrelated issues: Malraux's phantasmatic elaboration of a feminized Indochina in his novel, the origin and mise-en-scène of this masculinist desire, and the aesthetic and ideological ramifications of this type of "archeological" representation of Indochina. The operative mode will be intertextual rather than chronological, drawing on different sources to deconstruct Malraux's representation of Indochina.

Before turning to *La Voie royale*, let me critically foreground Malraux's peculiar predicament. Malraux, accompanied by his wife Clara and his friend Louis Chevasson, were caught stealing Khmer artifacts and sen-

tenced to prison for theft. The circumstances surrounding these events and Malraux's arrest for the theft in Cambodia have been thoroughly investigated by Malraux critics; the following factual discussion of "the Malraux-Chevasson Affair" is indebted to the meticulously researched biographical work of Jean Lacouture, Walter Langlois, and André Vandegans. On July 21, 1924, Malraux was sentenced to three years in prison (Chevasson to eighteen months) and a five-year prohibition of residence in Indochina. On October 28, 1924, the court of appeals reduced Malraux's sentence to one year in prison (and Chevasson's to eight months), and granted both prisoners the right to petition for a suspended sentence (Langlois, *André Malraux* 50–51).

"Pillage of the Angkor Ruin" headlined the weekly Cambodian newspaper *L'Echo du Cambodge* on January 5, 1924. In its "Chronicle," the *Bulletin de l'Ecole française d'Extrême-Orient* described the affair in the following terms: "At the end of the year [1923], Mr. Parmentier [head of the archeological department] had to take note of the damage done to the temple of Banteay Srei by a band of looters of ruins, who had attempted this raid under the pretense of an official mission and who, with their booty, have been handed over to the law" (307).

As in the scholarly journal, the colonial police also portrayed Malraux as a vulgar "adventurer-swindler [aventurier-escroc]." Reports in newspaper accounts, however, painted a very different image of Malraux: "He is a tall, thin, pale young man, with a hairless face illuminated by a pair of extremely lively eyes. . . . He speaks with great facility and defends himself with an acerbity that reveals unquestionable qualities of energy and tenacity. . . . He has been able to defend his positions with surprising energy, refuting the investigation on every point" (Lacouture 70). The writer for the *Echo du Cambodge* also reported that the accused had given "a veritable archeology lecture" (Lacouture 70). Although Malraux's solid performance dispelled the prosecution's attempt to depict him as a vulgar "common law thief," it also weakened the defense in its effort to obtain mitigating circumstances by alleging the youthfulness and inexperience of the accused. Among the witnesses the state called were Cremazy, the Siem-Reap delegate, who simply confirmed the charges, and, more importantly for us here, Henri Parmentier.

Parmentier was not only the head of the archeological service but also the archeology expert invited by the examining magistrate, M. Bartet, to

study the damages done to the temple. Unfortunately, only fragments of his entire disposition, as they were relayed by newspaper accounts, have survived. Parmentier had gone on site to complete the inventory and continue the preliminary survey of the Banteay Srei temple first conducted by Georges Demasur, "resident-architect of the Ecole française" as early as 1916 (Malraux, *Oeuvres* 1155). He had reported the results of his preliminary survey in his 1919 essay published by the *Bulletin*. According to Langlois, "as head of the Archeological Service, he was open to criticism for his failure to include Banteay Srei in the list of monuments to be classified, and he was not eager to paint an alluring picture of the site. As he described it, the temple was little more than a pile of stone rubble lost in the jungle. Still, as a responsible scholar, he [admitted] that the quality of its sculptured decoration was indeed remarkable. . . . He concluded his testimony with words of praise for the flair shown by the two young amateurs" (Langlois 35).

Malraux used Parmentier's deposition for his own defense. Vandegans notes that to mitigate the gravity of the deed, he argued that the ruins of Banteay Srei could hardly be called a temple due to their decaying state, a condition plaguing most of the ancient monuments of Indochina before their restoration. Malraux declared: "Can you call a heap of stones whose height does not exceed 1m20 (according to Mr. Parmentier's deposition) a temple, ruins on which my friend Chevasson only had to pick up truncated bas-reliefs?" (35). The same argument was presented very effectively by Malraux's defense attorney during the Saïgon trial: "It must be reckoned that the small towers of the temple of Banteaï-Srei and its library, of small dimensions, are so regrettably ruined that even the most minute parts which remained precariously balanced, and the stones they reveal, form a unity as much as building material methodically lined up waiting to be used in the construction of an edifice; like these building materials, these stones rest on the ground and are superposed without mortar nor cement, the largest massive structures having collapsed" (Vandegan 225). By describing Banteay Srei not as a monument in ruin but as a pile of rubble that even an archeologist would find impossible to restore, Malraux and the defense team willfully underestimated its true artistic and cultural value. Today, Banteay Srei stands as one of the jewels in the golden age of Khmer classical architecture.

One of the most fascinating facets of the entire trial lies in the discus-

sion of the ownership and status of the Banteay Srei ruins and the relevance of the Colonial Office's decrees. In his opening remarks for the prosecution, Moreau, the state prosecutor, discussed the status of the temple of Banteay Srei, which, according to him, cannot be considered *"res nullius* [bien sans maître]," since the entire region of Siem-Reap where Angkor Wat and other temples such as Banteay Srei were located was an integral part of the kingdom of Cambodia. Although Siam had conquered it at the close of the last century, it ceded that province back to France in the 1907 treaty, and France subsequently "returned" it to the king of Cambodia who, it was argued, became the legitimate owner of the land and everything therein. For Moreau, it was a simple question of theft, and he demanded "for Chevasson, confirmation of the sentence passed on 21 July and, for Malraux, in addition to the sentence passed by the Phnom Penh tribunal, an extension of the ban on entering certain areas and the withdrawal of his civil rights" (Lacouture 76–77).

Béziat, the defense attorney, argued against this point of law. For him, the question was not only to know if these incriminating deeds fell under the jurisdiction of the law, but which law, the French or the Cambodian. The temple was located in a territory that was reunited with Cambodia only through a decree signed by the governor-general of Indochina, a decision confirmed eight years later by a decree from the French president, that is to say, beyond the legal time statute permitted by the law. Thus, according to the defense, the region was not Cambodian from a legal point of view. French law could therefore only regard these "stones" as "abandoned property" (Lacouture 76–77).

Béziat also attacked the argument of the so-called untouchable character of the monument. Although Parmentier had examined the ruins, or débris, of the temple as early as 1916, he did nothing to place it on the list of monuments to be preserved. Béziat suggested that the deplorable condition of this monument in ruin prevented Parmentier from including it on the list.

The defense attorneys even went on the offensive, pointing out that the deeds, which were considered theft by the prosecution, had certainly been perpetrated by others before their clients' actions: "How many people have taken from the ruins of Angkor artistic riches of far greater value? . . . If my client is condemned for the slip that he has made, then, in the past, we should also have condemned those admirals, prominent

residents and other mandarins of equal importance for the depredations that they committed against these same monuments" (Vandegans, *La Jeunesse* 22, quoted in Lacouture 77). This embarrassing revelation of wrongdoing did not spare colonial officials who were also guilty of the same type of "depredations," revealing at the same time the pervasiveness of the traffic in Khmer artifacts smuggled out of Cambodia.

On October 28, 1924, the appellate court agreed with the defense and condemned Malraux to a suspended sentence of a one-year jail term, without the travel restrictions to Indochina the state had requested (Chevasson was sentenced to an eight-month suspended term). The court, however, ordered the restitution of the stolen bas-reliefs, a decision Malraux vowed to appeal in the highest French court (Lacouture 76).

Six years after these events (significantly, after the publication of *La Voie royale*), André Malraux still believed himself to be the rightful owner of these bas-reliefs.[6] In an interview in *Candide*, he declared the following:

Please take note that I was on an unpaid mission [en mission gratuite], a mission which only gave me the right to requisition the natives. Hence, not being an appointed civil servant, I was not bound by certain obligations. I was there at my own expense. And the sculptures I brought back, others could have taken them before me, had they been willing to brave the jungle. Besides, if the sculptures had not been seized, I would have bequeathed half to the Musée Guimet. Now, the issue is to get them back. *They are sequestered in the Phnom-Penh Museum, which belongs to the King of Cambodia.* It's a new trial, since the Cour de Cassation has already declared void previous judgments against me; but the final ruling remains to be handed down. (Rousseaux 3; my emphasis)

Malraux entered into a polemic with the French literary journalist André Rousseaux not simply because of the unflattering comparison to Lord Elgin bequeathing the frieze stolen from the Parthenon to the British Museum, but also because of the contradictions he sees in a man who compromised his revolutionary and literary potential. Malraux responded violently in an open letter published in the *Nouvelle revue française*, where he reiterates that "I did what I set out to do, I would do it all over again" ("Lettre" 915). Malraux is unrepentant and simply considers himself to be the rightful owner of these bas-reliefs, even though decrees forbidding their removal had been passed.

When the Malrauxs set out for Indochina on their 1923 expedition,

the illegal traffic of Khmer artifacts was already a serious concern for the French authorities. The year before their ill-fated expedition, the *Revue archéologique* sounded the alarm in its "archeological news" in a short rubric entitled "Poorly Kept Treasures." They warned: "An admirable head of a buddha, a masterpiece of Khmer art, has entered the Fogg Museum. The United States already possesses, we are told, eight heads of the same origin. Considering the great number of Khmer sculptures and the diffi- culty in reaching the ruins of Angkor, one can allow, without airing a grievance, the emigration of these few specimens; however, these flights should not become too numerous. *Caveant consules*" (187). In response to the sacking of Cambodia, the government initiated a program to develop policies to preserve such national treasures. "In the early 1920's," writes Langlois, "several particularly flagrant expropriations of Cambodian an- tiquities forced the Governor General of Indochina to take corrective action. He appointed a special commission to study the situation and to make recommendations for a new and more coherent body of regulations to preserve the historical and archaeological remains of the peninsula. The new commission and the Governor General's plans for reforms were announced in a decree, dated August 21, 1923, but not actually published in the EFEO Bulletin until the end of the year [*Bulletin de l'école française d'Extrême-Orient* 23 (1923): 580–81]" (Langlois, *Indochina* 8). Langlois speculates that Malraux may have learned of these new decrees and may have tried to act before they were strictly enforced.

Although a number of critics have debunked many of the myths surrounding Malraux, Malraux critics, with rare exceptions, are still pro- tective of his reputation in this affair. They have been reluctant to ques- tion the colonialist ideology implicit in his writings, glossing over many problematic aspects of his work, and all too often taking Malraux's words at face value in spite of their knowledge of his legendary mythomaniac propensity. They dismiss, for instance, Malraux's "Indochina adventures" as merely the result of the inexperience of youth: "If for Malraux the Indochina expedition was to a large extent the trial of his aesthetic credo," writes Walter Langlois, "it was, on another level, the trial of his manhood" (*Indochina* 9). Because the Indochina adventure marks an im- portant turning point in Malraux's career, *La Voie royale* can be read as the phantasmatic rewriting of these events.

Malraux himself suggests this type of rereading. He incorporates and transfigures certain "decisive elements of [his life] experience." He also acknowledges that Mayrena's legend was "in part the source of my novel *La Voie royale*" (*Anti-Memoirs* 258), an observation deleted from the later version of *Le Miroir des limbes* (1976). On the other hand, there is also a problematic tendency among Malraux critics to see Claude Vannec, the archeologist in *La Voie royale* who sets out to rediscover the royal road of the ancient Khmer empire, and Perken, the Danish-German adventurer whom Claude meets on his journey to Asia, as Malraux's alter-egos. Emmanuel Mounier, for instance, writes that "more than any other novelist, Malraux split himself, and spoke himself among his characters; we can record in their voices the echo of his interior voices, track him in a world which he has never entirely separated himself from" (14). Pierre Drieu La Rochelle complicates this view in a critical analysis of Malraux's novel. He writes, "The events in his novels . . . reveal a direct transfer of reality into the narrative" (884), but is quick to add that "This hero is not Malraux, it's the mythical figuration of his self. More sublime and more concrete than himself" (884).

Malraux's protagonists—these "mythical figurations of the self"—appeal to Drieu La Rochelle because for him "Malraux, a new man, establishes the new man." Malraux's heroes give life to what Drieu La Rochelle believes to be a new breed of man who embodies a new ideal of the man of action, one who combines action with reflection, and engages in activities of both the man of action and the man of letters: "He has traversed philosophical and historical speculation, Asia, the Revolution. He will always roam about these diverse provinces to renew his booty; but he will not establish himself in any of them. A politician? An archeologist? A businessman? It is too much or not enough for a man. A writer? Still too much or not enough?" (881). Drieu La Rochelle, in an uncanny fashion, describes Malraux's many interests and avocations, referring to Malraux's eclectic activities as rare book chineur, art dealer, and speculator on the Paris Stock Exchange, to his stint as amateur archeologist in Indochina and revolutionary in China. He even anticipates Malraux's entry into the realm of politics.[7]

One of the most interesting insights in Drieu La Rochelle's analysis is not to be found in the explicit reference to Malraux's many experiences

nor even to those he foresaw, but resides in the metaphorical images used to glorify the masculinist view of action. Drieu La Rochelle conveys rather well the incessant movement of the adventurer roaming across vastly different geographical and critical terrains, amassing and accumulating new knowledge, a cultural booty on which his own legend could be established. The adventurer, a central figure in Malraux's novelistic creation, allows Malraux, the author, to rewrite the very myths of his public persona, a fiction in the heroic mode, that even the most rigorous and erudite Malraux scholars endorse, perpetuating Malraux's reputation and self-fashioned identity first sanctioned by a contemporary figure such as Drieu La Rochelle.

During his trial for the theft of Khmer artifacts, Malraux claimed that he was preparing a detailed study of Khmer and Siamese art based on his discoveries in the jungle (*L'Impartial*, September 16, 1924; quoted in Langlois, *Indochina* 9). Clara Malraux, however, gives a much less honorable reason for the expedition in her memoirs. Because they had lost all their money on a bad investment, André is alleged to have said: "Well then, we'll go to some little Cambodian temple, we'll take away a few statues, and we'll sell them in America; and that will give us enough to live quietly for two or three years" (Clara Malraux 245). Although critics like Sabourin tend to dismiss Clara as being an unreliable witness (Malraux had divorced her and remarried), her account seems to be corroborated by a staunch defender of the young Malraux. René-Louis Doyon, the director of *La Connaissance*, where Malraux published his first literary essay on the origins of cubist poetry, presents the following arguments in his "Defense for André Malraux":

Also very good at finance, there is no doubt that André Malraux dreamt of conquests, treasures, great bargains; good taste, culture and art were at the source of his actions; he was perhaps driven by a business sense; the latter strongly justifies the former. And I am afraid that his judges, like his contemnors, unaware of his powerful intellect and this frenzied passion for the esthetic, have judged this young man like a common law thief. It is extremely unfortunate.

Malraux has studied Angkor, its style, its treasures; from there to dream of an enterprise which, unfortunately, included depredations and a plunder [des déprédations et une rapine], there is only one step to take, but a bold one for a man who is averse to *action which is not in the spirit of dream*. (3; emphasis in original)

Doyon wants to sway public opinion in favor of his young confrère, "artist of taste, writer after all, and *young* man, very *young*" (3; emphasis in original). He asks: "Can we forgive a boldness [une hardiesse] which can be described as chic and an audacity which is the mark of courage and masculinity [une marque de courage et de gaillardise]?" (3). Doyon's defense plea is particularly effective because it transforms the plundering and pillage ("des déprédations et une rapine") into a courageous and heroic adventure. Terms such as *conquêtes, hardiesse, audacieux, courage, gaillardise* underline the heroic and masculinist view of the entire enterprise. Part of the blame can also be placed on the idealism of youth and, more importantly for us here, on the influence of dreams and fantasies. These dreams of conquest, treasures, and successful financial deals are the catalysts to action.

Doyon also suggests that these dreams have an erudite origin. They emanate from Malraux's scholarly knowledge of Angkor, its art and style. Malraux undoubtedly had an artistic flair for recognizing previously neglected works of art, but his artistic competence was not placed in the service of archeological knowledge, as he has led many complacent critics to believe. He applied his knowledge for private, financial considerations and selfish concerns. Clara's autobiographical memoirs make this clear: "We had often been to the Musée Guimet together. Sometimes he had been to the Bibliothèque Orientale without me. He and I had studied the inventory of the Khmer monuments" (245). Clara also describes the intuitive logic that led André to postulate that if the road the pilgrims followed on their journey to Compostelles from the Flanders region were "studded with cathedrals," in addition to these large sanctuaries, smaller chapels that have disappeared from sight must exist. It therefore followed that "from Siam to Cambodia, all along the Royal Road that runs from the Dangrek Mountains to Angkor, immense temples were built, the ones that have been located and described in the Inventory but there were certainly others, little ones that are unknown at present" (245).

The French had gained a certain familiarity with Khmer art. In fact, as I said earlier, a model of Angkor Wat was such a popular success that it became a recurrent fixture at successive Paris World's Fairs and Colonial Expositions. The Malrauxs were not unlike other French people who knew very little of Khmer traditions and customs, a sentiment Clara

Malraux expresses rather well: "What did we know of Cambodia aside from what we learned from Loti, the Inventaire and accounts written by Chinese monks whose experiences were far too distant to be of any use to us" (245–46), she writes in her memoirs. In addition to the *Inventaire* and travel accounts written by Chinese monks in the thirteenth century,[8] Clara also alludes to the work of Pierre Loti, the writer of exotic travel narratives, and more particularly to his account of his pilgrimage to Angkor Wat, appropriately called *Pèlerin d'Angkor.* Loti, twenty years earlier, upon meeting three Frenchmen sent to Siam to conduct archeological surveys, writes: "They encouraged me to stay because, they assert, in addition to the large temples everyone visits, the forest is also filled with *unknown ruins;* one finds almost everywhere, on the banks of rivers and swamps, a great number of monuments made of terra cotta, reminiscent of a more singular art dating back to the fourth century, or to the first days of the vast Khmer empire" (168; my emphasis). The possibility of a discovery, of finding "unknown ruins" of singular beauty, of wandering off well-traveled paths and encountering these ancient vestiges almost effortlessly, appealed to a would-be adventurer like Malraux. In Malraux's case, this desire for things Indochinese, for possessing them, would find an unlikely outlet. Malraux undertook the publication of Loti's text in a rare 1927 illustrated edition in the Aux Aldes imprint, entitled *Les Pagodes d'or,* illustrated with Burmese miniatures from the seventeenth century.[9]

Besides the *Inventaire* and *Pèlerin d'Angkor,* Clara mentions other texts: "in order to dream about Cambodia, those who were not specialists but who liked narrative had virtually nothing but Francis Garnier's *Voyage d'Exploration en Indochine* or the *Voyage dans les Royaumes de Siam, Cambodge et Laos,* the one dating from 1873, and the other from 1863; or if they had the taste for archeology, Maréchal's *Angkor*" (250). One important question remains to be examined, the question of the expedition as "notre petite opération renflouante" [our little dealings in speculation]" (113; my translation).

Clara reveals in some detail how André moved heaven and earth to obtain the order for his archeological mission. He first contacted members of the museum and went on to seduce them with his knowledge of oriental arts. What so impressed these men who would later write letters of recommendation on his behalf was that Malraux also appeared to be

thoroughly acquainted with new discoveries and current trends in archeological research. If we are to believe Clara, André devoted time in libraries and consulted many of the specialized journals such as the *Bulletin de l'école française d'Extrême-Orient*, the *Revue archéologique*, the *Bulletin de la commission archéologique indochinoise*, the *Annales du Musée Guimet*, and the *Revue indochinoise*. This bookish knowledge was to serve him well. The Colonial Office had no reason to refuse an authorization, for such a mission would not be financed by the French government. France could only gain from its success. If new discoveries were to be made, they were obligated to inform the proper authorities of their findings. Let us now turn to Malraux's novel.

Passage to Indochina

Malraux's Indochina novel begins *in medias res*, with Claude Vannec's inquisitive gaze, his obsessive attempt at discerning and making sense of a white adventurer, Perken, who, the reader learns, "has played a part in the affairs of independent Asian states" (4). This singular scene of self-recognition—which develops into an embrace of specularity—takes place on a steamer off the coast of Somalia in the middle of the crossing to Indochina, where Claude, a young and ambitious French archeologist, is to lead an unpaid archeological mission. Rumor and gossip circulate about "Perken [who] had become a legendary figure on board, a constant theme of conversation for the passengers . . ." (14): "He had heard rumors of the missions on which Perken had been sent by the Siamese Government amongst the unpacified tribes of the interior, how he had organized the Shan tracts and the Lao frontier; he knew of the curious relations, sometimes cordial and sometimes acrimonious, between Perken and the Bangkok authorities, the mania he had displayed in earlier days for absolute power, a savage mastery of men, of which he would not brook the least control—and then his decline, his 'eroticism'" (6). The role played by rumor and its performative power in transforming a singular figure into a legend are evident here. Perken appears to be more than a mercenary for the Siamese government; he embodies the figure of the adventurer. Fed by rumors, the "Perken myth" flourishes. Claude, like the reader, is left

wondering who Perken really is. Very little of his "biography" is known, except that "he had lived amongst the natives, ruled over them in districts where many of his predecessors had been killed, and it was rumored that the methods by which he had achieved this were more strenuous than law-abiding" (14).

As the sea journey progresses, more detailed information unfolds regarding Perken's peculiar adventures, his success at establishing an independent kingdom amidst still unsubdued indigenous peoples, the Moi or "savage" mountain peoples of Indochina.[10] Significantly, the shadowy figure which first appeared to Claude as a "silhouette confuse [muddled silhouette]" (7; mistranslated as "strange personality" on page 3) or "silhouette virile [virile silhouette]" (11; translated as "shadow" on page 9) exudes an aura of masculinity further reinforced by rumors and gossip: "that fabulous aura of scandal, phantasy and fiction which always hovers about the white man who has played a part in the affairs of independent Asiatic states" (3–4); "potins et . . . manilles, la trame de bavardages, de romans et de rêveries qui accompagne les blancs qui ont été mêlés à la vie des Etats indépendants d'Asie" (7). The French original conveys more effectively the space created by rumors, fiction and daydreams which constitutes the framework of the adventurer's life ("la trame de l'existence"). Only fourteen days separate these men from reaching the Asian shores and enacting their fantasies.

Perken intrigues Claude, who regards him as one of the last incarnations of the true adventurer, the conqueror and man of action who rejects the "community of man." The narrator describes in unambiguous terms how Claude had been "attracted" to Perken: "Claude had first been seduced by the tone of his voice [Claude avait été séduit d'abord par le ton de sa voix]" (11). This "fraternité virile," which Eve Sedgwick would undoubtedly describe as a homosocial relation, has not elicited the critical attention it deserves, particularly in regard to what the idea of an imagined community of virile men implies, omits, and represses. The figure of the adventurer in Malraux's novels—and, we must add, in many contemporary accounts—constructs a problematic image of masculinity, one that defines itself in relation to a lack, that is to say, one that excludes women and displaces them onto the exotic figure of native women in the role of prostitutes, congai, or concubines, as transient lovers of these

virile men. As we will see below, the adventurer in *La Voie royale* will find far more pleasure in possessing bas-reliefs depicting native women than with the women themselves.

Much has already been written on the figure of the adventurer. In his *Portrait de l'aventurier*, Roger Stéphane examines three exemplary figures, T. E. Lawrence, Malraux, and Von Salomon, whom he considers constitute the "archetype of the adventurer." He argues that adventurers are men whose "quest for experience" "engender[s] a new man: the witness to the absurd" (42). According to Stéphane, these men are the last among a rare breed who "have attempted to find authenticity through adventure, the last to have wanted to write history without a capital letter, to subordinate history to their fate" (42). He proclaims the end of the "era of individual adventures" (42) and the rise of the new age of the "militant." Beyond pronouncements that today have lost their critical edge and appear to reflect merely the pervasive influence of Sartrean existentialism, Stéphane mentions one element meritorious of renewed attention. He notes, albeit in passing, that the emergence of "a Lawrence has its place only in the historical conjuncture of 1914, and must therefore be understood with regard to British colonial imperialism" (26; my translation). The same could be said of Malraux and of French colonialism. In Malraux's case, the 1920s determined his aesthetics and political trajectory, a period Malraux critics have dubbed his "Indochinese adventure." His entanglement with colonial justice for stealing Khmer bas-reliefs became a cause célèbre in Paris and contributed to constituting and perpetuating his self-fashioned legend as a courageous adventurer, an antifascist militant, and a fervent anticolonialist supporter.

I privilege a rereading of *La Voie royale* as a symptom of French colonial ideology not simply because I regard the novel as Malraux's fictional rewriting of his 1923 archeological expedition in Indochina but also because of the ideas on art it embraces. They are, in my mind, complicit with the contemporary colonial ethos shared by a large number of petty colonial administrators, as could have been expected, but also by even progressive writers and art historians. One example to show the ubiquity and tenor of this sentiment will suffice.

The *Revue archéologique* recommends to its readers an essay on Khmer art written by Denman W. Ross and published in 1922 by the Fogg Art

Museum. Ross, a professor of art history at Harvard University, can hardly contain his enthusiasm for Cambodian sculpture: "There are no ruins in the world more wonderful and impressive than those of Cambodia, which have come to our knowledge within quite recent times" (6). He goes on to compare them to Greek and Egyptian sculptures:

The head of the Buddha at the Fogg Museum is not only the finest of all these examples but it is the finest that I have seen anywhere, either in Paris or in Cambodia. It represents not only the best of its kind in Khmer sculpture but is, in my judgement, one of the supreme achievements of the Art of Sculpture. As such it may be compared with the Chios head (from Greece, about 450 B.C.) and with the head of Shepseskaf, the son of Mycerinus (from Egypt, about 2800 B.C.); both in the Boston Museum. Comparing the head of the Fogg Museum with these recognised masterpieces it will be appreciated as their equal if not their rival. (13)

Malraux's conception of art, his highly celebrated comparative analysis of artworks, is indebted to this type of analysis. The same year, in his first art criticism essay, a preface he contributed to the catalogue of an exposition of Galanis's work, Malraux expresses in very similar terms the same argument: "We can feel only by comparison. . . . The Greek genius will be better understood through the contrast of a Greek statue with an Egyptian or Asian statue than by the examination of a hundred Greek Statues" (Malraux, "Preface" 90).

Although a comparative approach to art criticism strikes us as being original and innovative, Ross's essay also exemplifies the condescending attitude of Western critics toward Cambodia and its people:[11] "Once a populous and, in its way, a civilized country, Cambodia is now, most of it, a jungle for wild elephants, tigers, and serpents. There are only a few people left there and no civilization of any consequence; only ruins, the evidence of the civilization that has passed away. There are ruins here and there, all over the country" (6–7). The myth of an empty and desolated land, where only a few savages live in fear of wild animals in a hostile and debilitating milieu, is being constructed and disseminated. Many unfounded claims are being made here. One of the most disturbing aspects of this type of speculative logic treats ruins as the only cultural icons worthy of Western attention. They must be salvaged and

reclaimed from the uncivilized for the greater benefit of humanity. (A similar righteous argument is advanced today to support UNESCO's attempt to have the temples of Angkor declared part of the "patrimoine mondial [patrimony of the world]."") For Ross, contemporary Cambodia has "no civilization of any consequence." Such a bigoted assessment was the prevailing view in the twenties and thirties, particularly among the learned. Thus, we are not surprised to read in Malraux's novel that Claude Vannec's archeological knowledge of Indochinese art and of the country is inflected by such commonplace ideas:

The decorative motifs have greatly suffered from the constant humidity of the undergrowth and the violence of the tropical rainfall. . . . The vault has caved in completely. . . . It is certain that further discoveries are to be made in this region, which nowadays is practically uninhabited and overgrown with scrub jungle where herds of elephants and wild buffaloes roam. . . . The blocks of sandstone of which the arches were constructed litter the interior of the cloisters in an inextricable confusion; the highly regrettable state of dilapidation which prevails seems due to the use of wood as a building material. . . . Here and there large trees have sprouted in the débris and grown so tall as to overtop the coping of the walls; their gnarled and knotted roots have tightened round the stones and welded them together. . . . *The whole region is practically a desert.* (46–47; my emphasis)

The image presented here conjures an uninhabited region where wild animals roam the dense jungle. Wild elephants, as a sign of the country's devastation and abandonment to the elements, become a recurrent motif in Western literary tradition. Dislocated bits of dilapidated temples littering the jungle floor are the only traces left by a once prosperous civilization. More importantly, this description asserts that today "the whole country is practically a desert [le pays est presque désert]" (39). This account, gleaned from the "last great archæological survey of the country" (35), the 1908 *Inventaire* drawn up by E. Lunet de Lajonquière, figures prominently in Malraux's novel, as Claude often returns to it, consulting the text as if it were a Bible. It also establishes the modalities by which Claude and Perken conceive of space and interpret the archeological map of Siam and Cambodia.

Several critics have referred to *La Voie royale* as an archeological novel. It is legitimate to ask what criteria were used to compel critics to describe

this piece of fiction thus. Does the manifest theme of the novel, the quest for Khmer artifacts, justify this label? Would "geographic" be an equally accurate description, especially in light of the protagonists' phantasmatic and physical engagement with the topography and geography of Indochina? The description of the entire region as a desert ("the country is practically a desert") lends credence to this hypothesis. Because the jungle covers a large expanse of the country, we must question critically the use of the term "desert." This question goes to the heart of how both Claude and Perken dream and fantasize about space and how they ultimately map Indochina. For Claude, the personal desire for Indochina translates into the mapping of so-called unknown territories into a manageable space delimited and circumscribed by a network of identifiable archeological sites. For Perken, it means being willing to locate these bas-reliefs in exchange for arms, so that he can rebuild his empire and contain the encroachment of modernization on a territory he controls with the help of the indigenous people.

Before examining the ideological implications of their individual and intimate relation to Indochina, another question must be raised: What is the connection between fantasy and desire? We return briefly to the work of Laplanche and Pontalis for a few clues. They believe that the primary function of fantasy is to act as "the mise-en-scène of desire" (17; my translation). They warn: "Fantasy, however, is not the object of desire, but its setting. In fantasy the subject does not pursue the object or its sign: he appears caught up himself in the sequence of images. He forms no representation of the desired object, but is himself represented as participating in the scene . . ." (17). Malraux's novel can be reexamined in light of this definition of fantasy ("he appears caught up himself in the sequence of images"), which bears an uncanny resemblance to cinematic practice. In fact, when Malraux rewrites the "royal way" episode in his *Antimémoires*, it is in the form of a dialogue between the Baron de Clappique and the narrator, the former hoping to interest the author by pitching his screenplay of *David Mayrena, the King of the Sedangs* (255) to him.[12] (The filmic quality of Malraux's novel is the object of Mary Rowan's study.) Less attention must therefore be placed on the manifest objects of desire—Claude's search for Khmer artifacts and Perken's reconquest of unsubdued territories—and more emphasis placed on the entire mise-en-scène of these desires.

Staging and Mapping the Desire for Indochina

The map, central to the discourse of geography, is also one of the key elements in figuring and staging this desire for adventure, for territorial claims and possessions. Perken could therefore claim that his sole ambition is not to become king among savages like Mayrena[13] but to "build a kingdom" (73) and "to leave a scar on this map" (74; my translations). What does it mean to leave one's mark upon the map of Indochina at this particular historical juncture? To better circumscribe this question, one must turn to important innovative studies undertaken recently by postmodern geographers.

In their informative *History of Cartography*, Brian Harley and David Woodward examine the function of maps in society. Harley has most consistently argued for a reexamination of maps not as some disinterested reflection of an empirical reality but as part of a discourse of power, as a "cartographic language" that delimits "the territorial imperatives of a particular political system" ("Maps" 279). Maps, particularly during the colonial era, were used very effectively to stake and mark out a territory in contention, or to settle and circumscribe imperial claims. Maps were also instrumental in delimiting the sphere of influence, the boundaries of a nation, indispensable for the administration of cities and the control of the population, essential for maintaining state power and developing commerce. For Harley, the map is not an objective form of knowledge, but an object that needs to be deconstructed in order to explore its textuality, its rhetorical and metaphorical premises.

Building on Harley's work, Christian Jacob in *L'Empire des cartes* asserts that the cartographic object can be seen from two inextricably linked perspectives: "The map as a rational construct, a space of knowledge governed by geometry, symmetry, the exigencies of a field of knowledges, and geography; the map as an intelligible model, an apparatus [dispositif] to be read, interpreted, and interrogated as well as to be seen" (16). This definition describes the functional use of maps, one that Claude Vannec will pursue and to which we will turn below. But there is an equally important role played by the map, one for which a strictly functionalist view of cartography fails to account: "The map's power of seduction on the imaginary [le pouvoir de séduction imaginaire de la carte], its dreamlike and mythical stakes [ses enjeux oniriques et mythiques]; the dreams

aroused by the map when the gaze is allowed to wander and glide on its surface, as if this type of representation constituted a privileged space where desires, aspirations, affective memory, the cultural memory of the subject can be projected" (16). Inscribed in this dialectical relation, the map is endowed with overarching powers of seduction, of arousing desire. The dialectical vision of map as image and instrument is one that has not elicited exclusively the interest of geographers but has also engaged philosophers such as Michel de Certeau and François Wahl. For Wahl, "the map which exposes or rather constructs an expanse to be covered, cannot be thought without movement" (39). This enigmatic proposition is illuminated by de Certeau, who writes that "a movement always seems to condition the production of a space and to associate it with a history" (*Practice* 118), which is the same as saying that the actions of historical subjects specify space. Wahl also adds something quite significant, the fact that "even before describing or taking note [constater] of the Earth, it proclaims its appropriation" (42). The map for de Certeau is "a totalizing stage on which elements of diverse origin are brought together to form the tableau of a 'state' of geographical knowledge" (*Practice* 121). Maps have undoubtedly made the penetration of heretofore unknown regions possible, marking out at the same time the entire world. But maps also organize space in an abstract fashion: Harley observes that their silence concerning many aspects of native cultural affairs makes the appropriation of land and territory a much easier proposition.

The map, in Malraux's novel, plays a crucial role in mediating and solidifying the masculine bond between Perken and Vannec. It can even be said to mediate their understanding of Indochina, of the possibility of acting out what only appeared for other men as impossible dreams and chimerical fantasies. Claude, for instance, makes extensive use of an archeological map of Siam and Cambodia to convince Perken to enter into a virile partnership to facilitate the location of Khmer bas-reliefs and to locate "lost temples" in the Cambodian jungle. The following dialogue between Claude and Perken is symptomatic of the pervasive role played by maps:

"Those are the lakes. The red spots clustering round them are the lake temples; the other red spots you see dotted about the map are other temples."
"And the blue patches?"

"The dead cities of Cambodia. All have been explored already. I think there are more of them—but that's another story. This is my point; d'you notice that the red dots—the temples, that is—are thickest where that black line begins, and what's more, that they tend to run parallel with it?"

"What's your black line?"

"The Royal Way, the road that linked up Angkor and the lakes with the Menam river basin. It was quite as important in its day as the road between the Rhone and the Rhine was in the Middle Ages."

"Let's see. The temples follow the road as far as. . . ?"

"Up to the limit of the really explored area. (The exact name of the place doesn't matter.) My theory is that if you follow, by compass, the line of the old road, you're bound to come on temples. Supposing Europe became covered with a dense forest, wouldn't it be absurd to imagine you could travel from Marseilles to Cologne by way of the Rhone and the Rhine, without coming across ruined churches?" (34)

Claude's deductive reasoning is remarkably similar to the arguments advanced by Malraux himself (as reported by Clara Malraux). In the novel, Claude credits his Orientalist training at the College of Oriental Studies and his knowledge of Sanskrit in helping him draw this conclusion.[14] Still not convinced, Perken asks him, "Do you suppose you're the first to have deduced this from the map [Vous croyez être le premier à interpréter ainsi cette carte]?" (35). Hence the question of "reading" and "interpreting" a map once again emerges. An earlier passage in the novel seems to illuminate Perken's question:

Another fortnight to endure—long days of hope deferred, the craving of an addict balked of his drug. Fourteen more days at sea. He took out the archæological map of Siam and Cambodia once again; he knew it better than his own features [il la connaissait mieux que son visage]. His eyes were fascinated by the thick blue rings with which he had encircled the Dead Cities, the dotted line that marked the ancient Royal Way, fraught with presentiments of a lingering end in the green depths of the Siamese forest. "It's an even chance I leave my bones there!" A maze of jungle tracks, strewn with the skeletons of small animals left to their fate beside the dying campfires, the tragic issue of the last expedition into the Jarai country—Odend'hal, the white chief, hammered to death with spear-hafts by the Sadete tribesmen, while close at hand the palm-fronds rustled in the darkness as the draught-elephants of the party forced their way through

towards him. How many nights would he lie awake, pestered by mosquitoes, aching with exhaustion; or else asleep, dependent on his guide's precarious wakefulness? Seldom was there the chance of a fair fight. (9)

The archeological map is more than a carte-instrument. It reveals the modalities by which Claude dreams of and fantasizes about the conquest of space. It seduces him into action. Also illuminating is the narrator's comparison of Claude's knowledge of the map and that of his own "face," as if the map had become "a corporal territory." The features and inscriptions he added to make the map more intelligible to himself can be identified as his own, betraying Claude's narcissism ("il la connaissait mieux que son visage"). The marks or writings Claude has left on the map—the red dots signifying where temples are located, the blue patches of the dead cities, and the dotted (or broken) black lines of the Royal Way—personalize his map and make it more meaningful for others too.

The difference between his map and those that lined the walls of the Colonial Office, described as "ingenuous maps where far-flung cities, Djibouti, Vinh-Tian and Timbuctoo, stood out like capitals in vast pink patches" (37), are not self-evident. These conventional maps lay out and record the French colonial empire and establish the presence of the French in every corner of the globe, from Africa to Asia. Claude's map, on the other hand, bears his "personalized" signature. If maps are a kind of language, as Harley has argued, the maps adorning the empty halls of the Colonial Office tell the official story, one that makes use of a transparent language, a "naive and innocent honesty and integrity." Pink patches cover areas colonized by the French; they are part of the overseas territories constituting the French colonial empire. But these "ingenuous maps [cartes ingénues]" (32) do not tell the entire story. They fail to narrate the stories of the adventurer who has risked his life to build an empire for himself or for his country.

The End of History: The Triumph of Art over Time

Malraux critics assert that his writings on art provide "the key to Malraux's novelistic oeuvre" (Harris, *Andre Malraux* 143). René Girard, on the

other hand, believes that the thinking on art of many of Malraux's fictional characters constitutes "the first rough draft [ébauche] of many analyses found in the *Voix du silence*" ("Les Réflexions" 544). As early as his 1922 essay on the Greek painter and book illustrator Galanis, Malraux stated that "Art is not situated in time by its subject" (Preface 90). This type of meditation on art, refined and elaborated in his later writings on art and particularly in the three volumes of *La Psychologie de l'art* (1947–1949) and its revision into a single volume entitled *Les Voix du silence* (1951), can be read *en filigrane* in such a novel as *La Voie royale*.

A passage omitted from the final version of *La Voie royale* echoes what Malraux had written on Galanis: "I began with the following proposition: such and such German or American museums display art objects in their exhibiting rooms *by abandoning history and geography*. They do not bring together the works of an era, of a same location, but rather place vis-à-vis a Roman Christ and a Wei Buddha, a Nara figure and a Paalava god, a Greek archaic and an archaic from here. The curator, in this case, is sensitive above all to what the statues have in common—besides, you see the kinship of a Kore from Attica and a head of an angel from Rheims—let us say: their architecture" (Langlois-Ford manuscript, in Malraux, *Oeuvres* 1204–5; my emphasis). Claude goes on to argue that "the intrinsic nature of the work of art is to belong, in a collective and fairly subtle fashion, to the one who looks at it" (1205). According to him, "All the plastic arts, until the 19th Century, are born in this possession, *from* this possession. Yet, all art, by the very fact of its permanence, tends to free itself from it" (1205). In later writings, Malraux would make this disengagement from history and geography the cornerstone and most radical aspect of his "psychology of art." In *Les Voix du silence*, as Jean Leymarie has noted, Malraux attempts to "disentangle the ambiguous relations between art and history" (249). Malraux writes: "History may clarify our understanding of the supreme work of art, but can never account for it completely; for the Time of art is not the same as the Time of history. . . . history aims merely at transposing destiny on the plane of consciousness, art transmutes it into freedom" (623), which brings him to postulate the notion of art as a triumph over death, "l'art est un anti-destin" (637), "All art is a revolt against man's fate" (639).

Many art historians have taken issue with Malraux's philosophy of art.

Stefan Morawski examines not only the reception of Malraux's art studies, but the genealogy of Malraux's ideas and conceptual apparatus, his indebtedness to various esthetic influences. He shows that Malraux hesitates between two conceptual models: a formalist and an existential approach to the work of art. At times, "Malraux takes a stand for artistic values par excellence, but in this case, style is cut off from its metaphysical sources, from its expression bound to transcendence. Conversely, in other instances, the purely pictoral values give way to the value of expression which fosters the contact of the artist with the Absolute" (152). This contradiction also manifests itself in the ways Malraux analyzes the processes of the evolution of art: "On the one hand, one goes from forms to forms; on the other, however, form requires a stimulus from the outside, that is to say that it must stem from an individual expression. At times, the history of art consists of anonymous series, . . . at other times, on the contrary, it constitutes the history of marked individuals who respond, each time, in a different manner to the same existential necessity in the struggle against Fate" (152–53). Malraux reiterates this principle in a speech in May 1952, "au Congrès de l'oeuvre du XXe siècle, where he proclaims: 'there is something more important than history, and that is the constancy of genius' [il y a une quelque chose de plus important que l'histoire, et c'est la constance du génie]" (quoted in Leymarie 249). This romantic and existential notion of genius is indeed inconsistent with his view of the autonomy of the work of art, of its intemporality, and his pronouncements on the metamorphosis and mythic transmutation:

It looks as if, in matters of art, time does not exit. What interests me personally, I must say, is the slow decomposition, the gradual change that comes over such works—their secret life which battens on men's deaths. Every work of art, in fact, tends to develop into a myth. . . .

For me museums are places where the works of an earlier epoch which have developed into myths lie sleeping—surviving on the historical plane alone—waiting for the day to come when artists will wake them to an active existence. If they have a definite appeal for me it is because I know the artist has this power of summoning them back to a new lease on life. In the last analysis, of course, no civilization is ever understood by another one. But its creations remain—only we are blind to them until our myths come into line with theirs. (*La Voie royale* 50)[15]

These words are not proclaimed by Malraux but are uttered by Claude Vannec, the archeologist in *La Voie royale*. The ideas expressed here are strikingly similar to Malraux's conception of art and the thesis he defends in *Le Musée imaginaire*, where he selected seven hundred photographic reproductions of works of art out of thousands. In the later work, he explains that they do not constitute a "palmarès [a prize list]" (Morawski 90), but "the expression of a human adventure, the immense range [l'immense éventail] of invented forms" (*Musée imaginaire* 1:16). For Morawski, "the imaginary museum, that is to say, the museum of forms which evolves in an autonomous fashion, is, in fact,—he tells us—an 'ode to history' [un 'chant de l'histoire'] (*Psychologie de l'art*, I, 115), not its mirror" (Morawski 91). One of the *Imaginary Museum*'s most important contributions is its questioning of the "relation of contemporary art to artistic legacy [relation de l'art contemporain avec l'héritage artistique]" (Morawski 89). "Art," Malraux writes in *Antimémoires*, "consists of the works that have been resuscitated; one of the objects of culture is the whole body of resurrections. Allow me one major reservation, however: the thing resuscitated is not the thing as it was alive. It resembles it. It is its brother" (346). Malraux's imaginary museum, his conception of le musée imaginaire, is a museum of forms, which evolves in an autonomous fashion: "the museum is the reelaboration of a world as different from the truth as the work of art is to the real [le musée est la recomposition d'un monde aussi différent du vrai que l'oeuvre d'art l'est du réel]" (*Psychologie de l'art* 3:144; quoted in Morawski 91). What remains to be examined is the convergence of his aesthetic credo with this notion of history and the past as "adventure": "the past has become adventure . . . this adventure that we have called history [le passé est devenu aventure . . . cette aventure que nous avons appelé histoire]" (*Musée imaginaire* 1:60; quoted in Morawski 91 n.68).

At the time of the publication of *Le Musée imaginaire*, Malraux was severely taken to task for advocating an esthetic doctrine that arbitrarily removes history from artistic production. F. H. Taylor, then director of the Metropolitan Museum of Art, attacked Malraux for his extracting the work of art from its social context in order to establish its perennation, legitimizing at the same time the view of art as a religion (*New York Times* 22). Taylor also questioned the arbitrary and fragmentary nature of his selection as well as the perceived randomness by which Malraux dis-

played and confronted works of art from different periods and from different geographic locations.

Maurice Blanchot, on the other hand, espoused many of Malraux's views on art, which he expressed in his analysis of "the situation of the Museum in relation to the history of art within the framework of time" ("Time" 158–59). Blanchot still admonishes Malraux for wanting to preserve humanist values, that is to say, for not eliminating all discussion extrinsic to the work of art proper and thus not going far enough in his theorizing of the work's formal qualities. He nevertheless recognizes Malraux's visionary insights, which for him have far-reaching implications: "our historic vision is an illusion, a myth, but the myth is an enormous 'spiritual wealth.' This illusion represents the eternal truth, that part of the truth that exists in the vestige that remains present, accessible, that moves us, fascinates us, is utterly our own, as though this vestige acquired life through us and through this life out-lived us" ("Time" 159). To buttress his claim, he quotes Malraux to make his point more forceful:

The dialogue that links our culture with the ephemeral absolutes transmitted by resuscitated arts reestablishes with the past it outlines the relationship between Greek gods and the cosmos, between Christ and the meaning of the world, between the numberless souls of the dead and the living. Every Sumerian art work suggests the Sumerian empire, partly intangible, partly possessed. Great museums satisfy our taste for the exotic in history [*un exotisme de l'histoire*] and *grant* us a vast domain of human powers. But the long trail left by the sensibility of the earth is not the trail of history. It is not dead societies that art revives. More often it is the ideal or compensatory image they had of themselves. . . . ("Time" 159; my emphasis; quoted in Blanchot, *L'Amitié* 39)[16]

One important lesson to be learned from Blanchot's reading of Malraux's work is the debunking of the idea that native artifacts restore the glorious past of once great nations. Malraux made it clear that these cultural objects constitute the "ideal or compensatory" signs of a culture, not to be identified or confused with the culture per se, which can never be recovered. Disengaging the native artifact from its history, however, makes its transfiguration into a work of art to be possessed and collected in the West all the more simple and, in my view, problematic.

The Vogue for and Traffic in Khmer Artifacts

It is difficult to pinpoint with any degree of accuracy the origins of the West's fascination for Indochinese artifacts. The years following World War I saw a surge in interest in collecting Asian art and, particularly, Khmer antiquities. The demand for these artifacts and their scarce supply turned these objects into a very lucrative investment for would-be collectors. Those in possession of such objects could therefore demand high prices that would often be met.

Malraux conveyed this trend in the art market very clearly in his novel. To convince Perken that the discovery of bas-reliefs would bring money and translate into financial gain, Vannec affirms his thorough familiarity with potential outlets for the liquidation of such objects: "I know the biggest dealers in London and Paris. And it's easy to fix up a public sale. . . . There's nothing to prevent your selling directly—without a public auction, I mean. Pieces of that sort are extremely rare; the boom in far eastern curios started at the end of the war, and there've been no new finds" (39). Not until 1925, when Daladier passed a resolution to protect the expropriation of Indochinese artifacts, would the traffic in Khmer artifacts abate.

To blur further the artificial divide between biography and fiction, it must be pointed out that "Even before Khmer artifacts were actually in their custody, they [the Malrauxs] contacted dealers and made arrangements to sell them, preferably to museums and private collections in the United States, because they knew that they would bring the highest price (Malraux, *L'aventure*, 117)."[17] The fictional "resolution" of this episode in the novel will detain us here, and makes us call into question Western museographic practice in general. How do "native artifacts" extracted from their impoverished homes of origin come to be in the possession of rich private collectors or public museums? This issue shapes a disturbing aspect of art consumption at last being addressed seriously (see Karp and Lavine).

In *La Voie royale*, Albert Ramèges, the director of the French Institute, warns Claude: "to prevent any repetition of the regrettable incidents of last year—that all objects of whatever nature shall be left *in situ*. . . . A report will be drawn up about them. After perusing it, the Head of our

Archæological Department will, if necessary, proceed . . ." (53). Risking his life to explore and penetrate territories where "two of the leaders of official exploring parties . . . were murdered" (52), Claude resents the petty official who prevents him from removing any found artifacts from the peninsula: "What right had this official to claim a title over any objects he, Claude, might discover, to hunt for which he had come here, on which his last hope hung?" (54). Malraux expressed the same feelings of indignant discontent on numerous occasions, both at his trial and in print. The issue of rightful ownership is therefore a question that re-emerges also in his fiction. One must look at this entire Indochinese expedition intertextually, and critically, especially in light of apologetic assessments of his life and work. Langlois, for instance, presents Malraux's Indochinese adventure in the most innocuous fashion, offering three possible explanations for his actions: the first justification deals with what he believes to be Malraux's alleged "artistic studies":

Although he probably planned to sell part of whatever he found in order to defray the expenses of the expedition, his greatest concern was to obtain some outstanding objects for his own artistic studies. He has specifically stated that he intended eventually to present any superior pieces he might find to the School's rival in Paris, the Musée Guimet, whose remarkable collection of Asian materials had been built up by such gifts from dedicated private collectors, archaeologists, and retired colonial civil servants. (*André Malraux* 8)

This type of rationalization is only possible if we take Malraux's court deposition literally. And as I have also tried to show, the origin and provenance of these "gifts from dedicated private collectors, archaeologists, and retired colonial civil servants" most certainly are suspicious.

The second argument refutes the notion that "money had been the primary motivation—perhaps the only one—behind the expedition into the jungles of Cambodia":

In reality, this was the least important of the many reasons that led Malraux into this much publicized adventure. For example, on an aesthetic level, he has long maintained that a deep knowledge of other cultures, especially those outside the Greco-Roman tradition, is an essential prerequisite for a greater appreciation of Western civilization. He states this succinctly in his very first essay on art, the 1922 preface to an exhibition of paintings by his Greek friend Galanis: We can

feel only by comparison. . . . The Greek genius will be better understood through the contrast of a Greek statue with an Egyptian or Asian statue than by the examination of a hundred Greek statues. (9)

Clara Malraux's memoirs do not support this claim. Finally, he offers one last explanation:

Also, as Malraux made clear at the time of his trial, he was planning to write a detailed comparison of Khmer and Siamese art based on his discoveries in the jungle (*L'Impartial* September 16, 1924, page 1). Not only would the study reveal new aspects of the cultural complex of Indochina but his reactions to these ancient artifacts would stimulate new insights into the civilization that had resurrected them—his own. Perhaps he also hoped that such a provocative study would win him a certain fame in his chosen field of art and archeology, just as his controversial essay on cubist poetry had done several years earlier in the field of literature. (9)

Malraux gained stature not because of his insightful comparative study of Khmer and Siamese art, but as a direct result of the publicity generated by this affair. His reputation was further enhanced when members of the French literary intelligentsia mobilized themselves and rallied in support of the young Malraux.[18] Among those signing a petition on his behalf were the literary and artistic giants of the time, including André Breton, André Gide, Max Jacob, and Jean Paulhan. My aim here is not simply to dispute Langlois's interpretation, but to call into question the blindness of a benevolent approach to the work of one of France's foremost literary figures.

The extended discussion of fantasy, mapping, territorial conquest, masculine desire, adventure, and ownership provides the theoretical basis for an analysis of a crucial passage in *La Voie royale*, a scene where all of these issues come together. In their search for Khmer artifacts deep in the Cambodian jungles, Claude and Perken encounter numerous temples with no signs of any sculpture in them. After days in the jungle, they finally make a discovery worth their while: "Carved on two faces, the corner-stones represented two dancing-girls. The figures extended over three stones, placed one on top of the other" (102). The find triggers a daydream in Perken: "A picture held his eyes—his army on the march, sunlight glinting on the machinegun barrels, the target sparkling in the

sun" (102); "Il imaginait ses défilés, avec la ligne éclatante du soleil sur le canon des mitrailleuses, l'étincelle du point de mire" (79). He imagines the territory he carved out for himself to be impregnable since it could now be defended with machineguns bought from the sale of these Khmer artifacts: "In the region where I live I'm still my own master and, if I could get arms, I'd hold out there until my death. And then . . . there are the women. Yes, if I'd a few machine-guns I could hold the region against an army corps, unless they were ready to sacrifice any number of lives" (75); "Avec quelques mitrailleuses, la région est imprenable pour un Etat à moins de sacrifier un très grand nombre d'hommes" (61).

Each temple means for Perken ten machineguns or two hundred rifles with which he could arm the natives against "the impact of so-called civilization, with its advance-guard of Annamites and Siamese" (75). But before this fantasy can become a reality, he must find a way to remove these bas-reliefs—by cutting or breaking the stone in order to detach the sculptured faces—and transport them out of the jungle by ox-drawn cart. The following passage conveys his struggle against the stone:

Perken picked up the sledge-hammer and set to striking at the remaining stone. He expected it to give at the first blow; but it did nothing of the kind. He continued raining blows on it, mechanically, a prey once more to furious anger. He saw his men being mowed down for lack of machine-guns, flying in panic before a line of charging elephants. As he went on hammering and his thoughts grew blurred, he was gradually possessed by the sensual thrill which comes of every long-protracted struggle. Once more his blows were uniting him with his enemy, the stone (110–11; Une seconde, il vit ses défilés sans mitrailleuses ravagés, bouleversés comme par le passage des éléphants savages. Des coups répétés, de la perte de sa lucidité, un plaisir érotique montait, comme de tout combat lent; ces coups, de nouveau, l'attachaient à la pierre . . . (85)

The furor of his action, the will to conquer the stone, brings "erotic pleasure" heightened by daydream images of his territory and marches reconquered by nature (once again symbolized by a herd of roaming wild elephants). It is not a coincidence that the bas-reliefs, in contrast, represent lascivious Khmer "dancers" that he can control and possess. These "dancers," which Malraux the amateur archeologist never designates by their proper name, are in fact *devatas*, smiling divinities guarding the

temple (Le Bonheur 49). When the "dancers" finally surrender them-
selves, Perken finds himself "suddenly in harmony with the forest and the
temple" (111). Gombrich describes this type of communion perfectly
when he writes: "the mysterious and unintelligible works of art of the past
have become allies with the sublimities of nature to give us a screen onto
which to project our deepest fears and desires. The communion with art
like the communion with nature is in reality a communion with oneself"
("La Philosophie" 225). The work of art does indeed offer a screen onto
which to project one's most profound desires. Like Perken, Malraux wants
to leave his mark on the (literary) map of Indochina, one that will be
forever branded on our collective imaginary. Malraux's dreams and fan-
tasies are indeed the royal road to the unconscious and the colonialist
imaginary.

"Our age is precisely the age of the industrialization of fantasy" (236)
writes Malraux in his *Anti-Memoirs*. His early novels, and more particularly
La Voie royale, seem to commodify these nostalgic dreams of conquest
belonging to a bygone heroic age. And even though critics seem to have
been magnanimous in their assessment of Malraux's work—he is remem-
bered primarily today as much for his novels as for his political commit-
ment to the antifascist and anticolonial causes—a more disturbing aspect
of his work and biography emerge behind the well-rehearsed pronounce-
ments on his behalf. As Geoffrey T. Harris has elegantly shown, even his
editorials and articles in *L'Indochine* and *L'Indochine enchaînée*, short-lived
newspapers Malraux and Paul Monin edited in Saigon from June 1925 to
February 1926, can no longer be presented as proof of his commitment to
the emerging anticolonial movements.

Throughout his life, Malraux presented himself as a staunch defender
of revolutionary causes. How are we then to interpret his refusal to meet
Ho Chi Minh, the leader of the Vietnamese national liberation, during
his visit to Paris in 1947? What are we to make of his silence over the
Algerian War as de Gaulle's culture minister? Are we to see a radical
departure from his early anticolonialist stance? There appears to be no
contradiction between the young adventurer in Indochina in the twen-
ties, the Communist writer of the thirties, and the Gaullist after the
Second World War. This study attempts to remap a clearly delineated
trajectory, a conservative political ideology already present in Malraux's

early writings such as *La Voie royale*. Rather than disentangling fact from fiction, setting them in tension allowed us to examine the modalities that helped create the myths surrounding the life and work of Malraux in dire need of serious reassessment.

Emmanuel Mounier was correct when he asserted that "the first great myth of Malraux is the myth of the conqueror [le premier grand mythe de Malraux c'est le mythe du conquérant]" (39). Elevating the adventurer to the status of "intellectual hero" or "scholar in action" (Brombert 169) merely obscures the historical circumstances that have allowed the edification of such a prestigious figure. This humanist transfiguration also refuses to acknowledge the complicitous role played by "la colonisation savante [learned or scholarly colonization]" (Sénart 10)—a term used by a member of the (real) French Institute in the first issue of the influential *Bulletin de l'école française d'Extrême-Orient* in 1901—in achieving the complete military and cultural domination of the Indochinese peninsula. The conquest and colonization of Indochina continue to exert on the French imaginary a powerful lure. This continued fascination owes as much to masculinist novels such as Le *Voie royale* as to the display of Khmer artifacts in museums and expositions in the West.

Chapter 5

GEOGRAPHIC ROMANCE

"Errances" and Memories in Marguerite Duras's

Colonial Cities

> The story of my life doesn't exist. Does not exist. There's never any center to
> it. No path, no line. There are great spaces where you pretend there used to
> be someone, but it's not true, there was no one.
> —Duras, *The Lover*[1]

Duras's latest (post)colonial novel, *L'Amant de la Chine du nord*, reconfigures
a problematic space, an "imaginative geography" (Said, *Culture and Imperi-
alism* 90) overdetermined by history and politics. And yet, when asked to
describe her own practice of writing, Duras asserts: "The thing about my
literary work is that I've never mixed political theory with literature. It
never turns into rhetoric. Never. Even things like *The Sea Wall* [the En-
glish translation of *Un Barrage contre le Pacifique*] remain a story. That is
what saved me . . ." (Jardine and Menke 239). First published in 1950, *Un
Barrage contre le Pacifique* was an immediate critical success. This work drew
praise from critics who compared it to novels by Steinbeck and Caldwell.
Duras's portrayal of the life of "pauvres colons" in Indochina struck a
familiar chord in the American perception of the harrowing experience
of poor whites during the Great Depression. Others considered *Un Bar-
rage contre le Pacifique* to be "an indictment of colonialism" (Roy 376) or
a "tract on the evils of imperialism" (Blake 5)—readings that focus on
a particular sociohistorical moment and, more specifically, the Indo-
chinese War. Most commentators, however, seem to have taken heed of
Duras's own interpretation of her work and read her novel as a story that
appeals to values that have a "universal meaning" transcending her Asian
world: "Beyond the setting where the action is set, Marguerite Duras
touches the universal, the eternal" (Piel 182). One critic even went so far
as to write that "the story might just as plausibly have taken place in

France or anywhere in Europe" (Peyre 43). Such a problematic inter-
pretation glosses over the text's engagement with geography and history,
refuses to affirm Indochina as the scene where French colonial domina-
tion was played out, and, ultimately, elides the violence exerted on the
colonized peoples of Southeast Asia.

Unlike their humanist contemporaries, poststructuralist critics ap-
proach Duras's work from a distinctly modernist or postmodernist per-
spective.[2] Theorists such as Blanchot and Lacan favored Duras's more
abstract novels.[3] Their inaugural essays on Duras shifted the interest of
critics away from the "naive mimetic relation between language and
social reality" (Bhabha, "Representation" 113) toward self-reflexive tex-
tual questions such as "the site of the gaze," "voice," and silence. Today
these topics continue to find critical resonance in contemporary studies.
Julia Kristeva's reading of Duras's oeuvre is symptomatic of a type of
analysis, which, problematically, evacuates history and ignores the im-
portant ways the colonial situation and the specificity of historical con-
text figure in her work.

Kristeva believes that over time Marguerite Duras's work tends to
attach less and less importance to history and, eventually, brackets his-
tory altogether. "History," she writes, "moves to the background and
eventually disappears in Duras's works" (143). She argues that "all of
Marguerite Duras's oeuvre may be found in the text of *Hiroshima mon amour*
(1960)." Kristeva, among other critics, acclaims this novel as the exem-
plary Durassian text because it combines "the socio-historical realism,
which first appears in the *Sea Wall* (1950) and reappears in *The Lover*
(1984)" with the "X ray of depression defined in *Moderato cantabile*." More
problematic however, is the claim that "This drama of love and madness
occurs independently of the political drama; the power of passion sur-
passes the political events, however atrocious" (143). Kristeva fails to
recognize the interdependency of personal drama and political events
and greatly overstates the capacity of Durassian melancholy and the
psychic realm to absorb political events and history. By subsuming the
political under the realm of the intersubjective, Kristeva dehistoricizes,
not unlike humanist critics, Duras's work.

A postcolonial reading of Duras's novels foregrounds history and re-
articulates the relation between textuality and historicity. It will show

that the macropolitics of location are not subordinated to "passion" or pain, nor absorbed by what Kristeva calls "the psychic microcosm of the subject." Instead, they problematize the role assigned to desire in the constitution of the Durassian subject. Far from abstracting or neutralizing history, her novels transform, in radical ways, the way we understand *histoire* as both history and story: a public history determined by specific historical conditions, such as the impact and legacy of the French colonial presence in Indochina, which have the power to shape and transform the personal story of fictional characters. Duras's memory of colonial space—particularly her representation of the insertion and reinscription of the Durassian subject in the space of the colonial city of Saigon—and its figuration in later novels set in Indochina, provides a critical terrain for such an investigation. In the more than four decades that separate *Un Barrage contre le Pacifique* (1950) from *L'Amant de la Chine du nord* (1991), memory enables both the rewriting of history and of a story. *L'Amant de la Chine du nord* and *L'Amant*, awarded the Prix Goncourt in 1984, are read here as rewritings of *Un Barrage contre le Pacifique*. These three novels constitute what could be called the Indochinese trilogy. My analysis will pay particular attention to the complex processes by which subject locations are linked "to the questions of the effects of power, the inscription of strategies of individuation and domination in those 'dividing practices' which construct the colonial space" (Bhabha, "Signs Taken for Wonder" 170).

More specifically, this study focuses on Duras's representation of the relation between memory and a process I call "errance," to play on the meaning of swerving both from the path and from truth—as deviation or perversion—and wandering from one place to another, an accidental journey more than a process of forced displacement. I argue that it is precisely in the crossing of these peculiar spaces in the city, across newly mapped out "erotogenic" zones—dramatized in "la traversée du fleuve" or urban peregrination—that the Western female subject comes to an "imaginary" understanding of the colonial situation. Wandering creates a different type of spatial relation and circumscribes another space where the subject both inscribes herself and is being reinscribed. Placed in this "new" space, she encounters the Other, the native, the subject of desire, and derives pleasure. The discovery of the colonial city is not only linked

to sexual knowledge but, as will be suggested, to the liminal site of a journey into "une zone différente du voyage [a different zone of the journey]" (ACN 50),[4] "what de Certeau calls "'another spatiality' (an 'anthropological,' poetic and mythic experience of space" (93).

Although errance can be seen as a transgressive strategy used to undermine the discursive power of colonialist discourse that attempts to fix the subject in a position of intelligibility, the eminence of "romantic" errance in Duras's texts must also be interrogated. What does it mean for Duras to write about white women wandering in colonial cities and into their own sexualities? Would it have been possible for the "natives" to do the same on the same streets in Indochina? What do we make of the heroine's ability to derive *jouissance* from a politically charged situation? What allows feminine jouissance to be anchored in local color (Kristeva 142)? These questions will be examined against the discourse of French colonial urban planning and within the intertext of other discourses, particularly feminist theory and psychoanalysis.

Duras declared in a lapidary fashion that *"Barrage contre le Pacifique* is the true novel on memory and I was barely thirty when I wrote it" (Duras and Gauthier 231). A quarter of a century or so later, in the preface of *L'Amant de la Chine du nord,* she writes, "For a whole year I went back [j'ai retrouvé] to the days when I would cross the Mekong River, on the ferry to Vinh-Long. . . . The story enclosed me with these people, and with them only" (NCL 2). The English translation is incapable of conveying the polysemy of the word *retrouver,* which does not only mean "to go back" but denotes other meanings such as to rediscover, to find one's way again, and to remember. The importance of recollecting and forgetting must be highlighted because it occupies a crucial nexus in Duras's imaginary. For the author, memory is linked explicitly to *histoire* and *écriture.*[5] Writing allows the memories of her colonial childhood to be refigured in spatial terms, with such "real" geographical markers as the city of Saigon or the crossing of the Mekong River to Vinh-Long or Saigon as its coordinates. But to evoke memory or the process of remembering is also to summon forth what Maurice Halbwachs, the French sociologist and philosopher, calls "this first historical framework of childhood" (49), which is necessarily a reconstructed representation, a *lieu factice.* Halbwachs also suggests that "memory is . . . a reconstruction of the past with the help of

pieces of information borrowed from the present" (57) and that "memory is an image engaged in other images" (66). Duras takes this proposition to heart, as she sees, for instance, the Chinese crowd of Cholon thus: "a Chinese crowd, I can still see it now in pictures of present prosperity" (L 46).

In her interview with Michelle Porte, Duras speaks of memory as "something scattered everywhere" (Porte 96) that contains history, "the places which harbor this memory" (96). Duras's privileged "lieu de mémoire [place of memory]," to borrow Pierre Nora's terminology, is her colonial childhood, her *enfance*. In Duras's Indochinese trilogy, her literary or phantasmatic lieu de mémoire is also a "site of desire" (NCL 102), a "site of passion" (94) and a "site of anguish" (84)—in short, the colonial primal scene.[6] If Duras's "memories" shape three different versions of the same story, these "memories" also fill, substitute, and reconfigure a fictional lieu de mémoire.

Duras's novels reelaborate the colonial encounter in scenarios of fantasy and scenes of desire that do not simply illustrate the colonial and postcolonial theories of such figures as Frantz Fanon or Homi Bhabha, but disrupt the Manichaean logic of their arguments and problematize them in ways that will be addressed here. And even when Duras is at her most nouveau roman, a political reading of her novels is possible, as Jacques Leenhardt has demonstrated so elegantly in his analysis of Robbe-Grillet's *La Jalousie.*

If colonialist discourse relies on the concept of "fixity in the ideological construction of otherness" (Bhabha, "The Other Question" 18) in order to "fix" the colonial subject in what Homi Bhabha calls "the ambivalence of the colonial stereotype," Duras's female protagonists subvert this process of "fixation," reject such "fixed" positions of intelligibility, by wandering across boundaries and worlds, transgressing at the same time accepted colonial customs and values. Errance allows the narrator in Duras's *L'Amant* to be fully individuated: "Suddenly I see myself as another, as another would be seen, outside myself, available to all, available to all eyes, in circulation for cities, journeys, desire [mise dans la circulation des villes, des routes, du désir]" (L 13). Seeing herself as Other triggers the process of subjectification. The specular self and the power of the Other's gaze do not simply constitute the subject but draw the

subject into movements of cities, journeys, desire. Errance effects change and transforms the subject.

Although many instances of errance punctuate Duras's novelistic and filmic texts, I have chosen three emblematic scenes to problematize and illustrate the process of colonial subjectification.[7] These include Suzanne's wandering in the "upper district" in *Un Barrage contre le Pacifique*, the crossing of the Mekong River in *L'Amant*, and the amorous *dérive* in the *garçonnière* in *L'Amant de la Chine du nord*. Such paradigmatic scenes of errance also allow for a discussion of what Jameson calls the "ideological subtext" of the narrative, not as "some commonsense external reality" but as the process that "brings into being that very situation to which it is also, at the same time, a reaction" (Jameson, *Political* 81).

Here I wish to return to Maurice Halbwachs and his study of memory and space. In a series of apparently naive propositions, Halbwachs discusses the role played by spatial images in the multiplicity of collective memories. He argues that personal and collective formations of memory take their "anchoring point [point d'appui] on spatial images" (136) and, more specifically, on the "material environment [milieu matériel]," "the home" and "the material appearance of the city." He elaborates a theory of the localization of memories based on the notion that memories are "placed within many frameworks which result from distinct collective memories" (52). "The place [le lieu]," he adds, "has received the imprint of the group, and vice versa" (133). This reciprocity, this dynamic exchange between the location and the people, marks the collective memory in spatial terms.

But perhaps more immediately pertinent for our study is Halbwachs's argument that "When a group is inserted in a part of space, it turns it into its own image. It shuts itself up in the setting it has constructed" (133). This hypothesis could describe, albeit metaphorically, Duras's own literary approach, her strategy of writing. As noted earlier, she claims that "she remained in the story with these people and with them alone" (ACN 12; my translation). But Halbwachs's proposition could also explain and illuminate the logic of French colonial expansionism in Indochina, the mode by which Southeast Asia was colonized and occupied, its landscape transfigured.

During the belle époque of French colonialism, the will to trans-

form native space into a world and economy in its own image, that is to say, into an immediately identifiable French milieu with European-like cities, was asserted through policies elaborated by French colonial urban planners and architects. Since the construction of colonial cities followed Western models and norms, the French believed that "they had successfully replicated the urbane beauty of cities in their homeland" (Wright 161). What remains to be discussed is not so much whether they achieved such a lofty goal, but the premises underlying urban planning in Indochina. As will become evident in Duras's texts, the colonization of space also ushers in a new era of spatial and racial segregation. The European population was quite successful at hemming themselves in within the newly constructed areas, the "vital space" in the French quarters of the colonial cities.

A cursory view of various reports devoted to "the general development of colonial and tropical cities" reveals the causal relation between the "development of cities" and a French "political organization program" (Royer 16), which would test "the political efficiency of certain planning principles" (Rabinow and Wright 28). The Congrès de l'Urbanisme Coloniale, held in October 1931 under the general auspices of the Exposition Coloniale Internationale de Paris, marked, according to its organizers, a milestone in urban and architectural history. For the first time, "the broad lines of a gigantic program" (Du Vivier de Streel 10) were drawn. In the introduction to the proceedings of this Congress, Du Vivier de Streel, Directeur des Congrès de l'Exposition Coloniale, proposed what he considered to be a modern and efficient approach to the proper construction and administration of exotic cities, warning against "the violation of principles of town planning" (9). In his eyes, the most important guideline to respect was the "separation of European and indigenous districts" (13): "Hence the necessity—impressed by a concern for the health of whites— never to mix the indigenous population and the European population in an urban agglomeration" (11). If this principle is violated, he warned, "order and security are at stake; social peace, the nation's prosperity . . . can be compromised" (9). The French empire could come under attack from within. The reports and writings of Ernest Hébrard, architecte en chef de l'Indochine, the French urban planner responsible for redesigning native space in Indochina, suggest that Du Vivier de Streel's recommen-

dations had already been put into effect in Indochina. To be fair, Hébrard was much less of a segregationist. Although his policies were consistent with the contemporary colonial ethos, he seemed to deplore the minimal contact between native and European populations. Nevertheless, the policies of colonial urbanism were implemented. They illustrate a peculiar conception of spatial logic,[8] one that helps explain racial and class divisions that still exist to this day, not only in former colonial cities in Africa[9] and Asia, but also in Western "metropolitan" centers of today.

This particular subtext, the scene of French colonial urbanism, allows Duras's Indochinese novels to be read not just aesthetically but also politically. Jameson's conception of subtext as articulating its own situation and textualizing it as well, steers us away from a naive reading of Duras's novels as a mimetic reflection of reality. If colonial cities in Duras's work are seen as an important subtext to the "expressions of the spatial and territorial configurations by which Western countries have penetrated other regions and cultures" (De Bruijne 231), it is because "subtext is both a product and a projection of context, as well as a textual construction" (Parry 48). In Duras's novels, the city—Saigon or Cholon—is part of the French colonial empire. It plays a central function in the colonial administration and its economy. Seen from an increasingly smaller frame, Saigon is the capital of French Cochin China and, at a more local level, it is also a divided city with a recent colonial history. Colonial urbanism therefore provides an important framework for examining the internal spatial structure of the colonial city. A problematic urban concept like the "dual city"—the native and European quarters—can help us refine our political and economic understanding of the relationship between colonizer and colonized, the social and cultural relations that constitute the colonial condition.[10] Let us therefore turn to Duras's representation of the impact the strategic use of space had in colonial urban design on the peoples of Indochina.

Part 2 of Duras's *Un Barrage contre le Pacifique* begins with a description of a populated colonial city. A panoramic view guides the reader to a sprawling city spread out on both sides of a wide and beautiful river: "It was a large city of one hundred thousand inhabitants" (SW 135). Nothing seems capable of disturbing the tranquility of the idyllic and exotic setting. Duras is deliberately vague about the moment in time, using the

expression "dans ces années-la [in those years]"[11] to convey a golden, if waning, age of colonialism. Time seems to stand still or, as Benjamin put it, the "homogeneous, empty time" ("Theses" 262) can only be filled with a mass of insignificant events. But this tranquil scene can ravish and deceive. The "gros-plan [close-up]" fractures the illusion. The serenity and uniformity of the first scene is broken by the representation of a divided city, "the white town and the other," that unnamable "other" populated with "dangerous" and untidy natives. The reader, in effect, discovers spatial and racial segregation.

Duras's imaginative portrayal of the colonial world, set in binary terms, anticipates Fanon's Manichaeist political interpretation of life in the colonies:[12] white versus native, civilization versus barbarity, the city versus the country, culture versus nature, man versus woman, affluence versus poverty, colonizer versus colonized, silence versus noise are opposing terms of two interdependent systems that need and require each other to exist. Hébrard was well aware of this "interconnectedness" when he explained the logic behind his plans for the reorganization and sanitization of Indochinese colonial cities in the following terms: "In certain provinces, indigenous centers will exist; in others, it will be necessary to create them near the new European city; every European district needs an indigenous district to survive; it will provide indispensable domestic servants, small commerce and physical labor" (279). The need to create native districts in the proximity of the European city seems indispensable for the economy and comfort of the colonizer because they will bring an abundance of domestic servants and cheap labor for small and large businesses. Hébrard does not even consider the economic and social impact of forced displacement on the indigenous population when a "new European" city is created within the boundaries of the old native city, or when it is arbitrarily constituted by assembling two distinctly different cities, like the Chinese Cholon and the French Saigon, into one large agglomeration. In fact, these colonial policies are further banalized when he compares the natives' predicament to the migration of workers to the suburbs in modern Western cities, as in the "red belt" surrounding Paris: "One or more indigenous districts surround each European one; these native districts correspond, in essence, to the business districts and working-class neighborhoods of our modern cities, which are, in truth, sepa-

rated from the bourgeois neighborhood without a definite line being drawn on the map" (285).

Un Barrage contre le Pacifique conveys spatially the complex relation of dominance and oppression that characterizes French colonialism in Indochina. Duras's portrayal of the colonial city and, more precisely, of the upper district in the "white city," demonstrates the spatial organization of power, a colonial power exerted not only on the natives but also on the dislocated poor whites who did not succeed in reaping a profit from the land or from its inhabitants. Racial domination and class hegemony are explicitly played out on the metropolitan stage.

The "white" city or "haut quartier," at the center of the city, rises above the "other" city, the "lower district." Only the whites who have made a fortune live in the haut quartier. The boundaries of the white city or, as the narrator names it, "the Eden of the upper district," are delimited by the circuit of the trolley cars that "scrupulously avoided the fashionable upper district" (SW 137) and at the same time separated it from the "other" one. "They encircled it hygienically, following concentric lines, of which the stops were all at a distance of two kilometers at least from the center of the city" (SW 173). As the narrator points out, "only the natives and the poor white of the lower district used the trolleys"; the rich had their own cars. Thus, the city center is quite at a distance from any of the trolley stops, which should discourage any of the "natives" or poor white "intruders" from trying to reach it.[13]

Furthermore, in order to reach the center of the city, one first had to cross the fashionable residential quarter with its luxurious villas and homes constructed on large plots of land: "It was the largest and airiest part of the city." In his report, Hébrard tells us that "in French Indochina, European homes, with few exceptions, were isolated and formed garden-cities" (262). In 1931, of the 400,000 inhabitants living in the Saigon-Cholon agglomeration, only 8,000 to 9,000 were Europeans. Order and safety, we are told by du Vivier de Streel, hinged on the proper way of administering the colonial city. To safeguard European sovereignty, he adds:

Urban planners should make every effort to encourage European immigration to the colonies and provide, to this end, the most advantages possible to city dwellers of the white race in the cities they are developing.

To attract them, they must create well-ventilated districts, decorate them with every means that nature or art has put at the disposition of architects and administrators: public and private gardens, shaded avenues, porticos in the streets.... (12)

No formal signs, however, separate the native district from the European one, although there were discussions about circumscribing it with physical markers to allay the fears of white colonials who were terrified of being contaminated by "insalubruous" natives in the event of an epidemic. Radically transfigured, the colonial city with its new "wide streets and sidewalks" cannot shelter the "native" from the piercing and "voyeuristic" gaze of the colonizer. There is no place to hide. The "native"— and I include in this particular instance the poor white—is exposed, made to feel uncomfortable and out of place, as Suzanne's painful experience in the upper district bears witness, an episode discussed below.

What characterizes the upper district is the rigorous order of its urban design. These wide and immensely long streets are covered with asphalt and divided by manicured lawns and flowery flowerbeds, sprinkled several times a day. The sidewalks are lined with exotic trees. The narrator, ironically, compares this self-contained and controlled space to an "immense zoological garden" where only "rare species of whites watched over themselves" (SW 136). Nothing is allowed to grow wild; everything is domesticated or tamed. If one of the main projects of French colonial imperialism is total containment, here its success is unequivocal. Even more striking is the useless "orgiastic space," the frivolity and waste, the non–use value of colonial space—water is used to water plants when natives do not have water for drinking or bathing; they are forced to wash in the "rain from heaven and in the muddy water of the streams and rivers" (SW 135). The whites dispose of great empty space, while the natives are packed into crowded quarters.

Although one would expect the center of the white city to have been developed for the exclusive use of French colonial officials, the reader discovers that, in fact, this urban space was colonized and occupied by those who hold "real" power: "Là ne se trouvaient pas les Palais des Gouverneurs, le pouvoir officiel, mais le pouvoir profond, les prêtres de cette Mecque, les financiers" (B 167); "The more basic power—the financial—had its palace in the center of the white town. . . . The financiers

were the true priests of this Mecca" (SW 135).[14] The center of the upper
district was the financiers' true sanctuary for another reason. "Here only,
in the shade of the tamarind trees, were spread out the immense terraces
of their cafés. It was on these terraces, in the evenings, that the inhabi-
tants enjoyed themselves in their own congenial company" (SW 136).
According to Hébrard, these immense terraces give "Indochinese cities
the appearance of French cities" (280). Space circumscribed by the up-
town cafés and their terraces delineates another important facet of colo-
nial life. Social intercourse is restricted only to whites, what Halbwachs
described as the need and desire of a group to transform into its own
image the space onto which it is inserted, shutting itself up in that setting
and, at the same time and in the same process, preventing outsiders from
joining in.[15]

Barthes describes *le centre-ville* (the center-city), as "a complete site to
dream of and in relation to which to advance or retreat; in a word, to
invent oneself" (*Empire* 30). He adds: "it is here that the values of civiliza-
tion are gathered and condensed: spirituality (churches), power (offices),
money (banks), merchandise (department stores), language (agoras: cafés
and promenades): to go downtown or to the center-city is to encounter
the social 'truth,' to participate in the proud plenitude of 'reality'" (30).
The colonial center-city, as Duras describes it, condenses all of these
values—spirituality, power, money, merchandise—into one striking fig-
ure, the "large colonial vampire," and into one remarkable space, the
upper district constituted as "orgiastic space": "And, still further to mark
the superhuman difference between white people and the others [la
démarche blanche], the sidewalks in this fashionable district were im-
mensely wide. An orgiastic space, quite uselessly wide, was provided for
the heedless steps of the powerful-in-repose. And through the avenues
glided their cushioned cars on cushioned wheels, as if suspended in an
impressive semi-stillness" (SW 136). Duras goes one step further. She
compares the center-city to a "magic brothel": "The gleaming of the
cars, show-windows and watered asphalt, the dazzling whiteness of the
clothes, the shimmering coolness of the flowerbeds, made of the upper
district a magic brothel, where the white race could enjoy, in undiluted
peace [dans une paix sans mélange], the sacred spectacle of its own
existence" (SW 136–37). Leah Hewitt notes that Duras "extends the

definition of prostitution so that it becomes an apt metaphor for all social transactions" (116). But any discussion of prostitution should also include the place where all these promiscuous practices occur, namely, the upper district. In fact, what allowed the construction of the "magic brothel" with its "orgiastic space" is the labor and blood of native workers who are consumed by an entirely different landscape, the rubber plantation where "Latex flowed. Blood, too. But only the latex was collected as precious, only the latex paid a profit. Blood was wasted" (SW 137).

It is on the particular stage of the upper district that, one day, Suzanne wanders into the colonial city on her own. Her walk in the upper district is a humiliating experience, not simply because she does not belong there, but more importantly because she erupts onto the "colonial scene," disrupting the "paix sans mélange."

In *L'Amant*, Duras rewrites the scene of Suzanne's errance in the upper district but displaces and reconfigures it onto an entirely different space, the crossing of the Mekong River on the ferry. In this later work, the protagonist no longer experiences humiliation. The narrator, speaking in the first person, considers "la traversée du fleuve" to be one of the most important events in her life, an event that could not be reproduced pictorially: "The photograph could only have been taken if someone could have known in advance how important it was to be in my life, that event, that crossing of the river" (L 10). She adds, "I think it was during this journey that the image became detached, removed from all the rest" (L 10).

There are obvious resonances between the passage that describes the crossing and the one depicting Suzanne as she wanders in the upper district. Their coherence can be found in what Lacan calls "the theme of the dress." But rather than establishing similarities and differences, an intertextual reading reveals the extent to which they supplement each other. In *L'Amant* we are confronted with a singular image of the heroine of the novel. She elects to wear a worn, low-cut, transparent dress. Her choice of this particular dress and selection of mixed accoutrements (both male and female) makes her presence instantly conspicuous, a presence that draws attention. The man's hat and the lamé shoes have become an integral part of her costume; in fact, they have replaced and constitute her being and make her feel other, unlike both natives or white

colonists, male and female. The singularity of the self-(re)presentation is marked by ambiguous signifiers like the hat and the shoes: "The crucial ambiguity of the image lies in the hat" (L 12). If Suzanne's dress elicited laughter in *Un Barrage contre le Pacifique*, this accoutrement does not: "And then the clothes, the clothes that might make people laugh, but don't" (L 20). Her Chinese lover noticed her in that dress: "He is looking at me" (L 17). The accoutrement causes the looker to look at her differently. But she is quick to add: "I'm used to people looking at me. People do look at white women in the colonies; at twelve-year-old white girls too. For the past three years white men, too, have been looking at me in the streets, and my mother's men friends have been kindly asking me to have tea with them while their wives are out playing tennis at the Sporting Club" (L 17). Seduction and solicitation define the sexual economy of life in the colonies—a life the narrator discernedly names "bordel colossal." We can now better understand what the narrator means when she says: "Suddenly I see myself as another, as another would be seen, outside myself, available to all, available to all eyes, in circulation for cities, journeys, desire [mise dans la circulation des villes, des routes, du désir]" (L 13).

The narrator's mother does not condone these sexual practices, and denounces the corrupting influence of French colonial life in Indochina (A 27). Yet she allows her daughter to "err" in the city in this accoutrement in part because it brings the mother pleasure: "She looks at me, is pleased, smiles. Not bad, she says, they quite suit you, make a change" (L 23). The maternal look, however, also protects and supports: "She looks at me with some fellow feeling. She must think it's a good sign, this show of imagination, the way the girl has thought of dressing like this. She not only accepts this buffoonery [pitrerie], this unseemliness [inconvenance], she, sober as a widow, dressed in dark colors like an unfrocked nun, she not only accepts it, she likes it" (L 24). "This child-prostitute dress [Cette tenue d'enfant prostituée]" as it is constructed by the male gaze is reconfigured not only as a *pitrerie* or *inconvenance* in the mother's eyes but, more importantly, as the comforting outward sign of the unbridled imagination of an autonomous and liberated being. The inappropriate dress is a disruptive "choix contrariant, un choix de l'esprit [irksome choice, a spiritual choice]," dislocating in scandalous fashion fraudulent and venal notions of colonial propriety. In *L'Amant*, mimicry or blending in is no longer the preferred strategy. On the contrary, the reader now

witnesses the narrator's willed effort to reinscribe her body according to a new libidinal economy which redeploys visibility and transparence against the grain, not as the trace or symptom of desire structured by the male look, but contained and *détourné* (diverted and put off) from its eroticizing and objectifying goals: "the child already knows how to divert the interest people take in her to the interest she takes in money" (L 24). Transparent masquerade is now used as an effective strategy to flaunt the body without shame. It allows her to circulate, cross, and transgress different boundaries in the colonial city.

The Poetic Geography of Saigon

Colonial urban planners and architects established Saigon as a French city with imposing and grandiose buildings, reproducing in them the European neoclassical and baroque styles to demonstrate the ambition and desire of colonial society. The French were resolute to live in Saigon as if the city were merely an extension of *la patrie française*. All the symbols of colonial power were in the heart of the city. French civic and administrative grandeur manifested itself in an array of buildings, from the governor-general's palace and the Justice Palace, to the post office, the law courts, and town hall. The commercial district was well represented by the Bank of Indochina. Many other important buildings reflected French life as it had been recreated in Indochina. Among them, the Messageries Maritimes, the Lycée Chasseloup-Laubat, the Continental Hotel, the cathedral, the Municipal Theater, and the Pasteur Institute dotted the urban landscape of this "France d'Asie." These landmarks, as I have suggested earlier, would delimit their vital space, their *cadre de vie*, their symbolic world. As a first line of defense against "a semi-aquatic environment of mud and swamp" (Franchini 35) that could threaten and reclaim urban space, these constructions gave a semblance of solidity to a crumbling colonial empire.

It is in this peculiarly rarefied urban context and in its understanding of spatial order and hierarchies that Suzanne wanders into the haut quartier. Whereas in *Un Barrage contre le Pacifique* Suzanne's anxiety and fear of the city was conveyed through her painful experience in the haut quartier, where she was completely dominated and absorbed not simply

by an unfamiliar urban setting and, moreover, by a spatial dynamic that she did not comprehend, the young women protagonists of *L'Amant* and *L'Amant de la Chine du nord* appropriate this urban space for themselves and liberate it from its narrow functionalist purpose. The most revealing example is the young protagonist's refusal to reside at the Lyautey State Boarding School like every other student while attending the Lycée Chasseloup-Laubat. She transforms the place by slipping in and out at all hours, effectively turning it into a hotel: "the child lived on at the boarding school the way she would at a hotel" (NCL 110). What authorized this type of spatial appropriation? We will not deal with the most evident reason, the director's tolerance of her escapades, but sketch out how Duras's protagonists transform and alter the relations between spatial and signifying practices.

Duras, in these novels, sets Saigon as a metaphoric space, one that transforms the literal Saigon of urban planners and geographers into a poetic urban text, determined by the errance of the young girl. These novels constitute a discourse on/of the city in a way that eludes scientific cartographic surveys precisely because the wandering of the young woman unravels urban order and French colonial complacency as well as the notion of stable and coherent community. For the young white female protagonist, the unmarked borders are permeable.

Many of the urban markers that define the space, the *lieu symbolique* inhabited by the French, are mentioned in Duras's novels: the Cercle Sportif (A 26), the Messagerie Maritimes (A 131), the rue Catinat (A 33), rue Lyautey (ACN 59), jardin zoologique (ACN 106), la fumerie du Mékong (ACN 124), la Cascade (ACN 155), le Jardin des plantes (ACN 185), the Éden-Cinéma (ACN 150), Cholon (A 46), les Palais des Gouverneurs (B 167). Plotting the road traveled by the young girl and drawing up an inventory of places may allow us to map, with a certain degree of accuracy, the physical topography of the city. But something essential would be lost in the process of transcription. These landmarks, in Duras's narratives, deviate from their literal signification. They constitute not only a fiction; they also circumscribe an imaginary geography marked by a different type of spatial economy. They delimit a different space, a space of desire which is inhabited or occupied by the young girl. Barthes calls this space "un espace ludique [a space of play]" ("Sémiologie" 13). Discussing the importance of the center-city in the imaginary of young

people and adolescents, he goes on to describe the center-city thus: "the center-city is lived as a place of exchange of social activities, and I would almost say, of erotic activities in its broadest sense. Even better, the center-city is always lived as a space where subversive, rupturing and playful [ludique] forces meet and act on each other" (13). The young girl, in Duras's novels, transforms the streets of the center-city into an erotic stage where she plays the lead role: "The car's direction is opposite to her own line of travel. She puts her hand on the window. Then she takes away her hand and puts her mouth on the glass, kisses there, lets her mouth settle there. Her eyes are closed like in the movies. . . . The child had recrossed the street. Without turning back, she went on to school" (NCL 52). Rather than being merely a sign of sexual precociousness, this form of erotic playfulness could be described more appropriately in terms of a subversive type of urban performance which undermines and ruptures colonial space. Barthes adds that the center is "the privileged site where one finds the other and where we are, ourselves, the other. It is also the site where one plays. On the contrary what is not the center is precisely not the space of play, what is not alterity: family, residence, identity" ("Semiologie" 13). Going to the movies with a native houseboy, criss-crossing the city by car, strolling to the Jardin des plantes rather than attending classes, swerving from an established routine are some of the deviations and detours the young girl takes to mark her erotic city and to establish a different type of spatial practice. "To practice space," de Certeau writes, "is thus to repeat the joyful and silent experience of childhood; it is, in a place, *to be other and to move toward the other*" (110). What the young girl wants to detach herself from, in her peregrination, is precisely family (the mother), residence (she does not live "at home," the boarding school is a "hotel"), and a fixed notion of identity (she calls herself "the little white whore from Sadec" [L 35] or "this white child of Asia" [NCL 72]).

The Immobile City: Crisis of Metropolitan Experience

The long-term (in)habitability of the colonial city has always been explained in terms of ennui, a mixture of boredom and idleness caused, it is claimed, by the oppressive climate and, particularly, the heat of the

tropics: "Boredom, melancholia, nostalgia have often weighed on the spirits and tensed the nerves in the torpor of the days, the mugginess of the nights, and the monotony of a climate with unchanging temperature" (Franchini 58). But the young protagonist of *L'Amant* points to a different reason for this clichéd response to the colonies:

I look at the women in the streets of Saigon, and upcountry [dans les postes de brousse]. Some of them are very beautiful, very white, they take enormous care of their beauty here, especially upcountry. They don't do anything, just save themselves up, save themselves up for Europe, for lovers, holidays in Italy, the long six-months leaves every three years, when at last they'll be able to talk about what it's like here, this peculiar colonial existence, the marvelous domestic service provided by houseboys, the vegetation, the dances, the white villas, big enough to get lost in, occupied by officials in distant outposts. They wait, these women. (L 19)

Colonial existence as it is lived by these women is limited to a single practice of space. They cannot conceive of an-other space. Rather than traversing the liberating space of play as do the young protagonists and Anne-Marie Stretter, the enigmatic figure who haunts many of Duras's novels, these women occupy the unique space of their home, the stifling "white villas" they inhabit. No matter how many evenings consumed at the terrace of the Continental, sets of tennis played in the evening at the Club Sportif, Sunday afternoons spent at the horse track, charity balls and evening galas attended or theater and nightclubs frequented (Franchini 42–43), they will never adapt themselves to life in the colonies, in part because they fill their colonial existence with more of the same, that is to say, an unimaginative practice of space. Unlike the youthful practitioner of space who is capable of being Other, and moving toward the Other, these women are incapable of challenging the conventionality of colonial practices and getting out of the narrow confines of everyday life in the colonies. What awaits them, according to the novel, is madness, desertion, or death.

To challenge or subvert colonial conventions does not necessarily mean traveling to opium dens or slumming with natives in Cholon ("s'en-canailler à Cho Lon" [Franchini 43]). For the young girl, Cholon may indeed be "a city of pleasure that reaches its peak at night" (L 41). But more importantly, she practices a stunning *dérive* in the bachelor apart-

ment. And as Barthes reminds us, "it would be derisory to assimilate the eroticism of a city to the sole district reserved for this type of pleasures since the concept of place of pleasure is one of the most tenacious mystifications of urban functionalism; it is a functional notion and not a semantic one" (*Empire* 13). Although the garçonnière is in Cholon, the eroticism of the city is also disseminated in many other parts of the city, particularly in the streets of Saigon and in the protagonist's wandering in the city and, likewise, in her journeys from the boarding school to the lycée and to the apartment. These urban movements, a kind of erotic foreplay, are sensuously conveyed by the narratives.

It has been pointed out that *L'Amant* is "implicated in the colonial ideology of exoticism, because of its representation of racial 'others' who are completely appropriated, and assimilated into a romanticized and ritualized gesture of sexual possession. In this gesture, racial difference is coded as a 'passive,' 'feminine' presence" (Lionnet 135). The following passage seems to bear this out: "[She] undresses him. When she tells him to, he moves his body in the bed. . . . The skin is sumptuously soft. The body. The body is thin, lacking in strength, in muscle, he may have been ill, may be convalescent, he's hairless, nothing masculine about him but his sex, he's weak, probably a helpless prey to insult, vulnerable. She doesn't look him in the face. Doesn't look at him at all. She touches him. Touches the softness of his sex, his skin, caresses his goldenness, the strange novelty. He moans, weeps. In dreadful love" (L 38). To do justice to Duras's text, it should be mentioned that this passage is preceded by a sentence that gives a strikingly different image of the Chinese lover: "He's torn off the dress, he throws it down. He's torn off her little white cotton panties and carries her over like that, naked, to the bed" (L 38). This sentence undermines in a dramatic fashion the critic's argument of a passive, objectified other. However, the logic behind this type of reductive analysis is even more disturbing. The critic seems to be particularly distressed by Duras's representation of a different type of masculinity, one that does not rely on a traditional masculinist view of the male body. From a Westerner's point of view, the Chinese lover's body is an antithesis to the well-delineated stereotypical image of the healthy Western body. It is characterized by lack ("lacking in force, strength . . . virility"). It appears fragile and feeble, susceptible to unsuspected harm.

The idea of objectification seems even more remote when we consider

the question of the gaze. The heroine does not look in his eyes, but prefers to caress him, touch him. In essence, Duras presents a "new" man whose effeminate qualities ("douceur") are usually scorned, but here elicit loving passion. The Chinese lover moans and cries, demonstrating sensuality and pleasure generally coded in negative terms. So, rather than being appropriated and "exoticized," the figure of the Chinese lover seems to subvert the type of sterile masculinity associated with Western clichéd notions of virility. It is interesting to note that no such claims were ever made regarding the masculine status of M. Jo, Suzanne's effete would-be lover in *Un Barrage contre le Pacifique*, who is described in remarkably similar terms: "his face was certainly not handsome, nor was his figure. His shoulders were narrow, his arms were short, he must be much shorter than the average man. His small hands were well cared for, thin, rather good-looking" (SW 33). The race of the protagonist seems to authorize this type of critical benevolence.

We now come to our last example of Durrassian errance, what I dubbed the amorous dérive in the garçonnière. There, in the in-betweenness of different worlds, what Foucault calls heterotopias, Duras locates the space of desire and the site of transgression. Foucault calls heterotopias, by way of contrast to utopias, those "real places," or "counter-sites" that can be found in every culture and civilization, "all the other real sites that can be found within the culture, [which] are simultaneously represented, contested, and inverted" (24). He adds: "Places of this kind are outside of all places, even though it may be possible to indicate their location in reality" (24). The garçonnière is indeed the ultimate heterotopia.[16] Difficult to locate since it is not part of the concentric distribution of differences in power, wealth, and colonial ways of life, it is the site of "transgression," of the illicit love affair between a French girl of fifteen and her adult Chinese lover.

It is significant that the race of the lover has been changed since *Un Barrage contre le Pacifique*. "L'amant" is no longer a rich Frenchman but a Chinese lover. This double transgression (racial and sexual) repoliticizes Duras's novel and brings the question of colonial sexual taboo to the fore. If the white male colonizer can have many native concubines or lovers, the very idea of the possibility of a liaison between a white female colonizer and a male "native" is too scandalous to entertain. But this

unthinkable situation provides the plot of Duras's *L'Amant* and *L'Amant de la Chine du nord.*

The location of the garçonnière seems to be easily situated in *L'Amant*: "It's in Cholon. Opposite the boulevards linking the Chinese part of the city to the center of Saigon, the great American-style streets full of streetcars, rickshaws, and buses" (L 36). However, in *L'Amant de la Chine du nord*, Duras seems to locate it in a liminal space, almost a nonspace: "This is a street with cubicles [compartiments] like there are all over Indochina. It has the outdoor taps they call fountains. A covered arcade runs the length of it. It has no shops, no trams. Country merchants are resting on the beaten earth in the shadows of the arcade. The racket of Cholon is far away, very far, it's like being in a village in the middle of the city [un village dans l'épaisseur de la ville]. This is where it is, in the village. It is under this open arcade" (NCL 60). It is not quite in the city or the country, but in both: "un village dans l'épaisseur de la ville." A space where the outside is present in the inside: "In the first book, she had said that the noise of the city was so close you could hear it rubbing against the shutters, like people walking through the room. That they were in that public noise, displayed there, *where the outside came inside the room [dans ce passage du dehors dans la chambre]*" (NCL 69–70). But more important, it is situated "dans ce passage du dehors dans la chambre," surrounded and bathed in the dérive of the city noise: "I remember clearly, the room is dark, we don't speak, it's surrounded by the continuous din of the city, caught up in the city, swept along with it (L 40)"; "embarquée dans la ville, dans le train de la ville" (A 52).

Although Duras rejects any link between her fiction and "political theory," political representation returns even when she writes: "The Chinese city reaches them in the clamor of old tramcars, the noise of old wars, old worn-out armies [des vieilles armées harassées], the tramcars ring their bells constantly as they run" (NCL 60). Why compare the noises of the city to those of "old [colonial] wars, of old harrassed armies," if not to draw attention to history, to "mix political theory with literature"?

The protagonists of *L'Amant* and *L'Amant de la Chine du nord* associate Cholon with a particular memory. Cholon occupies a crucial place in their imaginary because they remember it as the site of sexual errance and

amorous jouissance, a location Barthes describes as "the city of Drift": "There exist cities of Drift: neither too big nor too new, they must have a past (like Tangier, an old international city), yet still be lively; cities in which several inner cities mingle, cities without a promotional spirit, idle cities yet not luxury cities, in which debauch reigns without taking itself seriously. . . . The city is, then, a kind of water which both carries and carries us away far from the shore of the real: here we are motionless (withdrawn from any competition) and deported (withdrawn from any conserving order)" ("Pierre Loti" 119). Saigon, with its assemblage of native, French, and Chinese quarters, is one such city where "debauchery reigns without taking itself seriously." The narrator of *L'Amant de la Chine du nord* has a very intimate memory of that inaugural moment of jouissance, the pain/pleasure of sexual initiation: "She still hears the sound of the sea in the room. And she remembers having written that. As she remembers the Chinese street. She even remembers writing that the sea was present that day in the lover's room" (NCL 69). The lover's bed is adrift in the presence and sound of the sea. When it recedes, the noise of the city returns in the lovers' room. Pleasure and desire are forever linked to the sounds of the ocean and city. The moment of (con)fusion is complete when Duras describes "the noise of the city" as being "continuous, all of a piece. It is the noise of vast spaces" (NCL 69).

Cholon is, then, an exemplary Barthesian city of Drift, a city that is also "a kind of water which carries and carries us away far from the shore of the real" (119). According to Barthes, the notion of "city of Drift" gives rise to a powerful image because it combines three important ideas: "that of love, that of floating, and the notion that desire is a force adrift— which is why the French word for drift, *dérive*, has been offered as the best approximation, if not the best translation, for the Freudian *pulsion*" ("Pierre Loti" 119). Love does not figure prominently in these novels. Desire as a force adrift, however, circulates in complex ways in Duras's sensual and voluptuous representation of the scene of jouissance. By reinserting the subject in an imaginary space, Duras's seductive narratives can lead readers astray and carry them far away from the shore of the "real." And they would succeed if only these texts had been completely detached from a local geography and not anchored in history. The physical location of the garçonnière in an indigenous cubicle reintroduces the

"real" and reanchors the amorous dérive in history. The "native apartment buildings" are described in *Un Barrage contre le Pacifique* and again in *L'Amant de la Chine du nord* (87–88):[17] "The apartments were in reality rows of double houses opening out on one side upon small courts and on the other side upon the street. They cost little to build and they met the needs of a whole class of native shopkeepers. They became the rage, and at the end of ten years such buildings existed in great number. Very soon they proved to be particularly favorable to the propagation of plague and cholera. The fact had been exposed in a survey made by the Colonial government. But since only the proprietors were advised of this, there were always people waiting to rent the 'apartments,' and always in great number" (SW 50). These cubicles were built solely to realize great dividends. The construction of such buildings did not stop despite the fact that this particular design, inexpensive to build, encouraged the propagation of contagious diseases like cholera and the plague. Fully aware of these health dangers, the colonial government, conniving with investors and speculators, did nothing to enforce stricter health codes. These speculators are not the white financiers of the upper district but are members of the "small group of financiers of Chinese origin who own all the working-class housing in the colony" (L 33). Thus, the Chinese lover, like his father who is the owner of the "native cubicle [compartiment indigène]" where the garçonnière is located, is directly implicated in the exploitation of Indochina and its people.[18]

In her last Indochinese novel, the colonial city is a much less ominous force, even though it still has incommensurable powers over the protagonist. Through the mediation of the "elsewhere," through her memory of the city, she is able to remember and call forth her relation with the Other. This transfigured city has become a "protective elsewhere," a screen onto which her desire or "memory" can be projected, a screen that, paradoxically, separates her from her lover, yet is the condition for its reemergence. As an inviolable protective matrix, it generates new meanings linked to her knowledge of an imaginative China ("une sorte de Chine lointaine"), a history of China related by her lover (ACN 88–90). This passage to another world, a liminal world where death, solitude, and desire have no bearing, forms the imaginative world of a childhood lost and regained. Its "pure immensité" cannot be filled with memories. In his

analysis of childhood and metaphors of place, de Certeau notes that "the childhood experience that determines spatial practices later develops its effects, proliferates, floods private and public spaces, undoes their readable surfaces, and creates within the planned city a 'metaphorical' or mobile city, like the one Kandinsky dreamed of" (*Practice* 110). Duras's literary démarche can be compared to the process mapped by de Certeau. Duras describes how, in *The Vice-Consul*, she came to her representation of the city of Calcutta: "to describe Calcutta, I used very precise signs: the palm tree, the pink laurel, leprosy. I did not describe Calcutta meticulously, I took certain signs or objects (four or five) and they revealed the city to me. I call this method, which I call mine, descriptions by color touches ('descriptions par touches de couleur')" (Knapp 655), a method she compares to "abstract painting." She uses the same technique to describe the city of Saigon in *L'Amant* and *L'Amant de la Chine du nord*. Since this abstract and imaginary cartography of the "mobile" colonial city is very much in evidence in these novels, one cannot look to Duras's Indochinese trilogy for a radical critique of the colonial situation. Like the protagonists of her novels, Duras negotiates the physical and symbolic geographies of Indochina in too ambivalent a fashion to support and sustain a coherent critical position. The staging of their memories of Indochina, however, succeeds in conveying the complex predicament of the postcolonial subject.

FILMIC MEMORIALS AND COLONIAL BLUES

Indochina in Contemporary French Cinema

Nostalgia for Indochina: those who have not experienced it cannot understand its bewitchment.

 (Hougron, "Preface" xiii).

In 1984, Salman Rushdie deplored the fact that the vogue for the British Raj had made a comeback in Great Britain. Among the numerous films, television shows, and novels that forlornly hark back to the British Empire, Rushdie is particularly critical of the revisionist enterprise of English filmmakers such as Richard Attenborough and David Lean, whose works he sees as an unfortunate attempt at "refurbish[ing] the Empire's tarnished image" (91). Rushdie examines the complex relation between history, politics, and fiction, focusing his attention more specifically on the discursive context that enabled this type of cultural production to emerge. He concludes that the critical success and commercial appeal of these colonial fictions can be ascribed, in part, to a nostalgia for a "defunct empire" and "the rise of conservative ideologies in modern Britain" (92), at a moment when the influence of Great Britain in the world stage has declined considerably.

Rushdie's penetrating observations find resonance in the French context; a similar trend can be perceived in France today, where "the French colonial empire" has aroused the interest of artists, scholars, and experts in all fields. Films and documentaries on the colonies have been produced, novels written, surveys conducted, and colloquia organized around this problematic issue.[1] Thirty years after the end of the Algerian War, or "Guerre sans nom" as Bertrand Tavernier and Patrick Rotman called it so provocatively,[2] the French are confronting the question of the colonies in an attempt to reevaluate l'idée coloniale and come to terms with their role as a colonial power.

Indochina has recently achieved prominence as the privileged subject of a great many French writers and filmmakers. The publishing and cinema industries have further contributed to the creation of an aura surrounding Indochina, commodifying it through the reissuing of novels and publication of new travel narratives on Indochina. The story of Pigneau de Béhaine, the French missionary responsible for the "opening" of Cochin China in the eighteenth century, even inspired Christophe Bataille's novella *Annam* which, significantly, won the Prix du Premier Roman.[3] Whereas creative and critical works that dealt with the French colonial subjugation of the Maghreb and Africa have fostered new lines of inquiry, it is my contention that our understanding of the imperial domination of Indochina by France continues to be reassessed nostalgically, in rather problematic terms. The privileged and most pervasively used metaphor for describing the conquest, colonization, and subsequent loss of the eastern part of the Indochinese peninsula remains to this day that of a passionate romance or a stormy love affair. One revealing example should suffice to convey the tenor of this problem: Bruno Masur, the most widely watched French television news anchor, described the historical ties that bind France and Indochina for almost a century thus: "France and Indochina . . . it's an old love story" (France 2, 9 février 1993). The bloody history of French colonial rule is entirely missing from this romantic fantasy.

French contemporary cinema resorts to similar analogies, translating and displaying what I will call the erotic and libidinal dimensions of the French "romance for Indochina" in readily recognizable cinematic figures. In fact, the elaborate mise-en-scène of Indochina in recent French films may be largely responsible for reconfiguring and accommodating many of the phantasms that have sustained the myths of the legitimacy of the French colonial presence in Indochina—founding myths of this "geographical romance" first elaborated by writers such as Claude Farrère, Myriam Harry, and André Malraux in the interwar period. One of the aims of this chapter is to show how the desire for Indochina is signified in French cinema. The modalities of a libidinal economy—the affective investment or romance for the country, its people, its landscape—appear to be the primary modes by which French directors represent Indochina and perpetuate received ideas about the country and its people. Three recent films, operating within that "romantic" nostalgic

framework, characterized by what I will call "colonial blues," partake in what Fredric Jameson calls "nostalgia film"[4] and merit our critical attention: Régis Wargnier's *Indochine* (1992) triumphed as best foreign film only a decade after Attenborough's *Gandhi* (1982) won the Oscar for best film; Jean-Jacques Annaud's film adaptation of Marguerite Duras's novel, *L'Amant* (1984), shot in English for wider commercial distribution and aptly called *The Lover* (1992); and Pierre Schoendoerffer's "docudrama" war movie, *Dien Bien Phu* (1992), a fictional reenactment of the battle that ended French colonial hegemony in Indochina. Incidentally, these three feature films, all shot on location in Vietnam at the same time, have been among the most expensive films ever produced in French cinematic history: *The Lover* reached $30 million, *Indochine* required the same amount, and *Dien Bien Phu* cost $25 million.

In his classic study *What Is Cinema?*, André Bazin described cinema as "the creation of an ideal world in the likeness of the real, with its own temporal destiny" (10). The French directors discussed below seem to have taken heed of Bazin's 1945 formulation. In their films, they have created "an ideal world in the likeness of the real," what I would call a phantasmatic world. This mimetic conception of cinema is problematicized by Teresa de Lauretis, who sees cinema as "an apparatus of social representation" (*Alice* 15) involved in "the production of signs" (4). To analyze these movies as "signifying practice" in a given sociohistorical situation, one must therefore consider both the material conditions that have allowed their productions and their implications "in the production and reproduction of meanings, values and ideology" (37). In other words, a politically consequent materialism in film demands that we examine the mediation that intervenes between "reality" and "representation," representation as a process of translation, as the central mode of production of strategies of containment, an issue of particular importance to postcolonial studies. Translation creates "coherent and transparent texts and subjects" and "participates—across a range of discourses—in the *fixing* of colonized cultures, making them static and unchanging rather than historically constructed" (Niranjana 3). This chapter also attempts to determine to what extent these filmic texts "fix" and mediate historical memory and participate in the construction and reconfiguration of a collective memory of Indochina.

Régis Wargnier's movie is engaged in recreating a coherent vision of

Indochina by relying on a melancholic (hi)story and "geographic romance." Naming his film *Indochine* signals, in a most lapidary fashion, Wargnier's faith in the evocative power of the name. The title puts in place and condenses in its more reductive and phantasmagorical form a certain "imaginary" of Indochina. The filmic strategies deployed by Wargnier in *Indochine* "construct images or visions of social reality," inscribe "the spectator's place in it" and "produce effects of meaning and perception, self-images and subject-positions for all those involved, makers and viewers" (de Lauretis, *Alice* 37–38). De Lauretis describes this predicament as "a semiotic process in which the subject is continually engaged, represented and inscribed in ideology" (37). Thus, particular attention must be paid to the film's vision/filmic construction of space and the address of the film as well as the ideology of vision, the way it constructs narrative space, and the implication of space and spectator in the narrative.

The film's opening sequence foregrounds many of the issues to which we have just alluded. The opening shot strikes the viewer in its blank whiteness. The first image of what appear to be white clouds has the ephemeral and insubstantial quality of a dream. The sound track features a chanting chorus of unaccompanied voices. The spectator seems to have been transported into a phantasmic world. The effect is broken when numerous boats filled with Asian officiants dressed in white, mauve, and black emerge from the mist, partially resolving the unintelligibility of the shot. At the same time, the credits begin to roll. The first credit, in white letters, records the movie star, Catherine Deneuve. The sounds and sight of a lone drummer seem to guide this exotic procession of boats. The mystery of this sequence is not fully penetrated until the two cenotaphs which have been laid side by side come into view. The viewer's suspicion that the "exotic" and enigmatic ritual appertains to a funeral are confirmed by the medium close-up of Deneuve, veiled and dressed in black. The voice-over—in the actress's voice—begins the narration and informs us that we are the witnesses to the funeral of Prince N'Guyen and his wife, lost at sea in a plane accident off Saint-Jacques Cape. Eliane, the narrator, goes on to furnish details about the identity and legal status of the little orphan girl, Camille, all dressed in white standing beside her. Eliane has lost her best friends but gained a daughter when she adopted Camille, the little princess from Annam.

The opening sequence of expository scenes situates the characters in space and time. The viewer quickly realizes that the preceding shots were seen from Eliane's vantage point and organized from her point of view as well. As both protagonist and narrator, she exerts complete control over the filmic narration, its development, its resolution. In fact, *Indochine* adopts and emulates every cinematic convention of classical Hollywood cinema, including plot linearity, the reliance upon an axis of action and upon the love story, the use of the protagonist as the principal causal agent and chief object of audience identification (Bordwell 18), and so on, to produce and anchor its images of Indochina.

Mary Ann Doane remarked that "rather than activating history as mise-en-scène, a space, the . . . love story inscribes it as individual subjectivity closed in on itself. History is an accumulation of memories of the loved one" (*Desire* 96). In *Indochine*, French colonial history becomes visible as Eliane's memories of events in her colonial past and of individuals she has loved. These "memories" are recorded as a unified or preconstituted visual space. One mediation specific to cinema is spectator positioning. *Indochine* exploits the identificatory mechanism of cinema on behalf of the colonizer: the spectator is sutured into a colonialist perspective. Through a cinematic mechanism of identification such as "suture," Eliane becomes the embodiment of the French colony in symbol and image, the "colonial Marianne"; simply put, she personifies Indochina.[5]

Eliane's relation to the "geographical" narrative is made unambiguous when the narrator/protagonist describes herself as "une Asiate." Here the term "Asiate" does not have its common pejorative signification such as the one popularized by Jean Hougron, the novelist who wrote an entire novel on the subject (*Les Asiates* [1954]). It does not mean "to give in to the milieu, to become 'Asiate,' in sum, to lose one's identity" (xii); here, it describes more simply a French woman born in Indochina who has never left it. The term also suggests, however, that the Français d'Asie (the French from Asia) also considered themselves to be the legitimate heirs of the great and powerful civilizations that once dominated the Indochinese peninsula.

A *découpage* (segmenting) of the film into analytic scenes would reveal that all of the scenes where Eliane appears are merely clichéd images,

postcardlike cinematic portrayals of colonial life in Indochina. She administers the land and the people, gathers with friends on the terrace of the Continental Hotel, entertains at her colonial estate, smokes opium in an opium den. All of these scenes of colonial everyday life are designed to reinforce her love and attachment to her native land and implicitly legitimate her presence there.

It can be argued that, rather than "activating history as a mise-en-scène, a space," as Doane noted, these images construct a feminized space which allows the erotic overinvestment of the white female "colonizer." As the substitute mother, the viewer identifies Eliane as the embodiment of "Indochina in the 30s, a colonial paradise" the "belle époque of French Indochina" (Noury 8). As I suggested earlier, the opening scene constructs Eliane as a caring mother who protects the natives. The irony of the term "protectorate," which designates a juridical regime that grants control over a subjugated country for a colonial power, can hardly be lost on the film's audience.

In contrast, the native protagonist Camille is divested of her "femininity" as the film unfolds. In this manner, she can be represented as the masculine "princess rouge" who, after killing a navy officer, escapes in the company of another naval officer (of course, Eliane's ex-lover). She bears his child, is tracked down, captured, and condemned to spend the rest of her life in the Poulo-Condore penal colony. Amnestied by the representative of the newly elected Front Populaire government, Camille chooses to commit herself exclusively to the national liberation struggle, effectively abandoning her child to Eliane's care. By the end, she has become literally invisible to the viewer, completely elided from the filmic text. In the last sequence of the film her son, while expressing a desire to see his "birth mother," who is part of the Vietnamese delegation at the 1954 Geneva Peace Conference, simply gives up on the idea of seeking her out and mutters that Eliane is his "mother." Camille is denied not simply the status of mother but more problematically the status of subject on the screen, erasing at the same time "ethnic" female sexuality.

One of the projects of colonialism, as Gayatri Spivak reminds us, is to constitute the colonial subject as Other. By exploiting the figure of the "monstrous" native mother, Wargnier deflects our attention from the colonialist projects of appropriating and exploiting the land and of

dominating its people economically, culturally, and politically. In Wargnier's film, French colonialism in Indochina as an oppressive economic, social, and political apparatus is merely used as a backdrop, diffused and "screened" into the background to bring the "mother-daughter plot" and the parallel love stories to the fore. And although the filmic text evokes certain aspects of French colonialism, in particular, the carceral universe of enslaved peasants and the repression, torture, and killings of suspected nationalists performed by the French Sûreté, these "events" are staged to underscore the fact that l'Indochine française, or "Indochina before the hurricane [L'Indochine avant l'ouragan]" as one writer put it,[6] needs to be saved and protected from a barbaric (native) society whose population can only act out irrationally and violently. The raging anger of a nationalist/Communist mob and its ensuing reign of terror are dramatized in a scene where the nationalists torture a local mandarin whose ostensible support of French colonialism led to his summary execution: death by fire on a makeshift pyre erected from his worldly possessions. Similar tragedies may have indeed occurred in the history of the Vietnamese fight for independence from France. The inclusion of a well-known French historian as a consultant to the film ought to deter anyone from contesting the film's historical accuracy. What is disturbing, however, is the manner in which "historical events" are used and framed simply to advance the plot and to play up and render more harrowing the predicament of our "heroines," rather than to question French colonialist practices. The most revealing example that comes immediately to mind concerns the way the Sûreté chief confronts Thanh, Camille's intended husband, who has been expelled from France for supporting the Yen-Bay rebellion. Furthermore, he participates in the Vietnamese student demonstration against French colonialism in front of the Elysée Palace, an episode discussed earlier that received much attention in daily papers in France and Indochina in the 1930s.

A more comprehensive analysis of the movie would attend to its blindness and omission, particularly in its use of female protagonists. Feminist film theory can be invoked to show that the "representation of woman as image (spectacle, object to be looked at, vision of beauty)" (de Lauretis, *Technologies* 37), women as the privileged site of desire (Mulvey), the locus of filmic position of woman as "narrative image" (de Lauretis), as

a construct for ethnic female spectator (Chow) determine the centrality of female subjectivity in the construction of cinematic representation.[7] These theories can help us better assess cinematic signification and representation and the ideological subtext of the movie. *Indochine* offers a particularly striking example of how a different (Other) culture can be "produced" as a feminized spectacle. This idea is confirmed by the film's reception in the French press. Jacques Siclier, the film critic for the French daily *Le Monde*, symptomatically entitled his review "Indochine, ton nom est femme" (Indochina, your name is woman). He goes on to explain the reasons that made *Indochine* strike a responsive chord in so many spectators: "It's splendid because the novelistic clichés are acknowledged and evident, and transcended by the lyricism of a mise-en-scène which links closely the lighting, the decor, the costumes, the sound and the music." For Siclier, romantic excess is a deliberate strategy, a cinematic convention designed to frame and narrate a love story. But as others have remarked, Siclier is also a "film critic who dislikes being anything but positive" (Forbes 408) and who therefore does not have any misgivings about Hollywood cinema. The director of *Indochine* can therefore feminize the Other culture with impunity by relying on a cinematic representational practice that privileges visual pleasure. The spectator is "penetrated" by the image of the Other. The blue-green hue cast by the Bay of Halong, the blue-gray of the bleeding of the rubber trees, and the smokey blue squalor of an opium den arouse strong visual responses because these "postcard" images of colonial life in French Indochina are always already part of the French collective memory and have been assimilated by the public at large. Hence, Eliane remains the paradigmatic figure of the *bâtisseur d'empire* (empire builder), the female epitome of French colonialism who is clothed in elegant costumes, designed especially for Catherine Deneuve by the Oscar-winning Italian designer Gabriella Pescucci.[8]

The movie's opulence and lavishness overwhelm its manifest content, displacing its ostensible subject (Indochina) onto the woman at its center, Catherine Deneuve. *Indochine* is not about French colonialism in Indochina at all, but about Wargnier's fantasies of colonial Indochina. Critical and popular acclaim notwithstanding, Wargnier's representation of Indochina exerts a dangerous fascination precisely because it brings visual pleasure without questioning or subverting any preconceived ideas about

French colonial rule in Southeast Asia. *Indochine* merely displays beautiful images and should only be remembered as a symptom of the current French fad for things exotic.

Restaging Indochina: Annaud's Phantasmic Love Affair with Indochina

Jean-Jacques Annaud's filmic vision of Indochina is entirely mediated by Duras's novel, *L'Amant*. Annaud is unabashedly candid about the effects Duras's novel had on him and his attempt to locate it in space and translate it into the filmic image:

I was on a quest for the emotions I had felt when reading *The Lover.* Marguerite Duras had plunged me into Asia. The pages smelled of jasmine, charcoal fire, and incense. With her I crossed the breathtaking immensity of the Mekong, I wandered the flatness of the delta's rice paddies that run as far as the eyes can see. I followed the rosewood-hatted young girl that she had been along the wide, tree-shaded avenues of the colonial city. I ambled beside the gardens overflowing with flowers, caught glimpses of the villas with their verandas in the white part of town. I accompanied her up to the haughty French High School building. Then I lost her in the red-and-gold exuberance of the Chinese part of town. And at dusk, in the silent solitude of the dorm, with her I heard, carried over on the wind from the [lagoon], the faraway singing of a beggar-woman. . . . ("Impressions" 174)

Like many readers, Annaud is seduced by Duras's lyrical evocation of Indochina. Duras's imaginative geography, however, has assumed the status of the "real" for Annaud. Distinct urban and rural markers circumscribe his mediated Indochina: the Mekong River, the rice paddies, the colonial city with its white villas and gardens, the lycée, the boarding house, and Cholon. Rumor has it that Duras herself wandered these wide streets on her way to the Lycée Chasseloup-Laubat or to the Pension Lyautey when she was not meeting her Chinese lover in Cholon.

To remain faithful to the spirit of her work and make his film more "real," Annaud believes he has no alternative but to shoot it on location.[9] He scouts Vietnam in the hope of finding appropriate sites, that is to say,

those evoked or resembling the ones described by Duras in her novel. But the "spectacle" unfolding before him only disillusions him:

> But, lo, the airplane's door opened not on the mythical Indochina of the '30s but, rather, on the tragic reality of contemporary Vietnam, with its Third World pauperization and overpopulation made worse by 30 years of war followed by 30 years of Stalinism.
>
> Duras' flowered streets are cemented over by the Bulgarians. The fancy white villas are replaced with gray prefab council housing. The broken streets are swamped by the compact swarm of backfiring scooters. The Soviet trucks honk themselves a difficult path, leaving a thick billow of black smoke behind. As the billboard reads when you enter Da Nang, beneath the screeching of MIGs taking off for the Chinese border: WELCOME, TOURIST FRIENDS!
>
> The countryside will be different, I think to myself. Untouched, still "Asian." No. It, too, is Socialist. Looking for green, we find gray. The rice paddies hide behind the walls of the endless shantytown that stretches along the motorway. The Mekong, laden with motorboats with corrugated-iron roofs, looks more like a freeway outside Mexico City than the legendary river flowing all the way down from China. ("Impressions" 176)

Contemporary Vietnam no longer resembles "the mythical Indochina of the '30s" portrayed in Duras's novel. The quaint French colonial city has been transformed into an overpopulated third world Socialist city with its unattractive billboards, shantytown, and "prefab council houses." Erstwhile elegant boulevards have disappeared under the concrete poured by Bulgarians. The congested city is now filled with undesirable natives (or signs of their presence—the scooters, trucks, and MIGs left by the Soviets, the last among many unsuccessful waves of would-be conquerors). Even the countryside appears to have been contaminated by Socialist "filth." Annaud refuses to see in these new "signs" the contemporary "reality" of Vietnam. An abyss seems to separate Ho Chi Minh City from Annaud's idealized vision of an alluring French colonial city. For him, Ho Chi Minh City makes manifest the ill effects of unplanned urban development and the deleterious impact of Socialist progress and modernity on numerous third world countries that have not successfully negotiated their passage to a postindustrial economy. Disappointed, he leaves the country for Thailand, Malaysia, and the Philippines, more appropri-

ate parts of Asia "where it [Vietnam] is normally filmed." And yet something he cannot describe or articulate compels him to return:

So we [Annaud and his production manager] . . . went back to Vietnam. Strangely enough, that country we had rejected cast a delayed spell. Our memories sifted away the dirt, the pollution, the everyday troubles. What remained was what my lens had spontaneously isolated, separated from its background during my first scouting: the "Flemish" beauty of the endless plains, the bustling of life on the canals and on the river, the continuous presence of water. Captured also: the smiling seriousness of this ascetic population, so integrated, blended into the background, eternal. Its extraordinary dignity in the face of misery. And then, the unique relics of French presence, with its caricature Napoleonic order of avenues and monuments, the quaint charm of the Parisian "Belle Epoque" architecture, that feeling of resort towns, or an end-of-the-century "Riviera," moved to the equator. Jewels in the midst of ruins. The "good" side of poverty: The administrations were not able to move to new locations, so they remained in the most beautiful buildings from the colonial days. The façades have been kept up. That is where they hang banners "to the glory of the Socialist successes."

Thus, triumphant Ho Chi Minh City, the tropical clone of Moscow's suburbia, has saved decadent Saigon, the 19th-century French town. Despite it, because of it, all of Vietnam, too, is a museum. Set in the new Asia of skyscrapers and material success. A tired museum, weary and unique.

We shot the whole film in Vietnam. ("Impressions" 176)

Annaud believes that he can now recover the mythic Indochina of his dreams and phantasms through the act of remembering and by abstracting vision: "Our memories sifted away the dirt, the pollution, the everyday troubles. What remained was what my lens had spontaneously isolated, separated from its background. . . ." Paul Virilio compares "the field of vision" "to the ground of an archeological excavation" (quoted in Crary 1). This analogy describes perfectly the process by which Annaud comes to terms with contemporary Vietnam. The camera lens has become a more probing extension of his eye, capable of zeroing in, isolating, separating the essential from the inconsequential, the Socialist filth covering the surviving French monuments, "Jewels in the midst of ruins."

Nonetheless, Annaud's newly envisioned Indochina resembles only in a remote fashion the one Duras described in her novel. Transfigured are

the *compartiments indigènes* (native compartments) that appeared in Duras's urban landscape, the gray prefab council housing that made land specu-lators like the Chinese lover's father very rich. Willed away also are the smiling (if "dignified") natives, "so integrated, blended into the back-ground, eternal." Indochina, for Annaud, is not inhabited by the indige-nous people of Southeast Asia. This so-called ascetic population is sim-ply viewed in cinematic terms for their potential use as decor, extras, or props. The motion picture technique of the fade-out as an allegory of Annaud's directorial mise-en-scène of his Indochina suggests how con-temporary Vietnam can be made to disappear and be rendered invisible, when it is not completely assimilated into the background.

Contemporary Vietnam strikes a discordant note among its rich de-veloped neighbors that constitute "the new Asia of skyscrapers and mate-rial success" Annaud seems to scorn. Annaud privileges the "Vietnam in ruin" precisely because it preserved, paradoxically, the infrastructures of the French presence in Southeast Asia, what he vulgarly calls "the 'good' side of poverty." Thus, no mention is made of the material and political conditions that brought destitution and hardship on Vietnam, and of the economic embargo imposed by Western countries after Vietnam won the war against the United States and only recently lifted. Annaud can therefore regard Vietnam nostalgically as a vast museum where the cine-matographer as archeologist/curator can excavate in order to recover surviving French artifacts. The silence on the economic and political determinants and the flippant declaration that Vietnam is a museum illustrate perfectly what Niranjana described as "the fixing of colonized culture," of "making them static and unchanging rather than historically constructed" (3).

Oblivious to these questions, Annaud sets out to find French admin-istration buildings still standing or, as he called them himself, "the unique relics of French presence." He does so not simply to resurrect "the 19th-century French town," but to set the stage for his story. By refashioning the old colonial city onto the surviving façade of French monuments, Annaud demonstrates the efficacy and power of cinematic capital to recover French colonial Saigon from the Socialist ruins of Ho Chi Minh City, using contemporary Vietnam simply as yet another if more elabo-rate prop: "The film crew invades Vietnam, earns the authorities' trust and

the freedom dependent on such trust; it restores buildings, rebuilds roads and motors, and replants trees; it also designs and makes on location 2000 costumes, the decors, the bicycles, the boats used in the film; the Chinese man's limousine—the only traceable 1929 Morris Léon Bollé—is located in Seattle and sent to Vietnam; it tracks down the old period-liner in every port and locates it in Cyprus; it repaints entire areas of Saigon in the fresh colors of the French colony" ("L'Amant" 62). Beyond the immediate benefit of injecting much needed capital into an assailed economy, the exorbitant cost and the all-pervasive nature of the production leave its mark and filmic trace on a "Vietnam in ruin."[10]

The reasons Annaud wanted to adapt Duras's novel on the screen deserve attention for this analysis. First, the filmmaker found *L'Amant* to be inspiring, "a very beautiful novel, a good subject for a film." Second, he claims to have been seduced by Duras's portrayal of feminine sensuality, an aspect of sexuality he had never filmed in his previous, immensely successful commercial films. Moreover, as we see in his following comments, the French colonial past grips him with nostalgic fascination: "I carried around a type of guilt for having dealt in cinema with only half of the world: the male part, and I was particularly attracted by the evocation of feminine sensuality." He acknowledges one final motive: "There is in this novel another element which fascinates me: the French colonial empire. I have kept a nostalgia of this era of French presence and grandeur, even though I had not experienced it personally; it is the era of independence. I lived in Cameroun in 1967, and spent seven years crisscrossing and learning about Africa, to shoot my first movie, *Black and White in Color*: this experience, these climates, these cultures, this rapport with the other had prepared me for the exotic, colonial and interracial dimensions of "The Lover" (*L'Amant* 62). Annaud is both "fascinated by French colonial empire" and nostalgic for the "[grande] époque de présence et de grandeur françaises." *L'Amant* seems to be an appropriate choice for his film adaptation since Duras's novel takes place in Indochina during the golden age of French colonialism. It is worth noting that in his first feature film, *La Victoire en chantant* (1977) released in the United States as *Black and White in Color*, Annaud evokes a biting satire of French and German colonialism in Africa. This film, for which he won the Academy Award for best foreign film, was shot for a mere half-million dollars. More

importantly, linking his latest production to the first one serves the pur-
pose of situating his most recent movie in an ideologically uncontested
terrain, while providing at the same time the genealogy for his interest
and understanding of the "exotic, colonial and interracial dimensions of
L'Amant."

In *La Victoire en chantant*, Annaud succeeds in questioning the absurdity
of the colonial powers' presence in Africa and in debunking colonial
myths of the white man's burden, a belief enforced zealously by benevo-
lent civil servants, evangelical missionaries, and military troops who did
not hesitate to resort to physical and spiritual violence, torture, and
more to subjugate the African people in order to promote and enforce
the civilizing mission. *The Lover*, unfortunately, does not raise the same
type of questions. The Indochinese colony is merely reconstructed as an
elaborate stage where a love affair can be filmed. Not that an interracial
love affair cannot be an adequate vehicle for raising serious questions.
Alain Resnais's *Hiroshima mon amour* (1959), with a screenplay written
by Marguerite Duras, remains to this day one of the most thought-
provoking examples of an interracial love story. In Annaud's film, what
remains central to his movie is the illicit love affair between the young
French girl of fifteen and the Chinese man.[11]

It has been reported that "the film's huge commercial appeal is mainly
due to its five sequences—a total of 20 minutes—of frank if tasteful
erotica" (Robinson 3). Annaud wants to repoliticize his movie by placing
emphasis on the importance of the "interracial love affair." The race of
the Chinese lover does play an important role in the doomed love affair.
"Her family willingly compromise moral and racist objections for the
sake of financial benefit the liaison brings" (3), writes Robinson. Because
of the liaison, the young girl is also ostracized by her classmates, de-
nounced and vilified by the entire white colonial society (except the
teaching corps) for having transgressed sexual and racial taboos. But in
the end, the issue of class difference seems to play an equally important
role.

Annaud acknowledges that his greatest challenge as a film director
was the five love scenes of the movie: "to show physical love in its natural
beauty," "the beauty of carnal passion," declared the director. He went to
great lengths to show difference in mood, selecting various lighting to

convey passion, gloom, romance, and violence, even resorting to the use of what he calls "scientific cinema," that is to say, "macro-photography and 'endoscopy' in order to place the camera between the body of the lovers." He acknowledges: "I was in the bodies, in their most secret parts, but it does not show [j'étais dans les corps, dans les partis les plus secrètes, mais ça ne se voit pas]" (Heymann and Froden 31). These scenes were not shot on location but in a Paris studio.[12]

What then is gained (or lost) in filming *The Lover* on location? The answer may lie in French cinematic history. The argument for shooting on location is indeed an old one. In 1921, Jacques Feyder adapted Pierre Benoit's *L'Atlantide* to the screen, shooting all of the desert scenes in the Sahara desert rather than in studio sandboxes. The distance from the studio, the difficulty in transporting and protecting all of the technical equipment from the heat and the sand did not deter Feyder from shooting his story of empire building on the putative site of the action. In fact, his film benefited at the box office from having been filmed in the desert, making it appear "more real" to viewers in search of exotic sensations. *The Lover* has enjoyed the same advance publicity: the public's knowledge that it had been filmed in Indochina made it the more seductive and appealing.

Annaud insists that one of the reasons for his adaptation of Duras's novel is the "fact that this story took place in a French colony. Put differently, it was not simply a love-story: there was also the encounter [le contact] between two races, two cultures" (*L'Amant* 12). Adapting *L'Amant* to the screen can be regarded as a phantasmic mise-en-scène of Annaud's love affair with Indochina.

Dien Bien Phu: Pierre Schoendoerffer's Filmic Memorial to Indochina

"Docudrama," "film-vérité" (Macia), and even "fresque historique [historical fresco]" (Siclier) have been used to describe Schoendoerffer's *Dien Bien Phu*.[13] Did the subject of the film, the decisive battle that ended the Franco-Indochinese War and effectively put an end to French colonial domination in Southeast Asia, make these critics attach such "labels" to

this film? Were they caught up with the filmic images of war and over-whelmed emotionally by the sight of French and Vietnamese extras drawn from the battalion of legionnaires and Vietnamese troops who actually fought the battle in 1954, the use of vintage period tanks, artil-lery pieces, and planes as props, the shooting on location on a site that resembled the historical battlefield? So caught up that they forgot these elements merely constituted the "reality effect" of the movie and may not deserve the name of "document," "truth," or "history," unless of course one speaks of "filmic truth" or problematizes what each of these terms means?

Schoendoerffer himself seems reluctant to place his movie in a precise film category. Although he admits to having filmed "a fiction," when asked if his movie is "a historical evocation," he answers: "Yes. And no! It is a fresco, a saga" (127). His ultimate aim is to render "the essence of Dien Bien Phu" and to reveal a forgotten (and shameful) chapter of French colonial history to the viewers. In an illuminating essay entitled "From the Battle to the Movie," Schoendoerffer elaborates on what he has tried to achieve in his film: "My movie, *Dien Bien Phu*, wants to be like [se veut semblable à] a symphony" (118), "a visual and auditory sym-phony" (128). The musical simile is indeed an appropriate, if clichéd, analogy. It should come as no surprise that the sound track was recorded first, even before actual filming began: "Georges Delerue composed a concerto, the 'Concerto de l'adieu,' magnificent, premonitory of what was to be the soul of the film. A concerto is a dialogue between an instrument and an orchestra. In the movie, the instrument, a first violin, a woman, is the voice of France; the orchestra of Hanoi is Vietnam. Dele-rue's music, noble, rigorous, charged with restrained emotion, partici-pates in a larger concerto; it dialogues with the terrible percussion music composed of the sounds and furors of war" (128). Unfortunately, like the music, Schoendoerffer only succeeds in evoking a sentimental war story by drawing a parallel between the "disappearing colonial world of Indo-china" (Macia 3) and the bloody battle. Thus, at the very moment the battle of Dien Bien Phu begins, Schoendoerffer follows the wanderings of Howard Simpson, an American journalist stationed in Hanoi in search of a scoop, a character reminiscent of the scheming and manipulative Fowler in Graham Greene's *The Quiet American* (1955). Simpson will at-

tend the last "soirée of the empire" at the Hanoi opera house, as will the French governor-general and the entire French colony. Although this last concert is also meant to signify the end of an era, it fails completely to establish a semblance of a dialogue between France and Vietnam as Schoendoerffer would have it. This is due, in part, to the director's own totalizing ambition. Schoendoerffer wrote the screenplay, the dialogue, and the commentary. He also narrates the voice-over. The spectator is merely subjected to the "vision" of a female violin soloist and the maudlin sound of a "musical interlude" before the onslaught.

This singular sight contrasts markedly with scenes that depict the horrors of war. Images of life in the fortified camp are interrupted by the pounding of mortar shells which kill and maim indiscriminately. Unlike the air cavalry sequence in Francis Ford Coppola's *Apocalypse Now*, where helicopters attack against invisible enemy targets, accompanied by the music of Wagner, these scenes fail to convey the absurdity of war. They merely present and reinforce the image of the heroic soldier who fought courageously against an enemy superior in number—the Vietminh outnumbered the French four to one—and in "fire power." One of the movie's last sequences, picturing antlike Vietminh soldiers overrunning the French entrenched camp, the doomed fortified camp deep in enemy territory, is symptomatic of this impulse.

To be fair, Schoendoerffer does portray the anxieties and fears of the soldiers. He also cuts to scenes that focus on the actions of the cowards, or the "rats" as they are called, who come out only during the night to look for food that has been parachuted in. But ultimately, his movie pays tribute, in the "memorializing mode" of the official public commemoration, to the heretofore unsung heroes of the Indochinese War: the anonymous and forgotten French soldiers who, with their comrades from North and Central Africa and the Tonkin, fought and died for France. *Dien Bien Phu* is a movie that honors the men who never question authority, soldiers who "hate to be wasted." The only indictment is aimed at the incompetence of the military high command and its shortsighted war strategies.[14]

The monologic perspective of Schoendoerffer's filmic vision can be better circumscribed if we compare it to the way Patrick Jeudy, a French independent director/producer, constructs his own documentary film on

Dien Bien Phu. Although feature films and documentaries belong to two distinct genres with their own protocols and their own distinct conventions and styles, the differences are not as great as one might expect. Schoendoerffer's attempt to erase the fiction/documentary divide enables this type of linkage. There are definite points of convergence between the documentary and the feature film which transcend the subject they treat (their thematic content) or their status as part of an apparatus of representation, of a signifying practice. They both elaborate a certain vision of Indochina through filmic narration and construct an identity by inscribing desire on a space marked by different narrative strategies, by engaging "the spectator in the process of that reproduction as articulation of coherence" (Heath 404).

Entitled *Récits d'Indochine: Chronique des journées de la bataille de Dien Bien Phu*, Jeudy's film complements the fiction of *Dien Bien Phu*. Jeudy's ambitions are much more modest. He does not want his film to be either a "history film" or "a commentary on the war" but simply "a high-angle shot into the emotions [une plongée à l'émotion] of the days and nights of combat." Borrowing techniques of mass media, reportage, hand-held cameras, frequent zooms to express a variety of points of view—strategies that would find their narrative equivalent in Michael Herr's *Dispatches* (1968)—the director weaves together a narrative using information gleaned from a number of archival sources. These include the writings of war correspondents, sequences drawn from amateur films, excerpts from letters written by soldiers and members of their families, American and French newsreels, and testimonies of soldiers, doctors, nurses, and journalists. This documentary chronicles the suffering, anguish, and hope of the legionnaires and depicts different types of war scenes—images of the burial of the dead during combat, of the vertiginous fall of the (parachuting) paratroopers—and jumps to the celebration of Christmas Eve and Easter mass at the scene of battle. The director quite successfully conveys and highlights the bitterness and suffering of the soldiers in the war zone and their coming to the knowledge of their imminent defeat, with its impending humiliation and suffering. War footage is placed in radical juxtaposition with scenes shot in France during the New Year's Eve celebration, presenting the fear of family members and the French press's reaction to the cease-fire negotiations (Boillon 3).[15] This montage, this mix of dif-

ferent media, works not because it presents a coherent view of the battle but precisely because of its refusal to reconstitute a homogeneous space, to accept a monologic perspective, to position the spectator as the unified and unifying subject of its filmic vision. These images produce contradictions in both subjective and social processes.

Schoendoerffer's *Dien Bien Phu*, on the other hand, fails to engage viewers, move or convince them because of its filmic unself-consciousness, its inability to question its structuring vision, its will to contain the heterogeneous and bind the subject. It simply memorializes without addressing larger political issues. It never questions, for instance, the logic behind the presence of the French in Southeast Asia. What were the French fighting for? Why did the French underestimate the strength and determination of the Vietnamese (traces of their arrogance)? Was war the only remaining alternative to resolve political disputes? What does "Indochine française" mean in the fifties? These questions were not asked because they would have undermined the whole project of "memorialization" in Indochina, a mode that also pervades Régis Wargnier's *Indochine* and, to a lesser extent, Jean-Jacques Annaud's *The Lover.*

The critical reception of Schoendoerffer's film has been lukewarm when it should have been criticized severely. It is as if French movie critics believed that panning the film amounted to being disrespectful to the memory of the war dead and, more importantly, to the vision of an eyewitness account that survived the battle, the death march, and the imprisonment. *Dien Bien Phu* continues today to be understood emotionally rather than assessed critically for its filmic quality. And yet, it has found attentive support from an unlikely source: the French government. Schoendoerffer's film could not have been produced without the active intervention and patronage of the French government. The French Ministries of Foreign Affairs and Defense, using their diplomatic prerogatives, convinced the Socialist Republic of Vietnam to allow *Dien Bien Phu* to be shot on location. In addition to its political and diplomatic assistance, *Dien Bien Phu* also enjoyed the sanction of the Ministry of Culture. Although the French film industry always had the support of Jack Lang, the case of *Dien Bien Phu* is perhaps unprecedented in the scope and manner of the government's patronage.[16]

Why did the French government take such a strong interest in Schoen-

doerffer's film project at this particular historical juncture? What motivated it to take such an active role? What was at stake? I will begin to answer these questions in a somewhat oblique fashion. I would argue that the French government's "investment" in Schoendoerffer's project transcends the realm of financial consideration, the economics of film production, and extends itself into the realm of affect, a hypothesis confirmed and made evident in Vietnam.

On the second day of his official visit to Vietnam (February 10–12, 1993), the first one by a Western head of state, François Mitterrand visited the battlefield of Dien Bien Phu, a visit described as a "recueillement [meditation/homage]." Mitterrand's pilgrimage to the site of "one of the worst defeats inflicted on the French army" was a means to "exorcise a painful past" (France 2, 10 février 1993). Mitterrand was accompanied not only by General Maurice Schmidt, the former chief of staff of the French Army, who as a young enlisted man fought at Dien Bien Phu. Schoendoerffer also made the visit, giving his own personal account of the battle, which he survived and chronicled as a cinematographer and photographer for the French armed forces. The significance of Schoendoerffer's presence, next to Mitterrand, should not be lost to the public. It confers a certain (political) prestige upon Schoendoerffer's movie. Furthermore, the invitation to join the presidential party at the site of the battle bestows an official stamp of authenticity on the movie, sanctioning its legitimacy. *Dien Bien Phu*, then, appears to be a fitting tribute, a filmic memorial to a traumatic historical past.

The political "context" of the filmic text is provided to draw attention to questions that bear directly on the production, distribution, and reception of the movie because films are indeed "cultural events." My contention is that the notions of memory, commemoration, and memorial constitute the modalities by which *Dien Bien Phu* (and to a lesser extent, *Indochine* and *The Lover*) operates; they "memorialize" or address the spectator by constructing a memorial. They form as well the bases on which France's desires to pay homage to the memory of the war dead are inscribed and projected, what we could call the process (both conscious and unconscious) through which Indochina is reconstructed as an important chapter in the French historical past, its collective memory, and its "imaginaire national-républicain."

The commemorative "text" takes a full range of different forms: the decorative façade, the war memorial, the funeral inscription, the historical fresco, and, as I have argued, the filmic text. The only requirement is that it leaves a historiographic, monumental, ceremonial, or visual trace. Chagrined by the absence of any "commemorative" marker in Dien Bien Phu, Mitterrand expressed the hope that "a monument, to the memory of the French dead," would be raised there in the near future.

This wish has been realized in an unlikely site, in the city of Fréjus. A memorial had been planned by its mayor, François Léotard, the honorary president of the Parti Républicain and the defense minister in Edouard Balladur's government. Jacques Chirac, the president of the R.P.R. (Rassemblement pour la Républic, and, today, president of France) set the first stone of the memorial in 1988. And upon his return from Vietnam, François Mitterrand, the Socialist president, inaugurated the Mémorial des Guerres en Indochine on February 16, 1993. We see that the political use of "national" memories, what Eric Hobsbawm and Terence Ranger call the "invention of tradition"—a "process of formalization and ritualization, characterized by reference to the past, if only by imposing repetition" (4)—transcends party affiliations. Léotard was proud of this "continuity" and couched it in these terms: "The dead fell, almost forty years ago, under the colors of the flag of the Republic, and it was appropriate that we gather together, from the [political parties of the] right and the left, beyond our philosophical differences, beyond religion, beyond our convictions, to celebrate their sacrifice. And that is today's message. And it is also that of the Republic" ("Journal" n.p.). Here, historical memory is manipulated rhetorically. The summation of the Republic and its idealized precepts—the notion of sacrifice—and the conscious manipulation of its symbol—the flag—serve to contain history and justify the homogenizing and violent impulse deployed in the edification of a national memory of Indochina, which relies on an authoritarian, unitary, universalist, and intensely *passéiste* (backward-looking) construct.[17] This *"rassemblement"* (gathering) included not only French political figures from different parties, but also the veterans ("anciens"), the legionnaires and paratroopers, as well as indigenous troops, Vietnamese and North African soldiers who fought for France alongside the French. The presence and incorporation of "native troops" at the ribbon-cutting ceremony, which

fulfilled the official desire to be inclusive, served the egalitarian or democratic intent of representation, and lent, at the same time, a semblance of authenticity and truth. Everyone, regardless of spiritual, ideological, religious, or racial differences, paid homage to the men who fell "under the colors of the flag of the Republic." What we have before us is nothing less than the construction of new political allegories.

This "official ceremony," for some people, makes up for the nation's political amnesia. But it must also be underscored that it took the French (not unlike the Americans) almost forty years to pay tribute to those who died for France's continued colonial domination in Southeast Asia. The Mémorial des Guerres en Indochine would now stand as a monument for the war dead, dedicated, as its name suggests, to the wars in Indochina. The attempt to establish a continuity with a suitable historical past is reinforced by the words inscribed on the commemorative marble: "Here lie the bodies of 3152 soldiers who died for France in Indochina 1939–1954 [Ici reposent les corps de 3152 militaires morts pour la France en Indochine 1939–1954]." These dates are indeed important because they rewrite France's colonial history as a benign chapter of a larger world conflict: World War II, then, becomes its new historical point of reference. The soldiers who are being honored include those who fought the "invading Japanese" as well as those who perished in that infamous battle.

These official displays and public commemorations, carefully staged to include ("rassembler") the forgotten Other—Vietnamese and North African members of the troupe coloniale who fought alongside the French and awaited official recognition of their actions[18]—do not end the political amnesia and silence surrounding the "Indochinese question." Rather, they displace or erase a not-so-heroic vision of France's historical involvement in Southeast Asia from the collective memory. The Fréjus memorial, while honoring the men who sacrificed their lives for France in Indochina, refuses to name Dien Bien Phu, submerging the memory of the military defeat in the plural "Indochinese wars [guerres en Indochine]." Moreover, by presenting themselves at their most "heroic" and "commemorative," the French are determined to create a new official "memorial landscape [paysage mémoriel]." Who, or what, then, is really being mourned here? Admittedly the war dead, but there are also other "subjects" of loss that remain unacknowledged: the loss of an era, of a

colonial empire, of a utopian world; the loss of France's influence and prestige.

Current French cinematic production on Indochina is part of a complex "cultural memorial," a means for the French to "work through" and mourn the loss of Indochina, the jewel in the former French colonial empire. Because the relation between Indochina and France has always been and still is compared to a love affair, the process of remembering its loss resembles that of mourning. The "work of mourning," as Laplanche and Pontalis remind us, is an "intrapsychic process, occurring after the loss of a love object, whereby the subject gradually manages to detach himself from this object" (485). Schoendoerffer's entire film and novel-writing career, as one of the few to have evoked the Indochinese war throughout his career—with *La 317e section* (1965), *Le Crabe Tambour* (1977), and *Dien Bien Phu*—does not tend toward liberation of affect and discharge (abreaction) (Laplanche and Pontalis 60) as in catharsis, but "works through" certain issues in the commemorative remembrance of the war. Pierre Schoendoerffer asked himself "why the French are prepared to spend $25 million on a film of our most terrible defeat." "The answer, he believes, lies in romanticism: 'Indochina was a long love story for France, beginning with the missionaries. Dien Bien Phu is my adieu to that story'" (Ferguson 28). Hence, Schoendoerffer could write in all seriousness that "the shooting of this movie was a matter of love [une affaire d'amour]. I also think that the battle, in a strange way, was also a matter of love" (125). Like *Dien Bien Phu*, *Indochine* and *The Lover* are part of that filmic memorial that has been "erected" to remember the French colonization of Indochina as an extraordinary and memorable relation that, according to the script of *Indochine*, linked "men and women, mountains and plains, humans and gods, Indochina and France." These movies sustain and reinforce the founding myths of the French colonial presence in the Indochinese peninsula.[19]

The place of Indochina in the French imaginary is far from resolved. It will continue to arouse interest and provide the ideal topos for writers and filmmakers. What we desperately need, however, is to go beyond the romantic love story to address crucial questions that remain to be raised and answered. The problematic filmic engouement that I have called "colonial blues" moves us even further away from a serious historical

interrogation of the colonial situation. Colonial blues refers not simply to a nostalgic sentiment for a bygone era—life in French Indochina in the thirties—a willful ignorance of the history of the region, or a feeling of benevolence toward the natives. More importantly, it calls attention to the strategies and modes of representation used by French film directors to stage and "memorialize" French Indochina as a collective fantasy of French colonial history in Southeast Asia.

RETRACING THE LEGACY OF
"INDOCHINA ADVENTURES"

My purpose in examining a wide variety of textual and iconographic constructions of Indochina is to trace the emergence of Indochina as a mythic place of unlimited possibilities in the French imaginary, as an invention motivated by economic, political, and so-called humanitarian considerations disguised and promoted as military, erotic, textual, and visual "adventures."

Today, images of Indochina continue to permeate every facet of contemporary French culture. The most conspicuous ones are perhaps the ones disseminated by the tourist industry which reconstructs, in a problematic fashion, a landscape of fantasies and dreams. Because the name "Indochine" still has the power to elicit strong visual and affective responses, the tourist industry, like its fashion counterpart, has made wide use of its aura to attract new customers. In the tourist brochure *Rev'Vacances*, for instance, a popular French tour operator still calls the nations of Vietnam, Laos, and Cambodia by their collective colonial denomination, that is to say, "Indochine." The manner in which Indochina is represented is also reminiscent of Alfred Janniot's colonialist bas-relief. Framing the text that follows are pictures of a map of Indochina; a peasant working in a rice paddy; a happy, smiling native woman with her child; a sampan; and workers picking and washing vegetables, without any captions to specify their origin. These photographs naturalize and fix the people of Southeast Asia as a collective entity, in a golden time frame when modernity and progress have still not made their impact on these countries and their people. The text accompanying these photographs also betrays a deep-seated colonialist logic:

Indochina is finally opening up to the traveler bewitched by a world filled with history and mysteries.

> The magical names of Angkor Wat in Cambodia, Saigon and Halong in
> Vietnam, and Louang Prabang in Laos, bring back a cascade of sumptuous im-
> ages of thousand-year-old vestiges and idyllic landscape.
>
> Rev'Vacances invites you to discover these three countries bathed by the
> Mekong River. ("La Mémoire" 19)

Together, the text and photographs function to trigger phantasmatic
memories of a French colonial golden age.

Similarly, an ad in a 1992 issue of the *New York Times Magazine* seeks
the "culturally sensitive, curious, ecologically minded, and knowledge-
able . . . adventure travellers to Laos, Vietnam and Cambodia—the three
countries of Indochina" (83). Dubbed the "Indochina Adventure," the
nineteen-day journey is said to afford the unique opportunity for the
"like-minded, literate" traveler to explore some of the most "truly unique
architectural wonders of the world—Angkor Wat, Angkor Thom, Roluos,
and eleven other historic sites and temples." Two photographs of the
largest temples with their famed friezes make the exotic journey more
appealing. A caption in boldface urges the would-be traveler to "Come
Face to Face With Angkor Wat." The writer of this ad obviously knows
that Angkor Wat continues to exert a powerful influence on the traveler
and, by extension, on the West's imaginary. Angkor Wat is, undoubtedly,
the most easily recognized architectural symbol of Cambodia. But more
importantly, it also resignifies a phantasmatic "Indochina," an Indochina
named to promote and encourage traveling: [1]

> Our adventure travellers have meandered the streets of Vientiane, a city
> suspended in time, ambled through the Royal Palace in Luang Prabang, explored
> Phnom Penh's Silver Pagoda, Royal Palace and Royal Museum—where some of
> the finest examples of Khmer Art are displayed—personally seen the war room in
> Saigon's Presidential Palace and contrasted this experience with their personal
> observations of a Viet Cong command bunker in the tunnels of Chu Chi, and
> reflected on the generations of scholarship that is celebrated in Hanoi's Temple
> of Literature. They have also ventured into the Buddhist shrines carved out of the
> Marble Mountains at Danang, and taken a stroll around Hue's restored Citadel.

In terms that are reminiscent of Benjamin's description of Baudelaire's
flâneur, the "adventure traveler" who is, we must not forget, a "literate"

traveler, meanders, explores, ventures, and takes strolls. She or he visits not only traditional tourist sites (museums, palaces, and temples) but also casually tours unfamiliar places that have suddenly become tourist attractions, such as the war room in the presidential palace or even a Vietcong command bunker. Framed between visits to religious and archeological sites, the tour now accommodates visits to war sites, which have become an integral part of the tourist itinerary, a tourist pilgrimage displaced from its tragic historical context.

To speak of Indochina—rather than Southeast Asia—at the end of this century is to appeal to a certain memory of "Indochina," and more specifically to the nostalgic vision of the French colonial presence and its legacy, a memory that had been displaced by the traumatic vision of another Indochinese adventure, the American imperial intervention in Vietnam, that must at all costs be erased and forgotten. The American military invasion has given way to an anticipated army of tourists. Potential travelers are therefore urged to act quickly "before these countries are flooded by 'tourists' brought here by tour operators in their apprenticeship on Indochina, or before restrictions are imposed on the number of sites that can be visited at such places as Angkor Wat." Nothing is said explicitly of the restrictions caused by the guerrilla war still waged by the Khmer Rouge in Cambodia.

The advertising for "Indochina"—and not for Southeast Asia or individual countries like Vietnam, Cambodia, or Laos—elicits such a strong response because it is part of a much more serious trend, a "campaign" that attempts to reassess France's colonial past in Southeast Asia in a nostalgic exoticizing mode. By exploiting certain facets of French colonialism, and glossing over its more heinous aspects, recent cultural productions promote the image of France as a benevolent and "humane" colonial power whose civilizing mission brought light to dark corners of Asia. *L'Indochine avant l'ouragan, Invitation au voyage*[3] "Indochine ton nom est femme," and *Indochine* "tout court" are some of the revealing titles of texts that seem to lament the end of a golden colonial age, "the Indochina of the thirties . . . a colonial paradise" (Montella, jacket copy).

The success of Wargnier's film *Indochine* reinforces the French belief in the legacy of their cultural achievements in Southeast Asia, sanctioning the illusion of a benevolent France incapable of plundering and violence.

In countless reports and documentaries, the focus is always on still-standing aesthetic French markers such as the ornate beaux-arts buildings, the cathedral, and so on, as if to demonstrate that French architectural constructions in Vietnamese cities bear witness to the enduring legacy of the French imperial presence and cultural hegemony in Southeast Asia.

This study of contemporary French discursive practices on Indochina goes far beyond the merely academic inquiry. These new visual and textual formations, like the nineteenth-century exotic novel that helped make this region popular, today shape the mental geography and the imaginary of people who travel blindly and unencumbered through geographic and historical space. As temporal distance increases, these popular constructions may even, one day, be regarded as factual truth and assimilated as knowledge by those who have only a remote inkling of colonial history. These discursive formations have the potential to determine the framework of an insidious revisionist history, one that relies on popular iconographic, filmic, and literary clichés and vague notions of colonial history to erect renewed representations of a phantasmatic and exotic Indochina. The unending task of the postcolonial critic, then, is not simply to undermine and debunk these constructions, nor to provide an alternative and more accurate foundation of the history of the French colonial presence in Southeast Asia but, more importantly, to lay bare the process by which Indochina continues to be an unproblematic object of visual pleasure and consumption for the "exploring, absorbing, photographing," and literate "adventure traveler."[3]

NOTES

Introduction: Indochina as Fiction

1 One of the first coherent attempts at exploring French writings on Indochina was undertaken by Jean Ajalbert in *L'Indochine*. His anthology, however, which includes works written by a wide variety of French authors, lacks an overarching critical framework. The first and only full-length literary study of Indochina, to my knowledge, was written in the 1930s by Louis Malleret in his classic thematic survey, *L'Exotisme indochinois dans la littérature française depuis 1860*. Shorter studies also worth mentioning include Clive Christie's informative essay, "The Quiet American and the Ugly American: Western Literary Perspectives on Indo-China in a Decade of Transition 1950–1960." The work on Indochina of a new generation of French scholars must also be consulted. See, in particular, the work of Gilles de Gantès.

2 In the introduction to his translation of de Certeau's *L'Écriture de l'histoire*, Tom Conley points out that the English translation fails to convey the complexity of the French usage (xx).

3 A number of studies have been devoted to this subject. Consult Gervereau; Lewis; Paret, and Paret.

4 Although these examples among many others suggest the complexity of the historical conjuncture of the time, they fail to articulate the intensity of the violent force exerted on the colonized world by the West. For an in-depth discussion of the ravages caused by the colonizing powers, one could point to the seminal work of Edward Said for a model study of the complicit role scientists and scholars played in deploying Western knowledge in the service of colonization. Few studies, however, have been devoted to investigating the ideology of medical discourse and institutions such as the Institut Pasteur de Saigon, as well as probing the complicit role of doctors and pharmacists in the colonization of Indochina (see Bernard; Pluchon).

5 In his memoirs, André Thirion writes that he conceived the whole exposition as being in three main parts: Sadoul was put in charge of its proselitizing aspect, where statistics, engravings, and photographs of the history of the French colonial empire, of its conquest, exploitation, and *mise en valeur* of foreign territories were showcased. The second part, ideological in nature, which Thirion kept for himself, dealt with

"Leninist theory on imperialism." Aragon was responsible for "presenting cultural problems" (Thirion 289), which meant that he, with Eluard and Tanguy, had to assemble a collection of so-called primitive art.

6 For a discussion of the arrival trope, consult Mary Louise Pratt.

7 Molly O'Neill, the fashion editor for the *New York Times Magazine*, describes in her style column "the sudden fascination of American designers with the traditional dress of Indochina" in terms of affect and desire of "people enamored by the exotic" (71). Her column introduces an eight-page article written by Philip Shenon and lavishly photographed on location by Marie-Laure de Decker. The article displays Eastern-inspired dress by such American designers as Koos & DeWilde, Richard Tyler, Ralph Lauren, and Donna Karan. These so-called foot-soldiers of style are said to have "becom[e] intoxicated with its [Vietnam's] aroma" (72). The article generously displays "the new Indo-Chic clothes and the lush country that inspired them" (72). As is expected, the fashion industry has been lured by the erotic and exotic dimension of native apparels: "Without revealing much skin," it is said, "Eastern dress is subtly sexy. The slit on the side or up the back, the little mandarin collar and the frog closures are like erotic flash points" (74). Although these "Western designers" are also commended for their formal designs and "putting their own spin on the cheongsam, the sarong and the pajama, adding slightly more structure and definition to what is essentially languid and simple" (77), these prêt à porter and haute-couture erotic transfigurations of native clothes do come at a considerable price: Ralph Lauren silk vest and velvet sarong fetch $398 and $698, respectively. For $785, you can own a "raw silk jacket made locally" and a cotton skirt by Koos & DeWilde; for $635, "a cropped silk shantung vest" by Richard Tyler. And for the evening, Donna Karan "silk slip dress" can be had for a mere $2,195. These "Indo-Chic clothes" seem to have found a niche if we consider advertisement to be a reliable indicator of the fashion industry market. In the February 20, 1994, *New York Times Magazine*, five full-page color ads for the Ralph Lauren Collection featured only clothes inspired by Indochina.

Chapter 1 Representing Indochina: The French Colonial Phantasmatic and the Exposition Coloniale Internationale de Paris

1 Two official publications give the reader an idea of the scope of the Exposition, the nine-volume *Rapport général de l'Exposition Coloniale Internationale* and the *Exposition Coloniale Internationale de Paris: Le Livre d'or*.

2 According to Lacan, "the phantasy is the support of desire; it is not the object that is the support of desire" (*Four* 185).

3 See particularly "Hysterical Phantasies and Their Relation to Bisexuality," "A Child Is Being Beaten," and "The Unconscious."

4 Cora Kaplan examines Freud's essay "The Unconscious" (1915) and his analysis of

the hybrid nature of fantasy as conscious and unconscious forms and calls attention to the problematic usage of "individuals of mixed race" as used by Freud to illustrate how primal fantasies hide and reveal their origins (see Kaplan 132–33).

5 The etymology of the name "Indochine" reveals its modern genealogy. In 1570, Abraham Ortelius, "citizen of Antwerp and Geographer to Philip the Second, King of Spain," named the entire region "that on the East of the Ganges River," "India extra Gangem, India beyond Ganges" (108). The entry under "Indo-Chine" in the *Grand dictionnaire universel du xixe siècle*, published in 1873, still refers to the name "Inde Transgangétique ou Inde au delà du Gange." There is conflicting evidence as to who coined the name "Indochina." One source claims that "Indochine" was a "word coined by the geographer Malte-Brun. Conrad Malte-Brun, born in Denmark in 1775, co-founder in 1821 of the Société de Géographie" (Daney 17). The O.E.D. asserts that the name "Indo-China" was invented by "John Leyden [1775–1811], Scottish poet and Orientalist" (7:883).

6 Marcel Carné, the French film director, contested the prevailing and dominating role of architecture at the Exposition. He opposed *le factice* (the phony quality) of the architectural reproduction of the "truth" of "cinéma lancé à la conquête du monde [cinema launched in the conquest of the world]" (16).

7 France stood behind Great Britain as the second largest colonial empire, not an enviable position for the French, whose slogan could approximate but not compete with the English "Greater Britain."

8 Angkor was the capital of the Khmer kingdom from the ninth till the fifteenth century. The city of Angkor was moved and rebuilt several times, with a temple-montagne at its center. The funeral temple, Angkor Wat, in the south of the city, was erected in the first half of the twelfth century and abandoned by the Khmer kings following the Siamese occupation in 1431.

9 The proceedings of the Congrès d'urbanisme colonial were published the following year (see Royer).

10 Sylviane Leprun examines this particular aspect of the "colonial scenography" in her informative study, *Le Théatre des colonies.*

11 The analysis that follows relies on the detailed photographic reproductions of Janniot's bas-relief.

12 The limited scope of this essay prevents us from examining the complicit role of architecture and colonial urban design with medical discourse. The neo-Sudanese architectural style, for instance, was invented to accommodate Western notions of monumental and decorative space and promoted as a more efficient and hygienic way of living that would transform native space, allegedly to prevent the transmission of tropical diseases.

13 In the following chapters, I trace the emergence of two oppositional discourses to the dominant colonial fiction: 1) the Surrealists writing in their anticolonial tracts (Breton and Éluard) and avant-garde journals (*La Révolution surréaliste* and *Surréalisme au service de la révolution*); 2) the Communists, who opposed the government colonial

policies in articles and editorials in *L'Humanité*. For the duration of the Exposition, the Communist daily reported on the bloody repression of the Yen-Bay rebellion, the death of tens of thousands of West Africans, compelled to forced labor and coerced into laying down the railroad tracks between Brazzaville and Pointe-Noire, and so on. The "natives" denounced colonial domination in student newspapers and staged public demonstrations at the Exposition. These dissenting voices would eventually find common ground in a rarely studied but significant "event," the Surrealists' Contre-Exposition organized by Aragon and Thirion, known as La Vérité sur les Colonies (see Hodeir and Pierre 125–34).

Chapter 2 Unruly Natives: The Indochinese Problem

1 The French Communists also considered "Tao's abduction and his odious deportation" to be the perfect opportunity to rally "the French working class" and a means to articulate their views and demands: "the opportunity to speak clearly and unequivocally and to snatch with strong force the militants whom we intend to save from the hands of the executioners and look after" (Gaillard 1).

2 For a detailed account and extended discussion of the political activities of Vietnamese students in France during the interwar period, consult Scott McConnell's informative and meticulously researched study, *Leftward Journey*. McConnell consulted archival material Archives Nationale, Aix en Provence (Series F7-13410). According to McConnell, Tao was imprisoned for allegedly "engaging in a Communist plot against the security of the state (136). See also Hue-Tam Ho Tai's study, *Radicalism and the Origins of the Vietnamese Revolution*. The work of the French historian Daniel Hémery is also very useful. He writes that "Nguyen Van Tao was arrested on May 22 in front of the Elysée, imprisoned at the Santé and also implicated in the legal proceedings brought against the leaders of the French Communist Party. A police decree allowed his deportation to Vietnam in June 1931" ("Du Patriotisme" 46).

3 Archives Nationale, quoted in Hémery, "Du Patriotisme" 24 n.60.

4 For an in-depth discussion of the impact on the Vietnamese resistance movement of communists and Trotskyists who wrote for the weekly, *La Lutte*, see Hémery, *Revolutionnaires Vietnamiens et pouvoir colonial en Indochine*.

5 A short gloss on the history of various governmental branches assigned to surveillance details shows the extent of their activities. The year 1919 marks the beginning of the surveillance. The first contingent of Indochinese soldiers and workers who remained on French soil after having served in the Great War were closely watched. In October 1919, Louis Arnoux, a policeman, created the Service de contrôle et d'assistance aux indigènes (CAI), dependent on the Ministry of Colonies, an agency financed by the Government General of Indochina, in permanent contact with agents of the French Sûreté in Indochina. According to McConnell, "CAI was the bureaucratic successor to an office at the War Ministry, charged with the sur-

veillance of the colonial troops who had been brought to France during World War I" (86). Various branches of French government agencies were also involved: the Third Bureau of the Headquarters General Staff of the War Ministry and the surveillance section of the Foreign Affairs Ministry, informed by their respective embassies; the Direction of the Sûreté at the Interior Ministry, bolstered on July 1, 1931, by a "surveillance and repression section of subversive and revolutionary activities of colonial natives in France [Section de surveillance et de répression des menées révolutionnaires auprès des indigènes coloniaux en France], better known as the Colonial Section (Hémery, "Du Patriotisme" 7).

6 For a discussion of the Yen-Bay rebellion and the French response, see Isoart (286–87) and Duiker (158–65). According to Hémery, "the ideological reorientation seals the historical failure of nationalism" ("Du Patriotisme" 43).

7 Vietnamese students and workers also took part in the procession to the Mur des Fédérés on May 22, 1930, to commemorate the Commune.

8 McConnell argues that "the new building, part of the newly opened Cité Universitaire in Paris, was designed as a lodging and social center for about one hundred Vietnamese students in a place where Frenchmen could both watch them and shelter them from disruptive political influences" (80).

9 The entire quote is as follows: "Nous, étudiants, nous avons à ramasser, à conquérir l'instruction qu'on nous refuse dans notre pays [We students, we have to collect, conquer the instruction that is denied to us in our country]."

10 A short survey of the different French government agencies regulating colonial education policies reveals the complexity of the decision-making apparatus. Unlike the centralized network that controlled and oversaw education in France, different agencies were responsible for colonial education: the Ministry of Foreign Affairs oversaw the education policy for the Tunisian and Moroccan protectorates, the Ministry of Interior for Algeria, the Ministry of Colonies for Indochina and sub-Saharan Africa. Moreover, each French official in charge of his own educational territory had considerable autonomy in drawing up policy (McConnell 155).

11 In 1925, André Malraux was the publisher of a daily called *L'Indochine*, which was dubbed a "Journal quotidien de rapprochement Franco-Annamite [a daily newspaper for Franco-Annamite rapprochement]." While he opposed the colonial policy that prevented Annamites from going to France, he endorsed a policy of association that would, in the long run, benefit the French Union. In one of his signed editorials, he writes: "I do not put here a man but a political attitude on trial. Not only is this attitude forbidden by French law, which does not believe that France represents such ugliness or shame that it must be hidden from the Annamites: not only is it so stupid as to make one cry from rage, but moreover, it will subject, in a very short time, our colonization to the most dangerous attack. I ask that France be accessible to those who want to know her. . . . And it is the later one [the one who does not accept the refusal opposed to him] who must interest us, if we disregard the local administration which does not want 'any incident [pas d'histoire],' and if we consider the superior interest of the

state. This one has the soul of a leader. We must rely on him to support our colonial enterprise [C'est sur lui que nous devons appuyer notre colonisation]" (n.p.).

12 "Déclassé" intellectuals, observed Taittinger, would always be a problem for the French Empire; the solution was simply not to create them. He adds:

> Give the Annamite, through professional education, the means to secure for himself a better and happier existence. We have begun. Let us commit ourselves more resolutely in this direction. It must be the primary aim of the education given to the Annamites. . . . Believe me! Let us give the Annamite people the means to improve the production in the ricefields, and in general, let us do all we can to ensure more prosperity, a better moral and material existence. But, above all, let us not create déclassés!
>
> We have in this area a responsibility. Most of these men, in whom we have awakened new [intellectual] faculties and embellished their mind, are uprooted people [des déracinés], poor wretches [des malheureux]." (Chambre des députés 2437–38)

13 He goes on to say: "I add, that by some misguided tolerance, examiners are often inclined to confer diplomas of the export type [de simple exportation]. Having returned home, these laureates or these pseudo-laureates [faux lauréats] find public offices and liberal professions held by others. They consider themselves to be misunderstood, become embittered and, because they have absorbed without having assimilated the lesson of equality, they lapse too easily into communism which is always on the lookout to collect grievances and exploit them" (Chambre des députés 2506–7).

14 The existence of student papers published in France constitutes an important archive and a source of empirical evidence for an analysis of the tenor of student claims and demands. "In Aix-en-Provence the bilingual *L'Annam scolaire*, created in April 1927 by Tran Van An and Lieu Sanh Tran, becomes *L'Etudiant indochinois* in February 1928 (six issues appeared). In Paris, the *Bulletin de l'AGEI* (eleven issues appeared from July 1927 to August 1928). In Toulouse the *Journal des Etudiants annamites*, created on the 15th March 1927, becomes *L'Avenir de l'Annam* in March 1928, then *L'Annam de Demain*, and once again the *Journal des Etudiants annamites* in October 1928" (Hémery, "Du Patriotisme" 16).

15 Hémery examines the dearth of student newspapers: "The publication of the newspaper *Viet Nam Hon* (The soul of Vietnam), an open forum for Annamite students and workers [tribune libre des étudiants et des travailleurs annamites] whose first number, with a circulation of 2000, appears on January 1st, 1926, precedes the creation of the Vietnam Doc Lap Dang, or Parti Annamite de l'Independence. The foundation [of the journal] is, in all probability, the culmination of the project initiated by the Union intercoloniale, and more precisely, Nguyen Ai Quoc" (Hémery, "Du Patriotisme" 16). Written in French, Vietnamese, and Chinese, financed by the subscriptions of members of the Association des Travailleurs Manuels, *Viet-Nam Hon* finds widespread readership in the army barracks, among "Indochinese tirailleurs, and

in metropolitan schools attended by young Annamite students. Banned on August 23, 1926, it continues to appear clandestinely under various titles until September 1927. But it will be doubled beginning September 1st, 1926, by a publication legally registered: the bilingual monthly *Phuc Quoc* (Restoration of the nation), banned, in turn, on October 11, 1926, followed, on January 15th, 1927, by the bimonthly *L'Ame annamite*, written in French, then in June 1927 by *La Nation annamite*" (Hémery, "Du Patriotisme" 16–17).

Chapter 3 The "Surrealist" Counter-Exposition: La Vérité sur les Colonies

1 The Colonial Exposition / The ring in the nose of the Catholic religion / The hosts of the national defense / Fetishes, fetishes, you are burned if you thumb / Your nose at men covered with sabres and gold decorations / and affront magistrates in the execution of their duties / The ring in the nose of the Third Republic / mandatory childbirth / The Nation needs soldiers / The Colonial Exposition / . . . / The bedizened executioners speak of the inaugural heaven / of France's grandeur and elephant herds / of penitentiary ships and rickshaws / of rice where the water sings of the golden-complexioned workers / of benefits reserved for the enlisted men / of the marine corps / of the ideal seascape of the Bay of Halong / of the loyalty of the chandernagoric natives / . . . / It rains and rains in torrents on the Colonial Exhibition

2 To my knowledge, the most extensive discussion of the "Contre-Exposition" is to be found in *L'Exposition coloniale* by Catherine Hodeir and Michel Pierre (125–34). Their informative and well-researched account does not, however, attempt a critical interpretation of its impact.

3 Elizabeth Williams examines the history of the Tracadéro Museum since its foundation in her "Art and Artifact at the Trocadero." Clifford remarks that "the notion that ethnography was a process of collection dominated the Mission Dakar-Djibouti, with its museographical emphasis" (66).

4 "According to [Georges-Henri] Rivière and [Paul] Rivet's proud calculations in *Minotaure* No. 2 (1933), 3,500 'ethnographic objects' were collected, along with six thousand photographs, a large collection of Abyssinian paintings, three hundred manuscripts and amulets, notations of thirty languages and dialects, and hundreds of recordings, 'ethnographic observations,' botanical specimens, and so on. The 'mission's booty,' in Rivet and Rivière's words, was the public measure of a successful mission" (Clifford, *Predicament* 137) in "Mission ethnographique et linguistique Dakar Djibouti." Similarly, Georges Le Fèvre reports that the Croisière jaune, sponsored by the French car manufacturer, Citroën, an expedition that traversed Asia from Beirut to Peking, was equally successful: "Rich with 5000 photographs, 50,000 meters of film, drawings, ethnographic documents, mineralogical samples, art objects and a natural history collection, it had reached its main goals" (*La Croisière jaune*, quoted in Leprohon 78).

5 "'Mission' functions as an all-purpose term for any redemptive colonial errand, whether military, evangelical, educational, medical, or ethnographic. It suggests hundreds of other voyages, all of them heroic, confidant gestures of a stable subject who conquers, instructs, converts, describes, admires, represents . . . other people and their world" (Clifford, *Predicament* 168). See Barthes's discussion of "mission" in *Mythologies* and in "African Grammar" in *The Eiffel Tower and Other Mythologies* where he writes: "Mission this is the third mana word. Into it we can put whatever is wanted: schools, electricity, Coca-Cola, police operations, raids, death sentences, concentration camps, freedom, civilization, and the 'presence of France. . . . France has a mission in France which she alone can fulfill'" (103–9).

6 Clifford quotes this passage in his analysis of "Power and Dialogue in Ethnography: Marcel Griaule's Initiation" (55–91). He believes that the thirty-three page pamphlet, "Instructions sommaires pour les collectionneurs d'objects ethnographiques," was prepared by Marcel Mauss, with the assistance of Michel Leiris and Marcel Griaule (see 66–67).

7 My use of the word "tribal" follows the art historians' common usage. Rubin reports that African scholars have criticized the use of "tribal" as "Eurocentric" (Ekpo Eyo, cited in the *New York Times*, October 12, 1980: 70). And yet, "because we are not addressing the cultures in question, but investigating the ideas formed of them in the West, the use of the word 'tribal'—which is a function of such ideas and the context in which they were formed—is not misleading," writes Rubin (74). Anthropologists use such unwieldy expressions as "the material culture of non-Western peoples" (Stocking 6).

8 In a footnote, Clifford writes, "For a glimpse of how the often incompatible categories of 'aesthetic excellence,' 'use,' 'rarity,' 'age,' and so on are debated in the exercise of assigning authentic value to tribal works, see the richly inconclusive symposium on 'Authenticity in African Art' organized by the journal *African Arts* [see Frank Willet]" (Clifford, *Predicament* 222–23).

9 I am indebted to Emmanuel Perret's cogent study, "The Perception of the African Object," in *Coloniales 1920–1940*, 108–21.

10 In Zurich, the Rumanian Tristan Tzara had been one of the "Dada personalities most interested in African and Oceanic art and in concepts of primitivism. He owned African sculpture as early as 1917. And in fact, a 1917 Galerie Dada exhibition had been built around what Hugo Ball (one of the founders of *Cabaret Voltaire*) described as a very beautiful and expensive African sculpture owned by Tzara" (Maurer 540).

11 Three examples will suffice: On May 17, 1931, *L'Humanité* examined "The horrifying distress of the natives from the A.O.F. [Afrique Occidentale Française]" who are "Enslaved by the bourgeoisie of the land of 'human rights'" (2). On April 25, 1931, *L'Humanité* reported that "In 'French Asia' hard labor is not a legend. And the slave trade in Asia [la traite des jaunes] goes on with the support and the protection of 'civil servants' [des officiels]" (1–2). On May 5, 1931, it investigated "The economic crisis in the nation of Annam. How through rice export, the imperialists aggravate famine" (1).

12 *L'Humanité* (10 août 1931)

13 Marc Allégret and André Gide encountered these conditions firsthand during their journey to Africa. Incidentally, the African journey became the catalyst to Gide's newly found commitment against French colonialism. Gide published his most polemical article on the colonial question in *La Revue de Paris*. "n.t." Gide's ethnographic account, "The Villages of the Massas Tribes," illustrated with three photographs by Marc Allégret, was published in *L'Illustration*. Allegret published his "Notes on the Massa-Mousgoum" in *Le Monde colonial illustré*.

14 Maurer mentions the various primitive art exhibitions organized by the Surrealists themselves. The first one was

> the opening exhibition of the Galerie Surréaliste in Paris on March 16, 1926, which featured objects from the collections of Breton, Eluard, Louis Aragon, and others. Another major event of this kind was the 1936 'Exhibition of Surrealist Objects,' held between May 22 and 29 at the gallery of Charles Ratton, the noted Parisian primitive art dealer. Amid the incredible mélange of items displayed was a large selection of pieces from the Primitive cultures of Oceania and America. These were placed side by side with natural objects, interpreted objects, and objects made by Surrealist artists and poets. The same pattern was followed on a larger scale when the 'International Surrealist Exhibition' was organized in London in 1936 by a group of English artists with the support of Breton, Eluard, and Man Ray. The exhibition consisted of over four hundred paintings, sculptures, and objects, including a large number of pieces from Africa, Oceania, and the Americas. Most of the objects in both exhibitions were borrowed from the collections of individual Surrealists. (546)

No mention is made of the exhibit La Vérité sur les Colonies.

15 This description of the content of Aragon's exhibit (which Hodeir and Pierre attribute to Aragon himself) is drawn from a four-page report entitled "L'Exposition Anti-Impérialiste: La vérité sur les colonies."

16 One must begin with William Rubin's introduction to his monumental, two-volume *Primitivism in 20th Century Art*, and to Jean-Louis Paudrat's essay, "The Arrival of Tribal Objects in the West: From Africa" in the collection.

17 Ageron begins his discussion of the Contre-Exposition with a literary trope, *une figure de prétérition*, a conventional declaration in which he expresses his reluctance and unwillingness to discuss an object while drawing attention to it:

> Even though it is not the appropriate place to present this little-known campaign, it appears necessary, however, for a just appreciation of the public mind in colonial matters, to evoke some of its manifestations. The French League against Imperialism, a vacuous association [une association fantomatique], which, after three years of existence, had only succeeded in gathering two hundred members, had to organize in Paris an "anti-imperialist Exposition." Those who financed it wanted to turn it into the Anti–Colonial Exposition [Celle-ci devait être pour ceux qui la commanditèrent l'anti-Exposition coloniale]. Baptized "The Truth about the Colonies," this counter-

exposition limited itself to present at the pavilion of the Soviets, annex to the Maison des Syndicats, a set of photographs on colonial wars, old satirical cartoons from *L'Assiette au beurre* and graphs charting "the fabulous profits" of capitalist societies. The writer Aragon exhibited a collection of art nègre, Oceanian, and Indian objects vis-à-vis religious images of the Saint-Sulpician type, these symbols of Western bad taste. Naive photographs depicting the happiness of the Asian peoples liberated by the Soviet revolution completed this mini-exposition. In spite of its exceptional duration (from July 1931 to February 1932) and collective visits organized by the trade unions, only five thousand visitors were counted by the Parisian police. ("L'Exposition" 571)

Ageron's condescending tone and inaccurate assessment—the counter-exposition was inaugurated September 20, 1931, and not in July; the number of visitors (one thousand a month) does not constitute a poorly attended exhibit—demonstrate a peculiarly troubling ideological parti-pris. He does not even question the fact that the French police kept a close watch on those opposed to government colonial policies.

18 Marc Meuleau's monumental study on the economic and political influence of the Bank of Indochina, *Des Pionniers en Extrême-Orient*, is required reading and provides a comprehensive history of the Bank of Indochina, spanning an entire century (1875–1975).

19 The circulation of images and objects from the colonies is indeed a problematic issue that still needs to be analyzed closely. One example will suffice. To finance the opening of an art cinema, Abel claims that "In the summer of 1925," Armand Tallier, one of the stars in Poirier's film, *Jocelyn*, with a friend, Mirga, "found a small (300-seat) cinema for rent behind the Pantheon and prepared to finance a season of film programs with what they called 'a light truck . . . some money left over from the African tour, certain trinkets which would fetch a little money on the flea market, and . . . for the rest, admission tickets.' On 21 January 1926, the *Studio des Ursulines* opened its door. . . ." (Abel 258–59). One can very well imagine an African object bought in Africa, then hung in an avant-garde studio, being sold on the flea market to finance the opening of an alternate specialized cinema that would show documentaries on Africa (and elsewhere), as Jean Tedesco perhaps did with his Théâtre du Vieux-Columbier, considered to be "the beacon of art cinema," where two important documentaries were first screened in November 1926 and in early 1927, Flaherty's *Moana* and Marc Allégret's film on Central Africa, *Voyage au Congo* (see Tedesco "Le Voyage" 12–13).

Chapter 4 Indochina as "Rêves-Diurnes" and Male Fantasies: Re-Mapping André Malraux's *La Voie royale*

1 Buisine remarks that "the entire colonial enterprise is essentially the concern of a masculine imaginary of conquest [toute l'entreprise coloniale relève essentiellement d'un imaginaire masculin de la conquête]" (227).

2 "But why did I go to Asia. Did you know that was the first question Valéry asked me, when I met him for the first time? [Mais pourquoi suis-je allé en Asie. Savez-vous que c'est la question que m'a posée Valéry, lorsque je l'ai rencontré pour la première fois?]" (Picon 12 n. 3). In d'Astier's interview, the same anecdote is told slightly differently: "'Why does China interest you?' Valéry had asked during our first encounter ['Pourquoi la Chine vous intéresse-t-elle?', avait demandé Valéry à notre première rencontre]" (d'Astier 59). China, Indochina, and Asia seem to be completely interchangeable terms for Malraux.

3 Another source that seems to corroborate this version is a 1928 biographical notice accompanying the German translation of *Les Conquérants*, which reads: "Biographische Notiz des Verfassers: Geboren in Paris. Vom französischen Kolonialministerium zu archäologischen Studien nach Kambodscha und Siam geschickt (1923). Führer in der Partei Jung Annam (1924). Kommissar der Kuomintang für Cochinchina, dann für ganz Indochina (1924–25). Stellvertreder Kommissar für Propaganda bei der Nationalistichen Regierung in Kanton zur Zeit Borodins (1925)" (Vandegans, *Jeunesse* 241). Vandegans also adds the following gloss: "It is a brief biographical sketch appended as a note to the German translation of the *Conquérants*, written by Max Clauss in *Europäische Revue* (août-décembre 1928): the first text on Malraux, of this type, to be known. Its main interest appears to lie in the fact that it was written only a short time (from three to five years) after the events suggested by the titles and posts mentioned in it; we discover the stages of a biography before the birth of any legendary distortion. We are free to dispute entirely the accuracy of the information, obviously given by Malraux himself. It would undoubtedly prove to be excessively untrustworthy. . . . The mention of the duties of 'deputy-commissioner in charge of propaganda' appears to make manifest the authenticity of the information" (241). One should indeed be much more critical of this type of biographical "evidence."

4 Malraux elaborates his views on eroticism in his "D. H. Lawrence et l'érotisme" (1932). For an extended discussion of "The Role of Eroticism in Malraux's Fiction," consult René Girard's essay of the same title and Lucien Goldmann's analysis of the "question d'érotisme" in Malraux's work (125–43). Goldmann writes that "dans les romans de Malraux, les relations entre hommes et femmes sont homologues aux relations entre les héros et le monde social et politique" (125–26), and "De la même manière, les relations avec les femmes de Garine et de Perken sont analogues à leurs rapports avec la réalité historique, ce qui veut dire que ce sont des relations purement érotiques" (126). Mounier also notes the interchangeability between eros and history: "The *invidia geographica*, on the margin of the revolutionary adventure, holds in Malraux's work the same place as eroticism—and from the battle to the conquest and to love, his images often exchange themselves [*L'invidia geographica*, en marge de l'aventure révolutionnaire, tient dans l'oeuvre de Malraux la même place que l'érotisme—et du combat à la conquête et à l'amour, ses images s'échangent souvent]" (60).

5 See Suleiman de Courtivron. D'Astier writes that "Malraux denies being mis-
ogynous. He denies that he excludes women in order to pursue his experience of
which they are merely a reflection [Il se défend d'être misogyne. Il se défend d'écarter
les femmes pour poursuivre son expérience dont elles ne sont qu'un reflet]" (60).

6 Primarily concerned about proving André Malraux's misogyny, feminist critics
have failed to examine Clara's complicitous role in the "Indochinese adventure."
Clara shares André's belief in their rightful "ownership" of the stolen bas-reliefs. She
recalls in her memoirs: "Now more than ever I was convinced of our right to put
works of art that were being *threatened by the jungle* back into circulation; there was a
risk of their remaining *abandoned* for many a long year still, so great were the numbers
of the monuments that the Ecole Française ought to have protected. We already
loved the temples and the heads that floated in our imagination [Nous les aimions
d'avance, ces temples, ces têtes et ces corps que nous imaginions (138)]. We should
have to part with some of them, that was true enough; but more and more clearly we
thought of other expeditions, here or elsewhere, that should be for our own delight
alone" (264; my emphasis). Or "And that was how I came to Banteaï-Sre, a temple
whose name had the same meaning as that of the city in which I spent my happy
vacations. Magdeburg and Banteaï-Sre, both the one and the other the 'virgin's
fortress.' . . . With the most important of our dreams coming true, we accepted all the
others. . . . Then we touched them, we touched our property; and my hand felt the
texture of the stone . . . [Alors nous avons touché ce qui nous *appartenait*, mes mains
ont palpé la texture de la pierre . . . (150)]" (273; my emphasis).

7 Mounier speaks of "The tight fusion that he has achieved for the last twenty years
between the political adventure, the aesthetic adventure and the metaphysical ad-
venture" (15). His writing follows the same discursive pattern. He touches upon a
vast array of subjects and themes, from his first essays on the origins of cubist poetry
or the graphic art of the painter and book illustrator Démétrius Galanis to the
philosophical meditations of the kind found in *La Tentation de l'Occident*, to ideas on art
and museography in *La Voie royale* and heroic actions in *Les Conquérants* and *La Condition
humaine*.

8 Tcheou Ta-Kouan, a monk sent by the Chinese emperor, spent a year at the end of
the thirteenth century in the former capital of the Khmer empire and wrote his
Mémoires sur les coutumes du Cambodge on his return to China.

9 For a fascinating account of Malraux's debut as an editor, see Langlois, "The Debut
of André Malraux, Editor (Kra, 1920–22)." Unfortunately, Langlois devotes only a
few lines to his later activities as a publisher: "Immediately after returning from
Indochina in 1926, he organized a luxury book publishing venture with his friend
Louis Chevasson. The series, first called *A la Sphère* and later *Aux Aldes*, included some
fifteen volumes, several of which are truly outstanding examples of the art book"
(122).

10 *Le Petit Robert* 2 defines Moi in the following fashion: "Vietnamese word meaning
'savage.' Pejorative term used by the Vietnamese to designate the 'mountainous peo-

ples of the South of Indochina,' the Stieng and Phnong peoples of Cambodia, the Khâ of Laos, of proto-Malaysian or Indonesian origin, driven back by the Thai people or the Vietnamese."

11 Ross explains geopolitical ambitions exclusively in terms of art conservation: "Of the Art, Khmer or Cham, very little has been known until now. During the Siamese occupation of the country everything was disregarded and neglected. There were very few travellers, very few books were written; very few photographs were taken; and almost nothing was published. Now that the country has come under the control of the French, systematic explorations and investigations are being made, a number of scientific men are writing descriptions and producing illustrations" (12). The colonization of Indochina by the French is seen here exclusively in terms of contribution to cultural preservation. When the French colonized the peninsula, the kingdom of Cambodia, the legitimate heir to the ancient Khmer empire, was on the verge of being absorbed on the east by Annam and on the west by Siam. Sixty years earlier, Siam annexed the Cambodian province of Siem-Reap, where the ruins of Angkor lie. France in 1907 imposed a treaty with Siam, which restituted Siem-Reap and two other provinces to Cambodia. It is at the turn of the century, in 1901, that the Ecole française d'Extrême-Orient was founded. Its goal, which appeared in the first issue of the *Bulletin* in January 1901, was "to undertake in a coherent fashion the archeological and philological exploration of the Indochinese peninsula. With the help of military personnel and civil servants transformed for that purpose into ethnographers, epigraphists, geographers and archeologists" (OC1 1153). The most pressing task at hand was to draw up an inventory of all archeological sites, a mission undertaken by E. Lunet de Lajonquière, significantly a "former commander of a French colonial battalion [chef de bataillon d'infanterie coloniale]" who had explored many provinces of Cambodia. In 1907 and 1908, he explored the area surrounding Angkor and published a list of his findings in the third volume of his (grand) "Inventaire descriptifs des monuments du Cambodge" (*Oeuvres* 1154), a list that, as we have seen, particularly interested André and Clara Malraux and will be consulted many times by Claude Vannec in *La Voie royale*.

This succinct summary of the state of Western archeological research in Indochina at the time of Malraux's "Indochinese adventure" provides a much needed context to Malraux's expedition and sets the stage for Malraux's first journey to Indochina. Ross's essay is not only symptomatic of Western thinking about the art of Indochina, but it also gives insights into Malraux's own perception of what constitutes if not legitimates at least acceptable practice.

12 The narrator describes their encounter in these terms: "It is difficult to film the reign, because there is none. It will exist only in Mayrena's imagination and his listeners' dreams. Clappique therefore has to film what took place during these six months in a rapid rhythm. And create an antiromantic exoticism. In short, an outlandish documentary" (*Anti-memoirs* 300).

13 Maurice Soulié narrates Mareyna's story in *Marie 1er Roi des Sedangs 1888–1890*.

14 Malraux never dispelled the ambiguity that existed between the adventures of the character in his novel and his own life experience, even sustaining the confusion so that he would, in the end, be attributed with the qualifications of his imaginary characters. Even after the publication of Vandegans's article "Malraux-a-t-il fréquenté les grandes écoles?" in 1960, which should have dispelled any ambiguity about his formal education, Malraux critics continued to assume that he had indeed been a student at the Ecole nationale des langues orientales vivantes, the Ecole du Louvre, and even the Sorbonne (see Vandegans, "Malraux").

15 The original French reads:

> On dirait qu'en art le temps n'existe pas. Ce qui m'intéresse, comprenez-vous c'est la décomposition, la transformation de ces oeuvres, leur vie la plus profonde, qui est faite de la mort des hommes. Toute oeuvre d'art, en somme, tend à devenir mythe. . . .
>
> Les musées sont pour moi des lieux où les oeuvres du passé, devenues mythes, dorment,—vivent d'une vie historique—en attendant que les artistes les rappellent à une existence réelle. Et si elle me touchent directement, c'est parce que l'artiste a ce pouvoir de résurrection. En profondeur, toute civilisation est impénétrable pour une autre. Mais les objets restent, et nous sommes aveugles devant eux jusqu'à ce que nos mythes s'accordent avec eux. (*La Voie royale* 42–43).

16 Once again I give the French original to give a sense of Malraux's tone:

> Le dialogue qui lie notre culture aux absolus éphémères que lui transmettent les arts ressuscités, rétablit avec un passé qu'il modèle le lien des dieux grecs avec le cosmos, du Christ avec le sens du monde et les âmes innombrables des vivants et des morts. Toute oeuvre sumérienne suggère un royaume de Sumer, en partie insaisissable, en partie possédé. Les grands musées satisfont en nous un *exotisme de l'histoire*, nous donnent un vaste domaine de pouvoirs humains; mais la longue trace qu'y laisse la sensibilité de la terre n'est pas celle de l'histoire. Ce ne sont pas des sociétés mortes que l'art ressuscite: c'est souvent l'image idéale ou compensatrice qu'elles se faisaient d'elles-mêmes." (159; my emphasis; quoted in Blanchot *L'Amitié* 39)

17 Jean Lacouture reports that some of the letters to the dealers were used against Malraux and Chevasson during the Phnom Penh trial (Lacouture 117).

18 Malraux's reputation was further enhanced by his winning of the Goncourt Prize for *Les Conquérants*, which received further attention with the Trotsky-Malraux debate. See Trotsky's "La Révolution étranglée" and Malraux's "Réponse à Trotsky."

Chapter 5 Geographic Romance: "Errances" and Memories in Marguerite Duras's Colonial Cities

1 I use the following abbreviations for the titles of Duras's work that I cite frequently. B: *Barrage contre le Pacifique*; SW: *Sea Wall*; A: *L'Amant*; L: *The Lover*; ACN: *L'Amant*

de la Chine du nord; NCL: *The North China Lover.* They will appear in the body of the text followed by the page number and in parenthesis.

2 Duras criticism, with rare exceptions, promotes and sustains the myth of Duras as a politically *désengagé* author, the *écrivain de romans* who simply writes stories. Although Duras concedes that existential philosophy had a formative influence on her early work, over the years she repeatedly distanced herself from Sartre. Duras expresses her ambivalent relation to Sartre in several interviews. In 1971, when asked whether she is an "existentialist," she answers: "I do not know if I am one. I would not like to be one but . . . I don't like Sartre: I do not mean the thinker but the writer. It is very difficult for me to speak about Sartre. I think he is more or less a father to us all" (Knapp 655). In 1984, she says that "Sartre was not a writer. He is a moralist" (*Apostrophes* n.p.).

3 Blanchot read *Le Square* (1955) as a narrative about "Two abstract voices in an almost abstract place. That is what reaches us [nous atteint] first, this type of abstraction" ("La douleur" 224). Lacan is also "atteint" by Duras's work. In his study of *Le Ravissement de Lol V. Stein* (1964), he examines "la place du regard" in eliciting desire and structuring the subject, what he elliptically calls "the grammar of the subject." The work of these two important theorists continues today to exert a strong influence on contemporary approaches to Duras's work. The importance of "voice" and "gaze" in Duras's novelistic and filmic productions is now taken for granted and has been the subject of a number of important critical analyses. These studies tend, however, to confine themselves to investigating issues that reflect the critics' modernist or post-modernist penchant, all too often confining their exploration of her work to questions of "literariness," of the status of her language, with its silence and gaps, in an effort to confirm the prescribed notion that her work broke new ground and can be legitimately identified with those of the nouveau romancier. More recently, feminist critics have turned their attention to the question of the roles of the mother and of death and desire, and how they figure in her writing, questions deemed central to a better understanding of Duras's work. Much can also be learned from studies devoted to the mother/daughter plot (see Hirsch). Duras herself has encouraged this type of reading. She writes: "The mother of *Journées entières dans les arbres* and the one in *Barrage contre le Pacifique* are the same. Ours. Yours. Mine as well" ("Mothers" 99). The claim that the mother in her novel represents all mothers is highly problematic. Such claims have been challenged by feminist critics (see Chow; Mohanty, Russo, and Torres) who question the politics underlying the claim of finding a "common" bond among very different groups of women.

4 The translation of "Ils traversent une zone différente du voyage" (ACN 50) as "They enter a different phase of the trip" (NCL 41) fails to convey the important notion of space and spatiality.

5 When asked if there is "une écriture de femmes," Duras answers: "What comes first is the image of a place or a movement, sometimes of a movement in a place. A sort of visual blinking where a mute image interrupts. And then words remove themselves

from the place seen; they are projected, naked projectiles, cut off from the syntax which usually links them in series, they are without articles. Blank spaces appear under the influence of the syntax's violent 'rejet.' It is only the beginning of a universe" (Gauthier 97).

6 Madeleine Borgomano locates the transfigured "primal scene" in the scene where Joseph throws himself on the body of his dead mother in *Un Barrage contre le Pacifique* (B 359), a novel she calls a "'novel of origins,' because everything begins there, the adventure of the subject as well as that of the text" (121). She adds: "In Duras's universe, this primitive scene is tightly linked with death and the death drive: although carnal, it is less perceived as a love scene or sexual violence. It is rather a scene of mourning, of final tearing off. The desire that this scene elicits in the subject, is first a desire 'inversé du monde,' a desire of fusion with death" (123).

7 There are too many examples to enumerate. The long march of the Laotian beggar in *India Song;* the *déambulation* of the people in *La Femme du Gange;* Ma's wandering in the city to sell a diamond in *Un Barrage contre le Pacifique;* her passage to Indochina from France on a Messageries Maritimes liner. The twenty-four-day journey—"the only voyages the women ever made" (L 108)—is, for many French women, their only opportunity for "adventure," a point that deserves to be discussed more fully elsewhere. It suffices to say that these accidental encounters and amorous adventures are played out on these ships in part because "The liners were like towns, with streets, bars, cafés, libraries, drawing rooms, meetings, lovers, weddings, deaths" (L 108).

Suzanne's first sexual contact with a man could also be mentioned. It occurs in M. Jo's car: "The car continued to roll through the chaotic brilliance and darkness of the city. And Monsieur Jo's hands trembled. . . . For the first time. And while the naked hand was on the naked breast. And above the terrifying city, Suzanne saw her breasts, saw the erection of her breasts higher than anything that stood up in the city. Her breasts, then, would be justified" (SW 180). Suzanne's sexual knowledge is not only mediated by the ominous presence of the city, it is linked to her metropolitan experience, a car ride "without aim, without end," which brings the sentiments of both fear and joy. The city as site of anguish and terror is also an erotic site of passion and desire. Errance, in Duras's novels, is not simply a theme but an important strategy of individuation, self-knowledge, and transgression.

8 See Friedman.

9 Alan Cowell describes Kinshasa, the capital of Zaire, the former Congo, as being a dual city composed of "La Cité, the great reptilian slum in Kinshasa," "short for La Cité indigène, the native quarter, as opposed to La Ville, the real city, where the colonials once lived and the rich live now" (31–32).

10 See Wright; Ross and Telkamp.

11 Herma Briffault's English translation is too precise; it reads: "in that epoch, the early twenties." In the French text, Duras does not indicate the exact epoch.

11 Fanon's portrayal of the colonial city is remarkably similar to the one described

by Duras: "The colonial world is a world divided into compartments. It is probably unnecessary to recall the existence of native quarters and European quarters, of schools for natives and schools for Europeans; in the same way we need not recall apartheid in South Africa. Yet, if we examine closely this system of compartments, we will at least be able to reveal the lines of force it implies. This approach to the colonial world, its ordering and its geographical layout will allow us to mark out the lines on which a decolonized society will be organized" (37–38).

13 This view is confirmed by Hébrard: "Many tramways crisscross Indochinese cities. Well developed networks serve popular areas. The tramways are exclusively used by the indigenous people. Generally, one waits in the street, without any special installation. We should contemplate the creation of shelters, at least in certain points, and if possible, a small square to avoid congestion" (282).

14 Herma Briffaut's translation of "pouvoir profond" as "the more basic power" loses the intensity of the French original.

15 As I have noted, the upper district is strictly segregated. In contrast, the lower district where the poor white colonials or "colonial natives" (les coloniaux indignes), like Ma and her children, are relegated, is the place of communication, of mixing, the "contact zone" (Pratt 33). Situated between the upper district and the native suburbs, the lower district is the liminal space where both natives and whites meet and mix.

16 Foucault considered both the colonies and the brothel to be "two extreme types of heterotopia." "The heterotopia is capable of juxtaposing in a single real place several spaces, several sites that are in themselves incompatible" (25). Duras's novel anticipates Foucault's theory of heterotopia and illustrates it when she compares the colony to a "bordel colossal" (B 198) and the colonial city to "un espace orgiaque" (B 168). Foucault adds that "The last trait of heterotopias is that they have a function in relation to all the space that remains. This function unfolds between two extreme poles. Either their role is to create a space of illusion that exposes every real space, all the sites inside of which human life is partitioned, as still more illusory (perhaps that is the role that was played by those famous brothels of which we are now deprived). Or else, on the contrary, their role is to create a space that is other, another real space, as perfect, as meticulous, as well arranged as ours is messy, ill constructed, and jumbled. This latter type would be the heterotopia, not of illusion, but of compensation, and I wonder if certain colonies have not functioned somewhat in this manner. In certain cases, they have played, on the level of the general organization of terrestrial space, the role of heterotopias" (27). The Foucauldian heterotopia of compensation is to be found in the colonies, for the colonies constitute the ultimate "place of illusion," where French cities are constructed in the tropics.

17 In *L'Amant de la Chine du nord*, Duras writes: "Those cubicles, they're like straw huts in the villages. They're a lot less expensive than a house. And you rent them for a fixed price. There aren't any surprises. That's what the Indochinese prefer, especially when they come from the countryside. People are never left to fend for themselves there, they're never alone. They live in the arcade along the street. You must destroy

the customs of the poor. Half the inhabitants sleep in the open arcades. During the monsoon it's cool there, it's wonderful" (NCL 79).

18 Part 1 of Duras's novel can be seen as a counternarrative to the colonial fantasies constituted and promoted by colonial propaganda posters: "[she dreamt in front of] Colonial propaganda posters: 'Enlist in the Colonial Army' said some. And others: 'Young People, a Fortune awaits you in the Colonies!' The picture usually showed a Colonial couple, dressed in white, sitting in rocking-chairs under banana trees while smiling natives busied themselves around them" (SW 17). Colonial life as it is portrayed by Duras in *Un Barrage contre le Pacifique*, and as it is endured by Ma and her children, does not compare to the image of life as it is "represented" in colonial propaganda posters, an image that has become the fundamental referent, the referential framework for their hoped for "reality." Fiction, therefore, has replaced a stark reality and becomes something to yearn for, the ultimate goal. But land management (and speculation, dealings) with its appropriation and expropriation is used as a means to both control the people who live there and to make economic gains through the market for land concessions. In the novel, "on the fifteen land concessions of the plain of Kam, they had settled, ruined, driven off, resettled and again ruined and driven off perhaps a hundred families" (SW 20). The natives fall victim not only to the white colonizers but also to rich Chinese pepper planters who have displaced and relegated them to unfarmable plots of land: "The better to maintain their hopes, she explained to them how the expropriations, of which many had been victims to the profit of Chinese pepper-planters, could also be attributed to the agents of Kam and their dastardly dealings" (SW 44). Appropriation, displacement, expropriation are among the strategies used by those in power, the petty land bureaucrats, to regulate and control the region.

Chapter 6 Filmic Memorials and Colonial Blues:
Indochina in Contemporary French Cinema

1 French television was a very effective vehicle for disseminating information on the subject. Schoendoerffer presented *Dien Bien Phu* (1992) *en avant première* (in preview) on the Franche-Comté regional newscast. TF1 presented *Récits d'Indochine*, a 1992 documentary made by Patrick Jeudy, on March 6, 1992, at 23.50. Bernard Pivot devoted a special "Bouillon de culture," a literary and cultural television program, to the subject of Dien Bien Phu on March 1, 1992. FR3 returned to this subject on March 19, 1992, with an evening entitled "Hommes de caractères" (Men with strong personality). After screening Pierre Schoendoerffer's *Le Crabe-Tambour*, a documentary on Dien Bien Phu entitled *La Mémoire et l'oubli* (1992), directed by Yves and Ada Rémy was presented. For a more detailed view of the programming, see Boillon 3.

2 Alain Bouzy reviews their documentary film thus: "Between 1954 and 1962, they were officially involved in peace-keeping operations [des opérations de maintien de

l'ordre], since this war was never given a name. Patrick Rotman and Bertrand Taver-nier, however, name this war: by asking those who took part in it as participants [acteurs] to narrate and by letting the camera 'listen' to these forty witnesses, all of them natives of the Grenoble region. Four hours of immersion in History through the sole mediation of narration. No artifice, no mise-en-scène (staging), but a simple montage which organizes the subject. The camera films in close-up shot [en plan serré]. Rotman asks simple questions. They remember" (n.p.).

3 It is worth mentioning that all three movies on Indochina were accompanied by either a photographic album of the shooting (see Jean-Jacques Annaud, *L'Amant* and Pierre Schoendoerffer, *Dien-Bien-Phu: De la Bataille au film*) or an outright novel (see Christian de Montella, *Indochine*). Following the success of the movies and books, Jean-Luc Coatalem published his *Suite Indochinoise* and Christophe Bataille *Annam*. The collected works of Jean Hougron had appeared in two volumes under the title *La Nuit indochinoise*. Military accounts of the war were also reissued (see in particular the work of Erwan Bergot and Pierre Schoendoerffer).

As far as cinema is concerned, only a few films on Indochina were ever shot. Very little attention has been paid to French feature films on Indochina in part because of their scarcity—Pierre Sorlin finds only one film that takes place in Indochina in the thirties (see Sorlin, "The Fanciful Empire: French Feature Films and the Colonies in the 1930s"). Pierre Boulanger, in his study of colonial cinema, *Le Cinéma colonial: De "l'Atlantide" à "Lawrence d'Arabie,"* concentrates on the Maghreb and Central Africa and does not deal in detail with any other parts of the French empire. The cinematic love affair with Indochina is a recent phenomenon. Why, one may ask, such an interest, an "engouement," un coup de foudre, un coup de coeur" (Siclier 14) for the Indochine of the interwar period? Such a passion for colonial movies was not always a prevailing trend. Of the 1,305 adventure films shot in the thirties, only 21 were made on Asia, and not a single one featured Indochina, remarkable in its absence (see Thobie et al. 305).

4 Jameson notices a disturbing trend in filmic representations of history which fetishize the image "as substitutes for any genuine historical consciousness." He writes: "When I talked about the loss of history, I didn't mean the disappearance of images of history, for instance, in the case of nostalgia film. The increasing number of films about the past are no longer historical; they are images, simulacra, and pastiches of the past. They are effectively a way of satisfying a chemical craving for historicity, using a product that substitutes for and blocks it. . . . But nostalgia art gives us the image of various generations of the past as fashion-plate images that entertain no determinable ideological relationship to other moments of time: they are not the outcome of anything, nor are they the antecedents of our present; they are simply images. This is the sense in which I describe them as substitutes for any genuine historical consciousness rather than specific new forms of the latter" (Stephanson 18). See his "Nostalgia for the Present" for a more extended discussion of nostalgia film.

5 Régis Wargnier wrote the screenplay with Deneuve in mind. The role of Eliane was created especially for her. Deneuve remembers: "He had spoken to me about a project revolving around a woman character who had the responsibilities of a man but who retained all the benefits of being a woman. He began with this simple idea, of Indochina and a young orphaned princess. I gave him an agreement in principle. From there the story developed" (Deneuve 68).

6 Jean Noury narrates the history of the French presence in Indochina through postcards in *L'Indochine avant l'ouragan.*

7 See Teresa de Lauretis, *The Technologies of Gender: Essays on Theory, Film, and Fiction;* Laura Mulvey, *Visual and Other Pleasures;* Rey Chow, *Woman and Chinese Modernity* and *Primitive Passions.*

8 "Dresses in the color of passion. Her elegance in *Indochine* is also that of the heart. . . . Gabriella has conceived for her, in Régis Wargnier's movie, dream clothes [des toilettes de rêve]. With each original sketch was attached a fabric sample. And, on the screen, the result is sublime" (Deneuve 69).

9 Annaud also provides the following reasons for adapting Duras's novel: "Among the reasons which led me to adapt it to the screen was the fact that this story took place in a French colony. In other words, it wasn't simply a love-story: it also involved the encounter of two races, two cultures, a phenomenon which fascinated me ever since the day, when, having just graduated from the IDHEC, I was sent as a delegate to the 'service des arts et du commerce de l'industrie cinématographique' of the Federal Republic of Cameroon. Africa had overwhelmed me" (*L'Amant* 12).

10 The following passage exemplifies the working conditions in "this completely impoverished nation":

> Assistants, assistant-directors had been living in Vietnam for several months. They cleared the terrain in Cochinchina, opened bank-accounts, requested authorizations for filming, submitted the screenplay to the censors, contacted the militia and the water-patrol; they surrounded themselves with historical advisors and convinced customs to allow them to import all of the equipment. The team in charge of the film sets had built a gigantic hangar to accommodate rickshaws, tilburies, bicycles, a country bus, antique cars, oxcarts, wagons, old chassis, items brought, as the weeks passed, by the last autochthonous artisans who had rebuilt them with period pieces and material. The team in charge of the costumes had set up dyeing, embroidering, and sewing workrooms where fifty Vietnamese dressmakers worked, subcontracting to two hundred manufacturers. The designer of these costumes would often travel to the Cambodian border in search of a few meters of lacquered silk which could be used to make a costume, a dress, a stole, a scarf. (Annaud, *L'Amant* 21–22)

11 Annaud may have succeeded in translating into the filmic image the writerly quality of Duras's novel in the credit title sequence. The gold nib of the black pen moves sensual on the surface of parchmentlike paper; the distinctive sound of writing is superimposed with the deep voice of Jeanne Moreau. Then the paper becomes

skin, the skin of the lovers. This beautiful sequence is not without precedent nor entirely original. It echoes the opening shot used by Alain Resnais in *Hiroshima mon amour*. The bodies of the entwined lovers are first seen as body parts, framed by the camera; later on, the same shots frame the bodies of Japanese victims of the atomic bomb and, still later, that of the French heroine's first lover, a German soldier.

12 Annaud writes that after the end of the filming in Vietnam, "the young woman and the Chinese man met eight days later in a Parisian studio, which was turned into a bachelor flat for seven weeks" (*L'Amant* 34). He ends his narrative thus: "In Vietnam, I had shown the young woman's unwillingness to adhere to the moral of a community which had rejected her. In the bachelor flat, I wanted to suture the spectator to the spectacle of pleasure, to make him/her love unrestrainedly the image of desire, the image of love" (35).

13 *Dien Bien Phu* premiered on March 4, 1992.

14 Jean-Luc Macia, in "Dien Bien Phu, notre 'Apocalypse Now,'" uses docudrama or film-vérité to describe Schoendoerffer's movie. The documentary or vérité refers to a variety of elements: the shooting on location with the collaboration of the Vietnamese, the fact that Allaire became the "military adviser" for the movie, the use of war equipment from the period, the Vietnamese extras, and so on. The distinction between "journalistic report" and "fiction" is blurred further by the overlapping plot lines (or, as Macia writes, "two films in one"). Schoendoerffer also depicts the life of two journalists, one French, the other American, in search of information for their daily column. One could argue that Schoendoerffer's movie questions its own representational practice, how and what journalists are able to cover within the constraints of military blackouts and, perhaps unwittingly, cover up, undermining its own authority in elaborating a transparent and "accurate" "coverage" of the war in Indochina.

15 I am indebted to Colette Boillon. Former enemies have also been given the opportunity to tell their version of the story. In her television program, the historian Danièle Rousselier attempts to balance the views of French military personnel, colonial civil servants, and politicians on the Indochinese question with those of the Vietnamese. She interviews peasants, writers, and leaders such as General Giap, the commander-in-chief of the Vietminh forces during the battle of Dien Bien Phu, giving her "televised documentary" a dialogical aspect that other television programs lack. Thus, we learn that the Vietnamese call the Indochina War the "first war," which gave rise to an even more dreadful "second war." One of the highlights of this program is "the dialogue between Colonel Allaire—sublieutenant during the Indochina War—and the writer N'guyen Dinh Thi—a renowned poet who fought against Allaire at Dien Bien Phu" (see also Macia).

16 These benefits were extended to *Indochine* and *The Lover*; all three movies were shot on location, thanks to the intervention and support of the French government. *The Royal Way*, an Andrei Konchalovski film based on the book by André Malraux, was scheduled to begin principle photography in Vietnam in May 1994, yet was not completed at the time of this writing.

17 For a discussion of the strategies in "hutchographic commemoration," see Ory, "Le Centenaire de la Révolution Française."

18 This official gesture of recognition for their sacrifice is, however, deflated by the February 10, 1993, news commentary on France 2, French national television, describing the battle of Dien Bien Phu: "But the fortified camp had transformed itself into a trap. Frenchmen were *in the minority* in the ranks of an army made up essentially of Thai, Annamites, and even Senegalese recruits, men who were less motivated than the 40,000 Vietminh warriors with their elite troops and suicide commandos who faced them" (my emphasis).

19 *Les cahiers de la cínematbèque* devoted an entire issue (titled "Souvenirs d'Indochine") to Indochina's role in French filmic representations.

Conclusion: Retracing the Legacy of "Indochina Adventures"

1 Barthes's visionary lucidity is eloquently expressed in *Empire of Signs*: "Someday we must write the history of our own obscurity—manifest the density of our narcissism, tally down through the centuries the several appeals to difference we may have occasionally heard, the ideological recuperations which have infallibly followed and which consist in always acclimating our incognizance of Asia by means of certain known languages (the Orient of Voltaire, of the Revue Asiatique, of Pierre Loti, or of Air France)" (4). In this respect, the latest TV ad for Air France, a brilliant minimalist line drawing that circles the globe marking its landscape with its most famous landmarks, predictably traces Angkor Wat in "Indochina."

2 J. Alliau, *Invitation au voyage*, Tulle, 1985.

3 Several questions beg to be raised when one is confronted with the issue of the "literate" traveler. What constitutes or makes a traveler literate in this particular context? Are there criteria against which the "colonial literacy" of an individual can be measured? How can we measure "colonial literacy"? What are the presumptions made when one raises the question of "literacy"? Is a partial knowledge of the colonial history of Southeast Asia sufficient in determining "colonial literacy," especially in the light of the competing British, French, and American hegemonic influence over the region?

WORKS CITED

Abel, Richard. *French Cinema: The First Wave 1915–1929*. Princeton: Princeton University Press, 1984.

Ageron, Charles-Robert. *L'Anticolonialisme en France de 1871 à 1914*. Paris: Presses Universitaires de France, 1973.

——. "L'Exposition Coloniale de 1931: Mythe républicain ou mythe impérial?" In *Les Lieux de mémoire: La République*, ed. Pierre Nora, ed. Paris: Gallimard/Bibliothèque Illustrée des Histoires, 1984. 561–91.

——. *France coloniale ou parti colonial?* Paris: Presses Universitaires de France, 1978.

——. *Au Temps des colonies*. Paris: Le Seuil/Histoire, 1984.

Ageron, Charles-Robert, ed. *Les chemins de la décolonisation de l'empire colonial français*. Colloque orgainisé par l'I.H.P.T. les 4 et 5 octobre 1984. Paris: Editions du Centre National de la Recherche Scientifique, 1986.

Ajalbert, Jean. *L'Indochine*. Paris: Gallimard, 1931.

Allegret, Marc. "Notes sur les Massa-Mousgoum." *Le Monde colonial illustré* (mai 1927): 107.

Alliau, Jeanne. *Invitation au voyage: Indochine des années 30*. Tulle: Imprimerie Orfeuil, 1985.

Allwood, John. *The Great Exhibitions*. London: Studio Vista, 1977.

Annaud, Jean-Jacques. *L'Amant*. Illustré par les photos de Benoît Barbier. Paris: Grasset, 1992.

——. "L'Amant." *Le Point* 1008 (11 janvier 1992): 62–64.

——. "Impressions of Vietnam." *Harper's Bazaar* (September 1992): 174–77.

"Apostrophes" [a French television literary magazine]. *Antenne 2* (28 September 1984).

Aragon, Louis. "Mars á Vicennes." In *L'Oeuvre poétique, 1930–1933*. Paris: Livre Club Diderot, 1975. 212–16.

——. "Une Préface morcelée: L'an 31 et l'envers de ce temps." In *L'Oeuvre poétique, 1930–1933*. Paris: Livre Club Diderot, 1975. 183–95.

Archives des Instituts Pasteur d'Indochine. Saigon: Instituts Pasteur d'Indochine, 1925.

August, Thomas G. "(The) Circus Comes to Town." *The Selling of the Empire*. Westport: Greenwood Press, 1985. 125–53.

L'Avenir de l'Annam. Toulouse (1 mars 1928).

Bal, Mieke. "Telling, Showing, Showing Off." *Critical Inquiry* 18 (Spring 1992): 556–94.

Barthes, Roland. *The Eiffel Tower and Other Mythologies*. New York: Hill and Wang, 1979.

——. *Empire of Signs*. Trans. Richard Howard. New York: Hill and Wang, 1982. Originally published as *L'Empire des signes*. (Genève: Editions Albert Skira, 1970).

——. *Le Degré zéro de l'écriture suivi de nouveaux essais critiques*. Paris: Editions du Seuil, 1972.

——. *Mythologies*. Paris: Editions du Seuil, 1957.

——. "Pierre Loti: Aziyadé." *New Critical Essays*. Trans. Richard Howard. New York: Hill and Wang, 1980. 105–21.

——. "Sémiologie et urbanisme." *Architecture d'aujourd'hui* 153 (décembre 1970–janvier 1971): 11–13.

Bataille, Christophe. *Annam*. Paris: Arlea, 1993.

Bayard, Emile. *L'Art de reconnaître les styles coloniaux de la France*. Paris: Garnier, 1931.

Bazin, André. *What Is Cinema?* Vol. 1. Trans. Hugh Gray. Berkeley: University of California Press, 1967.

Beauplan, Robert de. "Les Palais de l'Indochine." *L'Illustration* 4612 (25 juillet 1931), n.p.

Beautheac, Nadine, and François-Xavier Bouchart. *L'Europe exotique*. Paris: Société Nationale des Editions du Chêne, 1985.

Benjamin, Walter. "Paris, Capital of the Nineteenth Century." *Reflections*. Trans. Edmund Jephcott. New York: Schocken Books, 1986. 146–62.

——. "Theses on the Philosophy of History." In *Illuminations*. ed. Hannah Arendt. New York: Schocken Books, 1969. 253–64.

Bernard, Noel. *Les Instituts Pasteur d'Indochine: Centenaire de Louis Pasteur, 1822–1895*. Saigon: Imprimerie Nouvelle, 1922.

Bergot, Erwan. *Indochine 1951: Une année de victoire*. Paris: Presses de la Cite, 1987.

——. *2e Classe à Dien Bien Phu*. Paris: Presses de la Cité, 1988.

Berque, Jacques. *Dépossession du monde*. Paris: Editions du Seuil, 1964.

Bhabha, Homi. *The Location of Culture*. London: Routledge, 1994.

——. "The Other Question. Homi K. Bhabha Reconsiders the Stereotype and Colonial Discourse." *Screen* 24 (November–December, 1983): 156–61.

——. "Representation and the Colonial Text: A Critical Exploration of Some Forms of Mimeticism." In *The Theory of Reading*, ed. Frank Gloversmith. Sussex: The Harvester Press, Limited, 1984. 93–121.

——. "Signs Taken for Wonder: Questions of Ambivalence under a Tree Outside Delhi, May 1817." *Critical Inquiry* (Autumn 1987): 144–65; rpt. in *Race, Writing, and Difference*, ed. Henry Louis Gates Jr. Chicago: University of Chicago Press, 1986. 163–84.

Blake, Patricia. "The Stronger Bulwark." Rev. of *The Sea Wall*, by Marguerite Duras. *New York Times Book Review* 15 March 1953: 5.

Blanchot, Maurice. "La douleur du dialogue." *Le Livre à venir*. Paris: Editions Gallimard, 1959. 223–34.

———. "Le Musée, l'art et le temps." *Critique* 7 (décembre 1950–janvier 1951) 195–208. Rpt. in *L'Amitié*. Paris: Editions Gallimard/NRF, 1971: 21–51. Trans. by Beth Archer as "Time, Art and the Museum" in *Malraux*, ed. R. W. B. Lewis. Englewood Cliffs: Prentice Hall, 1964.

Bodard, Lucien. *La Guerre d'Indochine*. 5 vols. *L'enlisement, L'illusion, L'humiliation, L'aventure et L'épuisement*. 1963–1967.

Boillon, Colette. "L'offensive télévisuelle." *La Croix l'evénement* (6 mars 1992): 3.

Boivin, Jacques. "La guerre d'Indochine et le cinéma." In *Les Guerres de la France au XXe siècle*, ed. A. Ruscio. Paris: Edilec, 1983. 162–70.

Bordwell, David. "Classical Hollywood: Narrational Principles and Procedures." In *Narrative, Apparatus, Ideology*, ed. Philip Rosen. New York: Columbia University Press, 1986. 17–34.

Borgomano, Madeleine. *Duras, une lecture des fantasmes*. Paris: Editions du Cistre, 1985.

Bosquillon, Christophe. "De l'Exposition coloniale au Musée de la France d'Outre-mer. La mise en scène du colonisé dans la société française (1931–1960)." Unpublished thesis, Université Paris VII, 1985–1986.

Boudot-Lamotte, Emmanuel. "Le Musée des Colonies." *L'Architecture* 44.7 (juillet 1931): 239.

Boulanger, Pierre. *Le Cinéma colonial*. Paris: Editions Seghers, 1975.

Bouzy, Alain. "La Guerre sans nom." *Première* (March 1992): n.p.

Brée, Germaine. "Preface." *The Sea Wall*. Trans. Herma Briffault. New York: The Noonday Press, 1967. vii–xiv.

Brenier, Henry, and Henri Russier. *L'Indochine française*. Paris: Armand Colin, 1911.

Breton, André. "Ne Visitez pas l'Exposition Coloniale." *Tracts Surréalistes et déclarations collectives 1922–1939*. Paris: Le Terrain Vague, 1980. 194–95.

———. "Pour André Malraux." *Les Nouvelles littéraires* (16 août 1924): 2.

Brocheux, Pierre. *L'Indochine française*. Paris: Presses Universitaires de France, 1982.

Brocheux, Pierre. ed. *Histoire de l'Asie du Sud-Est. Révoltes, réformes, révolutions*. Lille: Presses Universitaires de Lille, 1981.

Brocheux, Pierre, and Daniel Hémery. *La Colonisation ambiguë, 1958–1954*. Paris: Editions la Découverte, 1994.

Brombert, Victor. *The Intellectual Hero*. Chicago: University of Chicago Press, 1961.

Buisine, Alain. *L'Orient voilé*. Caheilhan: Editions Zulma, 1993.

Cachin, Marcel. "Une Visite à l'exposition anti-impérialiste." *L'Humanité* (30 octobre 1931): 1.

Carné, Marcel. "L'Exotisme au cinéma: En marge de l'Exposition Coloniale." *Ciné-Magazine* 11.7 (1931): 15–20.

Chambre des députés. Séance du 6 juin 1930 (pp. 2428–2446); séance du 13 juin 1930 (pp. 2490–2508); séance du 20 juin 1930 (pp. 2596–2612). *Journal Officiel*.

Chow, Rey. *Primitive Passions*. New York: Columbia University Press, 1995.

———. *Woman and Chinese Modernity*. Minneapolis: University of Minnesota Press, 1991.

"Chronique: Indochine française." *Bulletin de l'Ecole Française d'Extrême-Orient* 24 (1924): 307–8.

Christie, Clive. "The Quiet American and the Ugly American: Western Literary Perspectives on Indo-China in a Decade of Transition, 1950–1969." Occasional Paper no. 10 (February 1989). Centre for South-East Asian Studies, University of Kent, Canterbury.

Claudel, Paul. "Mon Voyage en Indochine." *Oeuvres Complètes*, Vol. 4. Paris: Gallimard, 1952. 332–44.

Clauss, Max. "Ein Tagebuch der Kâmpfe um Kanton 1925." *Europäische Revue* (août–décembre 1928): 588–604.

Clément, Catherine. *Miroirs du Sujet.* Paris: Union Générale d'Editions, 1975.

Clifford, James. "Objects and Selves: An Afterword." In *Objects and Others: Essays on Museums and Material Culture*, ed. Georges W. Stocking, Jr. Madison: University of Wisconsin Press, 1985. 236–46.

———. *The Predicament of Culture.* Cambridge: Harvard University Press, 1988.

Coatalem, Jean-Luc. *Suite Indochinoise.* Paris: La Table Ronde, 1993.

Coloniales 1920–1940. Musée Municipal de Boulogne-Billancourt, 1990.

Conley, Tom. "Translator's Introduction: For a Literary Historiography." In *The Writing of History* by Michel de Certeau. Trans. Tom Conley. New York: Columbia University Press, 1988. vii–xxiv.

Cowell, Alan. "Magic and Decay." *New York Times Magazine* (April 5, 1992): 31–32.

Cowie, Elizabeth. "Fantasia." In *The Woman in Question: m/f*, eds. Parveen Adams and Elizabeth Cowie. Cambridge: MIT Press, 1990. 149–96.

Crary, Jonathan. *Techniques of the Observer: On Vision and Modernity in the Nineteenth Century.* Cambridge: MIT Press, 1990.

Daney, Charles. *Quand les Français découvraient l'Indochine.* Paris: Editions Herscher, 1981.

d'Astier, Emmanuel. "Dialogue." *L'Evénement* (septembre 1967): 57–62.

Davezac, Bertrand. "Malraux's Ideas on Art and Method in Art Criticism." *Journal of Aesthetics and Art Criticism* 22.2 (Winter 1963): 177–88.

De Bruijne, G. A. "The Colonial City and the Post-Colonial World." In *Colonial Cities*, ed. Robert J. Ross and Gerard J. Telkamp. Dordrecht: Martinus Nijhoff Publishers/Leiden University Press, 1985. 231–43.

De Certeau, Michel. *The Practice of Every Day Life.* Trans. Steven Rendall. Berkeley: University of California Press, 1984.

———. *The Writing of History.* Trans. Tom Conley. New York: Columbia University Press, 1988.

De Courtivron, Isabelle. *Clara Malraux: Une Femme dans le siècle.* Paris: Elissa Gelfard, 1993.

———. "The Other Malraux in Indochina." *Biography* 12.1 (1989): 24–42.

de Lauretis, Teresa. *Alice Doesn't: Feminism, Semiotics, Cinema.* Bloomington: Indiana University Press, 1984.

————. *The Technologies of Gender: Essays on Theory, Film, and Fiction.* Bloomington: Indiana University Press, 1987.

De Gantès, Gilles. "Coloniaux, gouverneurs et ministres: Le rôle des Français du Viet-Nam dans l'évolution du pays, 1902–1914." Ph.D. dissertation, Université de Paris VII, 1994.

————. "Le militaire, la femme, le fonctionnaire: La société européenne dans les villes d'Indochine, 1900–1920." *Etudes Indochinoises* 4 (Mai 1995): 31–40.

————. "La première 'mise en valeur' du Viêt Nam au début du XXème siècle: Les sources françaises et leurs limites." In *Viêt Nam: Sources et Approches*, ed. Philippe Le Failler and Jean-Marie Mancini. Aix-en-Provence: Publications de l'Université de Provence, 1996. 1–14.

de Lauretis, Teresa, and Stephen Heath. *The Cinematic Apparatus.* London: Macmillan, 1980.

Demy, Adolphe. *Essai historique sur les expositions universelles de Paris.* Paris: Librairie Alphonse Picard et fils, 1907.

Deneuve, Catherine. "Interview." Paris Match, 1992.

Deroo, Eric, Gabrielle Deroo, and Marie-Cécile de Taillac. *Aux Colonies.* Paris: Presses de la Cité, 1992.

Descours-Gatin, Chantal. *Quand l'opium finançait la colonisation en Indochine: L'élaboration de la régie générale de l'opium (1860–1914).* Paris: Editions de l'Harmattan, 1992.

"Description sommarie de l'Exposition anti-imperiale: La verite sur les colonies." Microfilm 69, series 461. Bibliotheque Marxiste de Paris.

Doane, Mary Ann. *The Desire to Desire: The Women's Film of the 1940's.* Bloomington: Indiana University Press, 1987.

————. "Film and Masquerade: Theorizing the Female Spectator." *Screen* 23. 3–4 (September–October 1982): 74–87.

————. "Woman's Stake: Filming the Female Body." *October* 17 (Summer 1981). 47–64.

Donato, Eugenio. "The Museum's Furnace: Notes Toward a Contextual Reading of *Bouvard and Pécuchet.*" In *Textual Strategies: Perspectives in Post-Structuralist Criticism*, ed. Josué Harari. Baltimore: Johns Hopkins University Press, 1979. 213–38.

Dorgelès, Roland. *Sur la route mandarine.* Paris: Albin Michel, 1925.

Doyon, R.-L. "Plaidoyer pour André Malraux." *L'Eclair* (9 août 1924): 2.

Drieu La Rochelle, Pierre. "Malraux, l'Homme nouveau." *Nouvelle Revue Française* 35 (1930): 879–85.

Duiker, William. *The Rise of Nationalism in Vietnam.* Ithaca: Cornell University Press, 1976.

Duras, Marguerite. *The Lover.* Trans. Barbara Bray. New York: Harper & Row, 1986. Originally published as *L'Amant.* Paris: Editions de Minuit, 1984.

————. *The North China Lover.* Trans. Leigh Hafrey. New York: The New Press, 1992. Originally published as *L'Amant de la Chine du Nord.* Paris: Editions Gallimard, 1991.

————. *The Sea Wall.* Trans. Herma Briffault. New York: Farrar, Straus & Giroux, 1967. Originally published as *Un Barrage contre le Pacifique.* Paris: Editions Gallimard, 1950.

————. "Vous faites une différence entre mes livres et mes films?" *Le Monde* (13 juin 1991): 18–19.

————. *Les Yeux verts.* Paris: Editions Albatros/Collection Ça/Cinéma, 1980.

Duras, Marguerite, et al. "Mothers." In *Marguerite Duras.* Paris: Editions Albatros, 1979. 99–101.

Duras, Marguerite, and Xavière Gauthier. *Les Parleuses.* Paris: Les Editions du Minuit, 1974.

Du Vivier de Streel, M. E. "Introduction." In *L'Urbanisme aux colonies et dans les pays tropicaux,* ed. Jean Royer. La Charité-sur-Loire: Delayance, 1932. 9–13.

Eco, Umberto. *Travels in Hyper Reality.* Trans. William Weaver. New York: Harcourt Brace Jovanovich, 1986.

Einstein, Carl. "André Masson, étude éthnologique. *Documents* 1.2 (1924): 93–104.

"Exposition Anti-Impérialiste: La Vérité sur les colonies." Microfilm, 69 series 461. Bibliothèque Marxiste de Paris.

Exposition Coloniale Internationale de Paris: Le Livre d'Or. Publié sous le patronnage officiel du Commissariat Général de L'Exposition. Préface du Maréchal Lyautey, introduction de Paul Reynaud, avant-propos de M. Olivier. Paris: Ed. H. Champion, 1931.

Fabian, Johannes. *Time and the Other: How Anthropology Makes Its Object.* New York: Columbia University Press, 1983.

Fanon, Frantz. *The Wretched of the Earth.* New York: Grove Press, 1968.

Farrère, Claude. "Angkor et l'Indochine." L'Exposition Coloniale, Album Hors Série. *L'Illustration* (Juillet 1931): n.p.

Ferguson, Sarah. "Return to Diên Biên Phû." *Sight and Sound* 1.8 (December 1, 1991): 26–28.

Ferro, Marc. *Cinéma et Histoire.* Paris: Denoël, 1977. Translated by Naomi Green under the title *Cinema and History.* Detroit: Wayne State University Press, 1988.

————. *Film et Histoire.* Paris: Editions de l'Ecole des hautes études en sciences sociales, 1984.

Fontenay, Fernand. "L'effroyable détresse des indigènes de l'A.O.F." *L'Humanité* (May 17, 1931): 2.

Foucault, Michel. "Of Other Spaces." *Diacritics* 16.1 (Spring 1986): 22–27.

Forbes, Jill. Review of *Le Cinéma français* by Jacques Siclier. *Screen* 34.4 (Winter 1993): 407–13.

Fougères, Michel. "Les Ruines khmères dans la littérature française." *Présence Francophone* 1 (automne 1970): 71–89.

Fournereau, Lucien. *Les Ruines khmères: Cambodge et Siam.* Paris: E. Leroux, 1890.

Fournereau, Lucien and Jacques Porcher. *Les Ruines d'Angkor: Etude artistique et historique sur les monuments khmers du Cambodge siamois.* Paris: E. Leroux, 1890.

Franchini, Philippe, ed. *Saigon 1925–1945.* Paris: Editions Autrement, 1992.

Freud, Sigmund. "A Child Is Being Beaten," *Standard Edition* 17. London: Hogarth Press, Ltd. 1959.

————. "Creative Writers and Day-Dreaming." *Standard Edition* 9. London: Hogarth Press, Ltd., 1959.

——. "Hysterical Phantasies and their Relation to Bisexuality," *Standard Edition* 9. London: Hogarth Press, Ltd., 1959.

——. "The Unconscious," *Standard Edition* 17. London: Hogarth Press, Ltd., 1959.

Friedman, J. "The Spatial Organization of Power in the Development of Urban Systems." *Comparative Urban Research* 1 (1972): 5–42.

Frohock, W. M. *André Malraux and the Tragic Imagination.* Stanford: Stanford University Press, 1952.

Gaillard, Roger. "La Vie de Tao est en danger!" *L'Humanité* (7 mai 1931): 1.

Garnier, Francis. *Voyage d'exploration en Indochine.* Paris: Hachette, 1873.

Garros, Georges. *Forceries humaines: l'Indochine litigieuse esquisse d'une entente franco-annamite.* Paris: A. Delpeuch, 1926.

Gauthier, Xavière. "Luttes de femmes." *Tel Quel* 58 (été 1974): 93–102.

Geertz, Clifford. *The Interpretation of Cultures.* New York: Basic Books, 1973.

Georges, Marcel. *Go sur Dien Bien Phu.* Paris: France-Empire, 1992.

Gervereau, Laurent. *La Propagande par l'affiche.* Paris: Editions Syros Alternatives, 1991.

Gide, André. "La détresse de notre Afrique équatoriale." *La Revue de Paris* (15 octobre 1927): 721–32.

——. "Les villages des tribus massas." *L'Illustration* (5 mars 1927): n.p.

Girard, René. "Les Réflexions sur l'art dans les romans d'André Malraux." *Modern Language Notes* 58 (December 1953): 544–46.

——. "The Role of Eroticism in Malraux's Fiction." *Yale French Studies* 11 (1954): 49–54.

Girardet, Raoul. "L'Apothéose de la 'plus grande France': L'idée coloniale devant l'opinion française (1930–1935)." *Revue de Science Politique* 15.6 (décembre 1968): 1085–114.

——. *L'Idée coloniale en France de 1871 à 1962.* Paris: La Table Ronde, 1972.

Goissaud, Antony. "A l'Exposition Coloniale: Le Musée Permanent des Colonies." *La Construction Moderne* (31 janvier 1932): 278–96.

Goldmann, Lucien. *Pour une sociologie du roman.* Paris: Gallimard, 1964.

Gombrich, Ernst. *Meditations on a Hobby Horse: And Other Essays on the Theory of Art.* London: Phaidon Press, 1963.

——. "La Philosophie de l'art de Malraux dans une perspective historique." In *Malraux: Être et Dire,* ed. Martine de Courcel. Paris: Plon, 1976. 216–34.

Greene, Graham. *The Quiet American.* New York: Viking, 1957.

Griaule, Marcel. *Arts de l'Afrique noire.* Paris: Duchêne, 1947.

Halbwachs, Maurice. *On Collective Memory.* Chicago: University of Chicago Press, 1992. Originally published as *La Mémoire collective.* Paris: PUF, 1968.

Hanotaux, Gabriel, and Alfred Martineau. *Histoire des colonies françaises et de l'expansion de la France dans le monde.* Tome 5. *L'Inde. L'Indochine.* Paris: Plon, 1932.

Haraway, Donna. "Teddy Bear Patriarchy: Taxidermy in the Garden of Eden, New York City, 1908–1936." *Social Text* 11 (Winter 1984–85): 20–64.

Harley, J. Brian. "Deconstructing the Map." *Cartographica* 26.2 (Summer 1989): 1–20.

——. "Maps, Knowledge, Power." In *The Iconography of Landscape: Essays on the Symbolic*

Representation, Design and Use of Past Environments, ed. Denis Cosgrove and Stephen Daniels. Cambridge: Cambridge University Press, 1988. 277–312.

Harley, J. B., and David Woodward, eds. "Preface." *The History of Cartography.* Chicago: University of Chicago Press, 1987. 1:xv–xxi.

Hartman, Geoffrey H. *André Malraux.* London: Bowes and Bowes, 1960.

Harris, Geoffrey T. *Andre Malraux: L'Ethique comme fonction de Pesthetique.* Paris: Letters Modernes, 1972.

———. "Malraux: De l'Indochine au R.P.F. Une continuité politique dans l'histoire." *André Malraux* 5 (1982): 9–34.

———. "La Tentation de l'Occident: In Defense of a Colonial Status Quo." *Mélanges Malraux* 17.1–2 (Spring–Fall 1985): 10–19.

Hébrard, Ernest. "L'Urbanisme en Indochine." In *L'Urbanisme aux colonies*, vol. 1, ed. Jean Royer. La Charité-sur-Loire: Delayance, Editeur, 1932. 278–89.

Heath, Stephen. "Narrative Space." In *Narrative, Apparatus, Ideology: A Film Theory Reader*, ed. Philip Rosen. New York: Columbia University Press, 1986. 379–420.

Heidegger, Martin. *The Question Concerning Technology and Other Essays.* Trans. William Lovitt. New York: Harper Colophon Books, 1977.

Hémery, Daniel. *Ho Chi Minh: De l'Indochine au Vietnam.* Paris: Découverte Gallimard/ Histoire, 1990.

———. "Du Patriotisme au marxisme: L'Immigration vietnamienne en France de 1926 à 1930." *Le Mouvement social* 90 (janvier–mars 1975): 3–54.

———. "Tha Thu Thau: L'Itinéraire politique d'un révolutionnaire vietnamien." In *Histoire de l'Asie du Sud-Est: Révoltes, réformes, révolutions*, ed. Pierre Broucheux. Lille: Presses Universitaires de Lille, 1981. 193–222.

Herr, Michael. *Dispatches.* New York: Alfred A. Knopf, 1968.

Hewitt, Leah. *Autobiographical Tightropes.* Lincoln: University of Nebraska Press, 1990.

Heymann, Daniel, and Michel Frodon. "L'Amour du travail." *Le Monde* (23 January 1992): 31.

Hickey, Gerald Cannon. *Kingdom in the Morning Mist: Mayréna in the Highlands of Vietnam.* Philadelphia: University of Pennsylvania Press, 1988.

Hirsch, Marianne. *The Mother/Daughter Plot: Narrative, Psychoanalysis, Feminism.* Bloomington: Indiana University Press, 1989.

Hobsbawm, Eric. *The Age of Empire (1875–1914).* New York: Vintage, 1989.

Hobsbawm, Eric and Terence Ranger. *The Invention of Tradition.* New York: Cambridge University Press, 1983.

Hodeir, Catherine. "Une journée à l'exposition coloniale." *Histoire* 69 (1984): 41–48.

Hodeir, Catherine and Michel Pierre. *L'Exposition coloniale.* Bruxelles: Editions Complexe, 1991.

Hougron, Jean. "Preface," *La nuit Indochinoise*, vol. 1. Paris: Editions Laffont, 1989.

Isoart, Paul. *Le Phénomène national vietnamien.* Paris: Librairie Général de Droit et de Jurisprudence, 1961. 286–87.

Jacob, Christian. *L'Empire des cartes: Approche thérotique de la cartographie à travers l'histoire.* Paris: Albin Michel, 1992.

Jameson, Fredric. "Nostalgia for the Present." *Postmodernism, or, The Cultural Logic of Late Capitalism.* Durham: Duke University Press, 1991. 279–96.

———. *The Political Unconscious.* Ithaca: Cornell University Press, 1981.

Janniot, Alfred. *Le Bas-relief du Musée des Colonies.* Paris: Librairie d'art, Louis Reynaud, 1931.

Jardine, Alice A. and Anne M. Menke. "Exploding the Issue: 'French' 'Women' 'Writers' and 'The Canon'?" *Yale French Studies* 75 (Fall 1988): 229–58.

"Journal de 20 heures." France 2 (French national television). 10 February 1993.

Kaplan, Cora. "The Thorn Birds: Fiction, Fantasy, Femininity." *Sea Changes: Essays on Culture and Feminism.* London: Verso, 1986. 117–46.

Karp, Ivan and Steven D. Lavine, eds. *Exhibiting Cultures: The Poetics and Politics of Museum Display.* Washington, D.C.: Smithsonian Institution Press, 1991.

Kessel, Joseph. "L'Aventurier." *Le Matin* (November 9, 1930): 1.

Khôi, Lê Thánh. *Le Viet-Nam: Histoire et civilisation.* Paris: Les Editions de Minuit, 1955.

King, Anthony D. "Colonial Cities: Global Pivots of Change." In *Colonial Cities,* ed. Robert J. Ross and Gerard J. Telkamp. Dordrecht: Martinus Nijhoff Publishers/Leiden University Press, 1985. 7–32.

Knapp, Bettina L. "Interview avec Marguerite Duras." *The French Review* 46.4 (mars 1971): 653–59.

Knibiehler, Yvonne and R. Goutelier. *La femme au temps des colonies.* Paris: Stock, 1985.

Korthals Altes, Liesbeth. "L'Ironie ou le savoir de l'amour et de la mort." *Revue des Sciences Humaines* 57.202 (avril–juin 1986): 139–52.

Kristeva, Julia. "The Pain of Sorrow in the Modern World: The Works of Marguerite Duras." *PMLA* 102.2 (March 1987): 138–52.

Lacan, Jacques. *Four Fundamental Concepts of Psycho-Analysis.* Trans. Alan Sheridan. New York: W.W. Norton, 1981.

———. "Hommage fait à Marguerite Duras, du ravissement de Lol V. Stein." In *Marguerite Duras.* Paris: Editions Albatros, 1979: 131–37. First published in 1965 in *Cahiers Renaud-Barrault.*

Lacouture, Jean. *André Malraux: Une vie dans le siècle.* Paris: Editions du Seuil, 1973. Translated by Alan Sheridan under the title *André Malraux.* New York: Pantheon Books, 1975.

Langlois, Walter. *André Malraux: The Indochina Adventure.* New York: Praeger, 1966. Translated by Jean-René Major under the title *André Malraux: L'Aventure indochinoise.* Paris: Mercure de France, 1967.

———. "The Debut of André Malraux, Editor (Kra, 1920–22)." *PMLA* 80.1 (March 1965): 111–22.

Laplanche, Jean, and J.-B. Pontalis. "Fantasy and the Origins of Sexuality." *The International Journal of Psycho-Analysis* 49 (1968): 1–18. Originally published as "Fantasme originaire, fantasme des origines, origine du fantasme." *Les Temps Modernes* 19. 215 (avril 1964): 1835–68.

———. *The Language of Psychoanalysis.* Trans. Donald Nicholson-Smith. New York: W.W. Norton, 1973.

Lawrence, T. E. *Seven Pillars of Wisdom.* 1926. Rpt., London: Penguin Books Ltd., 1962.

Le Bonheur, Albert. *Angkor: Temples en péril.* Paris: Editions Herscher, 1989.

Lebovics, Herman. *True France: The Wars over Cultural Identity, 1900–1945.* Ithaca: Cornell University Press, 1992.

Leenhardt, Jacques. *Une Lecture politique du roman* La Jalousie d'Alain Robbe-Grillet. Paris: Editions de Minuit, 1973.

Lemoine, Bertrand, and Philippe Rivoirart. *Paris: L'Architecture des années trente.* Lyon: La Manufacture, 1987.

Le Petit Robert. Paris: Presses Universitaires de France, 1993.

Leprohon, Pierre. *L'Exotisme et le cinema.* Paris: Les Editions J. Susse, 1945.

Leprun, Sylviane. *Le Théâtre des colonies.* Paris: L'Harmattan, 1986.

Leprun, Sylviane, and Alain Sinou. *Espaces coloniaux en Afrique noire.* Paris: M.U.L./Secrétariat de la recherche architecturale, 1984.

Lévy, Sylvain. *Indochine.* Paris: Société d'Editions Géographiques, Maritimes et Coloniales, 1931.

Lewis, R. W. B., ed. *Malraux: A Collection of Critical Essays.* Englewood Cliffs: Prentice-Hall, Inc., 1964.

Leymarie, Jean. "Malraux et la création artistique." In *Malraux: Etre et Dire,* ed. Martine de Courcel. Paris: Plon, 1976. 235–58.

Liauzu, Claude. *Aux Origines des tier-mondismes.* Paris: L'Harmattan, 1982.

Lionnet, Françoise. Rev. of *Autobiographical Tightropes,* by Leah D. Hewit. *SubStance* 68 (1992): 131–37.

Le Livre des Expositions Universelles 1851–1989. Paris: Ed. des arts décoratifs-Herscher, 1983.

Le Livre d'or de l'Exposition Coloniale Internationale de Paris 1931. Paris: Librairie ancienne Honoré Champion, 1931.

Loti, Pierre. *Les Pagodes d'or: Orné de miniatures birmanes du XVIIe siécles.* Paris: Aux Aldes, 1927.

———. *Un Pèlerin d'Angkor.* Paris: Calmann-Lévy Editeur, 1912.

Loutfi, Martine Astier. *Littérature et Colonialisme. L'Expansion coloniale vue dans la littérature romanesque française 1871–1914.* La Haye: Mouton & Co., 1971.

Lyautey, Louis-Hubert. *Lettres du Tonkin et de Madagascar (1894–1899).* Paris: Librairie Armand Colin, 1921.

Macia, Jean-Luc. "Dien Bien Phu, notre 'Apocalypse Now.'" *La Croix L'Événement* (6 mars 1992): 2.

Maigrot, Emile. "Le Futur Musée permanent des Colonies, à Vincennes. MM. Jaussely et Laprade, architectes." *L'Architecture* 53.1 (janvier 1930): 23.

Malleret, Louis. *L'Exotisme indochinois dans la littérature française depuis 1860.* Paris: Larose, 1934.

Malraux, André. *Antimémoires.* Paris: Editions Gallimard, 1967. Translated by Terence Kilmartin under the title *Anti-Memoirs.* New York: Holt, Rinehart & Winston, 1968.

————. *Antimémoires.* 1972 rev. ed. In *Le Miroir des limbes.* Paris: Editions Gallimard/ Bibliothèque de la Pléiade, 1976.

————. "C'est sur lui que nous devons appuyer notre colonisation." *L'Indochine* (14 août 1925): n.p. Reprinted in *André Malraux: l'aventure indochinoise* by Walter Langlois. Paris: Mercure de France, 1967. 314–16.

————. "D. H. Lawrence et l'érotisme." *Nouvelle Revue française* 38 (janvier 1932): 136– 40. Translated by Melvin Friedman under the title "D.H. Lawrence and Eroticism: Concerning *Lady Chatterley's Lover.*" *Yale French Studies* 11 (1954): 55–58.

————. "L'Homme et la culture artistique." *Carrefour* 7.11 (1946): n.p.

————. "Lettre adressée à Candide." *Nouvelle Revue Française* 35 (1 décembre 1930): 915–16.

————. *Oeuvres complètes.* Vol. 1. Paris: Gallimard/Bibliothèque de la Pléiade, 1986.

————. "Des Origines de la poésie cubiste." *La Connaissance* 1.1 (janvier 1920): 38–43.

————. "Préface." *Exposition D. Galanis.* Paris: Galerie La Licorne, 1922. 4. Rpt. in *Dictionnaire biographique des artistes contemporains (1910–1930)* by Edouard Joseph. Paris: Art & Edition, 1930. 2:89–91.

————. "A propos des illustrations de Galanis." *Arts et Métiers graphiques* 4 (1928): 225– 32.

————. *La Psychologie de l'art.* Geneve: Albert S. Kira, 1950.

————. "Réponse à Trotsky." *Nouvelle Revue Française* 211 (avril 1 1931). Translated by Berth Archer under the title "Reply to Trotsky." In *Malraux,* ed. R. W. B. Lewis. Englewood Cliffs: Prentice-Hall, 1964. 20–24.

————. *La Voie royale.* Paris: Editions Bernard Grasset, 1930. Translated by S. Gilbert under the title *The Royal Way.* New York: Vintage, 1955.

————. *Les Voix du silence.* Paris: 1951.

Malraux, Clara. *Nos Vingt ans.* Paris: Editions Bernard Grasset, 1966. Translated by Patrick O'Brian under the title *Memoirs.* New York: Farrar, Straus & Giroux, 1967.

Mareyna, Marie-David de. *Souvenirs de Cochinchine.* Toulon: Laurent, 1871.

Marseille, Jacques. *L'Age d'or de la France coloniale.* Paris: Albin Michel, 1986.

————. *Empire colonial et capitalisme français.* Paris: Albin Michel, 1984.

Maspero, Georges. *Un Empire colonial française, l'Indochine.* Paris: Editions G. Van Oest, 1929–1930.

Masson, André. *Hanoi pendant la période héroïque.* Paris: Librairie Orientaliste Paul Geuthner, 1929.

Maurer, Evan. "Dada and Surrealism." In *Primitivism in 20th Century Art: Affinity of the Tribal and Modern.* ed. William Rubin. New York: Museum of Modern Art, 1984. 2:535–93.

Mauss, Marcel. *Instructions sommaires pour les collectionneurs d'objects ethnographiques.* Paris: Musée d'Ethnographie du Trodadéro, 1931.

McConnell, Scott. *Leftward Journey: The Education of Vietnamese Students in France 1919– 1939.* New Brunswick: Transaction Publishers, 1989.

"La mémoire de vos rêves." *Rev'Vacances.* (hiver 1993–94): 1–75.

Meuleau, Marc. *Des Pionniers en Extrême-Orient: Histoire de la Banque d'Indochine 1875–1975.* Paris: Fayard, 1990.

Meyer, Charles. *La Vie quotidienne des Français en Indochine 1860–1910.* Paris: Hachette, 1985.

Mitchell, Timothy. *Colonising Egypt.* 1988. Rpt. Berkeley: University of California Press, 1991.

"Mission ethnographique et linguistique Dakar Djibouti." *Minotaure* 2 (1933): 3–5.

Mohanty, Chandra Talpade. "Feminist Encounters: Locating the Politics of Experience." *Copyright* 1 (Fall 1987): 31–43.

———. "Under Western Eyes: Feminist Scholarship and Colonial Discourses." *boundary 2* 13.1 (Spring/Fall 1984): 3–13.

Mohanty, Chandra Talpade, Ann Russo, and Lourdes Torres, eds. *Third World Women and the Politics of Feminism.* Bloomington: Indiana University Press, 1991.

Monet, Paul. *Les Jauniers. Histoire vraie.* Paris: Gallimard/N.R.F., 1930.

Montella, Christian de. *Indochine.* Paris: Fayard, 1992.

Morawski, Stefan. *L'Absolu et la Forme: L'Esthétique d'André Malraux.* Paris: Editions Klincksieck, 1972.

Mounier, Emmanuel. "André Malraux le conquérant aveugle." *L'Espoir des désespérés.* Paris: Editions du Seuil, 1953. 11–81.

Mulvey, Laura. *Visual and Other Pleasures.* Bloomington: Indiana University Press, 1989.

Munier, P. *Les Poètes français d'Indochine.* Hanoi: Cahiers de la Société de Géographie, 1932.

New York Times Magazine, Part II, The Sophisticated Traveler, May 17, 1992.

Nguyen Aï Quôc. *Le Procès de la colonisation française.* Paris: Librairie du Travail, 1925.

Niranjana, Tejaswini. *Siting Translation.* Berkeley: University of California Press, 1992.

Nora, Pierre. "Entre Mémoire et histoire: La problématique des lieux." In *Les Lieux de Mémoire,* ed. Pierre Nora. Paris: Editions Gallimard, 1984. 15–42.

"Notes sur l'Exposition anti-coloniale." Microfilm 69, series 461. Bibliothèque Marxiste de Paris.

Noury, Jean. *L'Indochine avant l'ouragan.* Chartres: Imprimerie Charon, 1984.

"Nouvelles archéologiques et correspondances." *Revue archéologique* (juillet–août 1922): 187.

O'Neill, Molly. "Why Are We in Vietnam?" *New York Times Magazine* (November 21, 1993): 71.

Ortelius, Abraham. *Abrahami Ortelii Anteverpiani Synonymia Geographica.* Antverpiae: Ex officina C. Plantini, 1578.

Ory, Pascal. "Le Centenaire de la Révolution française." In *Les Lieux de mémoire. Vol. 1. La République,* ed. Pierre Nora. Paris: Gallimard, 1984. 523–60.

Palà, Sylvie. *Documents: Exposition Coloniale Internationale de Paris 1931.* Paris: Bibliothèque de la Ville de Paris, 1981.

Paret, Peter, Beth Irwin Lewis, and Paul Paret. *Persuasive Images: Posters of War and Revolution from the Hoover Institution Archives.* Princeton: Princeton University Press, 1992.

Parmentier, Henri. "L'Art d'Indravarman." *Bulletin de l'Ecole française d'Extrême-Orient.* 19 (1919): 66–91.

Parry, Benita. "Problems in Current Theories of Colonial Discourse." *Oxford Literary Review* 9.1–2 (1987): 27–58.

Paudrat, Jean-Louis. "The Arrival of Tribal Objects in the West: From Africa." In *Primitivism in 20th Century Art,* ed. William Rubin. New York: Museum of Modern Art, 1984. 1:125–75.

Pavie, Auguste. *Missie Pavie: Indo-Chine 1879–1895.* 7 vols. Paris: E. Leroux, 1900–1919.

Pelet, Paul. *Atlas des Colonies françaises.* Paris: Librairie Armand Colin, 1902.

Perret, Emmanuel. *Coloniales 1920–1940.* Catalogue de l'exposition au musée Municipal de Boulogne-Billancourt, 7 novembre 1989–31 janvier 1990. 108–21.

Peyre, Henri. "French Tobacco Road: The Scene of 'The Sea Wall.'" Rev. of *The Sea Wall,* by Marguerite Duras. *Saturday Review* (June 13, 1953): 43–44.

Picon, Gaëtan. *Malraux par lui-même.* Paris: Editions du Ecrivains de Toujours/Seuil, 1953.

Piel, Jean. Rev. of *Un Barrage contre le Pacifique,* by Marguerite Duras. *Critique* (décembre 1950). Rpt. in *Marie-Thérèse Ligot commente* Un barrage contre le Pacifique *de Marguerite Duras.* Paris: Editions Gallimard/Foliothèque, 1992. 182–83.

Pierre, José, ed. *Tracts surréalistes et déclarations collectives 1922–1939,* vol. 1 Paris: Le Terrain vague, 1980.

Pluchon, Pierre. *Histoire des médecins et pharmaciens de Marine et des colonies.* Toulouse: Privat, 1985.

Poirier, René. *Des Foires, des peuples, des expositions.* Paris: Plon, 1958.

Porte, Michelle. *Les Lieux de Marguerite Duras.* Paris: Editions de Minuit, 1977.

Pratt, Mary Louise. "Arts of the Contact Zone." *Profession 91,* Modern Language Association of America; 33–40.

"Premier bilan de l'Exposition Coloniale." In *Tracts surréalistes et déclarations collectives 1922–1939* Vol. 1, ed. José Pierre. Paris: Le Terrain Vague, 1980. 198–200.

Rabinow, Paul, and Gwendolyn Wright. "Savoir et Pouvoir dans l'urbanisme moderne colonial d'Ernest Hebrard." *Les Cahiers de la Recherche Architecturale* 9 (1982): 27–43.

Rapport général de l'Exposition Coloniale Internationale. Représenté par le Gouverneur Général Olivier, Rapporteur Général. 9 vols. Paris: Imprimerie Nationale, 1931–1934.

Renoult, Daniel. "En 'Asie française' le travail forcé n'est pas une légende? Et la traite des jaunes s'y poursuit avec l'appui et la protection des 'officiels.'" *L'Humanité* (April 25, 1931): 1–2.

———. "La crise économique au pays d'Annam." *L'Humanité* (May 5, 1931): 1.

Renucci, France. *Souvenirs de femmes au temps des colonies.* Paris: Balland, 1988.

Rivoirard, Philippe. "L'Exposition coloniale ou l'incitation au voyage." *Coloniales 1920–1940.* Paris: Musée Municipal de Boulogne-Billancourt, 1989. 66–94.

Robinson, David. "In Bed with an Ingénue." *Life and Times* (June 18, 1992): 3.

Rosen, Philip, ed. *Narrative, Apparatus, Ideology.* New York: Columbia University Press, 1986.

Ross, Denman W. "An Example of Cambodian Sculpture." In *Fogg Art Museum Notes,* ed. Margaret E. Gilman. Cambridge: Harvard University Press, 1922. 2–13.

Ross, Robert J. and Gerard J. Telkamp. eds. *Colonial Cities.* Leiden: Martinus Nijhoff Publishers/Leiden University Press, 1985.

Roubaud, Louis. *Viet-Nam. La Tragédie indochinoise.* Paris: Valois, 1931.

Rousseaux, André. "Un Quart d'heure avec M. André Malraux." *Candide* 348 (13 Novembre 1930): 3.

Rowan, Mary. "Asia out of Focus: Decoding Malraux's Orient." In *Witnessing André Malraux,* ed. Brian Thompson and Carl A. Viggiani. Middletown, Conn.: Wesleyan University Press, 1984. 140–58.

Roy, Jean-Henri. Rev. of *Un Barrage contre le Pacifique,* by Marguerite Duras. *Les Temps Modernes* 58 (aout 1950): 375–76.

Royer, Jean, ed. *L'Urbanisme aux colonies et dans les pays tropicaux.* Tome 1. Paris: Delayance Editeur, 1932. Tome 2. Paris: Les Editions d'Urbanisme 1935.

Rubin, William. "Modernist Primitivism: An Introduction." In *Primitivism in 20th Century Art,* ed. William Rubin. New York: Museum of Modern Art, 1984.

Ruscio, Alain. *Les Communistes français et la guerre d'Indochine: 1944–1954.* Paris: Harmattan, 1985.

——. *Dien Bien Phu: La Fin d'une illusion.* Paris: L'Harmattan, 1986.

——. *La Décolonisation tragique: une histoire de la décolonisation française, 1945–1962.* Paris: Messidor/Editions Sociales, 1987.

——. *La guerre française d'indochine: 1945–1954.* Bruxelles: Editions Complexes, 1992.

——. *La Première Guerre d'Indochine, 1945–1954: Bibliographie.* Paris: L'Harmattan, 1987.

——. *Viet Nam: l'histoire, la terre, les hommes.* Paris: L'Harmattan, 1989.

Rushdie, Salman. *Imaginary Homelands: Essays and Criticism 1981–1991.* New York: Penguin Books, 1991.

Rydell, Robert W. *All the World's a Fair.* Chicago: University of Chicago Press, 1984.

Said, Edward. *Culture and Imperialism.* New York: Alfred A. Knopf, 1993.

——. *Orientalism.* New York: Pantheon Books, 1978.

——. "Orientalism Reconsidered." *Cultural Critique* 1 (Fall 1985): 89–107.

Salaun, Louis. *L'Indochine.* Paris: Imprimerie Nationale, 1903.

Sarrault, Albert. *Grandeur et Servitude coloniales.* Paris: Editions du Sagittaire, 1931.

——. *Indochine.* Paris: Firmint-Didot et Cie., 1930.

——. *La Mise en valeur des colonies francaise.* Paris: Payot, 1923.

Sartre, Jean-Paul. "Le Colonialisme est un système." *Les Temps Modernes* (mars–avril 1956): n.p.

Schoendoerffer, Pierre. *Dien-Bien-Phu: De la Bataille au film.* Paris: Fixot/Lincoln, 1992.

Schwartz, William. *The Imaginative Interpretation of the Far East in Modern French Literature 1800–1925.* Paris: Librairie Ancienne Honoré Champion, 1927.

Sedgwick, Eve Kosofsky. *Between Men: English Literature and Male Homosocial Desire.* New York: Columbia University Press, 1985.

Sénart, M. E. "Lettre." *Bulletin de l'Ecole Française d'Extrême-Orient* 1 (1901): 9–11.

Shenon, Philip. "The Mist Off Perfume River: The New Indo-Chic Clothes Return Home." *New York Times Magazine* (November 21, 1993): 72–79.

Shils, Edward. "Intellectuals in the Political Development of the New State." *The Intellectuals and Power.* Chicago: University of Chicago Press, 1972. 405–406.

Siclier, Jacques. "Indochine, ton nom est femme." *Le Monde* (17 April 1992): 14.

Silverman, Kaja. *Male Subjectivity at the Margins.* New York: Routledge, 1992.

Sorlin, Pierre. "Clio à l'écran ou l'historien dans le noir." *Revue D'histoire Moderne et Contemporaine* 21 (1974): 252–78.

———. "The Fanciful Empire: French Feature Films and the Colonies in the 1930s." *French Cultural Studies* 2 (1991): 135–51.

———. *The Film in History. Restaging the Past.* Oxford: Basil Blackwell, 1980.

———. *Sociologie du cinéma.* Paris: Aubier-Montaigne, 1977.

Sorlin, Pierre and François Garçon. "L'Historien et les archives filmiques." *Revue D'histoire Moderne et Contemporaine* 28 (1981): 344–357.

Soulié, Maurice. *Marie 1er Roi des Sedangs 1888–1890.* Paris: Marpon et Cie, 1927.

"Souvenirs d'Indochine." *Les Cahiers de la cinémathèque* 57 (October 1992).

Spector, Jack J. "Avant-Garde Object." *Res* 12 (Fall 1986): 125–43.

Spivak, Gayatri Chakravorty. "Subaltern Studies: Deconstructing Historiography." In *Selected Subaltern Studies*, ed. Ranajit Guha and Gayatri Spivak. Oxford: Oxford University Press, 1988.

Stéphane, Roger. *Portrait de l'aventurier: T. E. Lawrence, Malraux, von Salomon.* Paris: Sagittaire, 1950.

Stephanson, Anders. "Regarding Postmodernism—A Conversation with Fredric Jameson." In *Universal Abandon? The Politics of Postmodernism.* ed. Andrew Ross. Minneapolis: University of Minnesota Press, 1988. 3–30.

Stewart, Susan. *On Longing: Narratives of the Miniature, the Gigantic, the Souvenir, the Collection.* Durham: Duke University Press, 1993.

Stocking, George W., ed. *History of Anthropology: Objects and Others.* Vol. 3 Madison: University of Wisconsin Press, 1985.

Suleiman, Susan Robin. "Malraux's Women: A Re-Vision." In *Gender and Reading*, ed. E. Flynn and P. Schweikart. Baltimore: Johns Hopkins University Press, 1986.

Taboulet, Georges. *La Geste française en Indochine.* 2 vols. Paris: Librairie d'Amérique et d'Orient, 1955–1956.

Tai, Hue-Tam Ho. *Radicalism and the Origins of the Vietnamese Revolution.* Cambridge: Harvard University Press, 1992.

Taylor, Ronald, ed. *Aesthetics and Politics.* London: Verso, 1977.

Tcheou, Ta-Kouan. *Mémoires sur les coutumes du Cambodge.* Trans. Paul Pelliot. Paris: Adrien Maisonneuve, 1951.

Tedesco, Jean. "Le Cinéma de 1926 au Vieux-Columbier." *Cinéa-Ciné-pour-tous.* 52 (1 janvier 1926): 7.

———. "Le Voyage au Congo." *Cinéa-Ciné-pour-tous* 88 (1 juillet 1927): 12–13.

Thau, Ta Thu. [no title] *Tribune indochinoise.* (23 décembre 1927): n.p.

Thirion, André. *Révolutionnaires sans révolution*. Paris: Editions Laffont, 1972. Translated by Joachim Neugrosche under the title *Revolutionaries Without Revolution*. New York: Macmillan, 1975.

Thobie, Jacques, et al. *Histoire de la France coloniale 1914–1990*. Paris: Armand Colin, 1990.

Thomson, Brian. "L'Art et la roman: L'imagination visuelle du romancier. Entretien avec André Malraux." In *André Malraux*, vol. 4, *Malraux et l'Art*, ed. Walter G. Langlois. Paris: Minard, 1978. 83–104.

Thomson, Brian and Carl A. Viggiani, eds. *Witnessing André Malraux: Visions and Re-Visions*. Middletown: Wesleyan University Press, 1984.

Torgovnick, Marianna. *Gone Primitive: Savage Intellects, Modern Lives*. Chicago: University of Chicago Press, 1990.

"Trésors mal gardés." *Revue Archéologique* (Juillet-Août 1922): 187.

Trotsky, Leon. "La Révolution étranglée." *Nouvelle Revue Française* 211 (1 avril 1931). Translated by Beth Archer under the title "The Strangled Revolution." In *Malraux: A Collection of Critical Essays*, ed. R. W. B. Lewis. Englewood Cliffs: Prentice-Hall, 1964.

Valette, Jacques. "L'Expédition de Francis Garnier au Tonkin à travers quelques journaux contemporains." *Revue d'Histoire Moderne et Contemporaine* 36 (avril-juin 1969): 133–220.

Vandegans, André. *La Jeunesse littéraire d'André Malraux*. Paris: Jean-Jacques Pauvet, 1964.

———. "Malraux a-t-il fréquenté les grandes écoles?" *Revue des Langues Vivantes* 7.5 (1960): 336–40.

———. "Un Personnage de Malraux: Perken." *Revue des Langues vivantes* 7.6 (1965): 579–92.

"La Vérité sur les colonies." Reel 69 Series 461. Paris: Bibliothèque Marxiste.

Villiers de l'Isle-Adam, Philippe-Auguste. *L'Eve future*. Paris: Garnier-Flammarion, [1886], 1992.

Viollis, Andrée. *Indochine S.O.S.* Paris: Gallimard, 1935.

Virilio, Paul. *L'Espace critique*. Paris: Christian Bourgeois Editeur, 1984.

———. *L'Horizon négatif*. Paris: Galilée, 1984.

Wahl, François. "Le Désir d'espace." *Tel Quel* 85 (automne 1980): 39–45.

Werth, Leon. *Cochinchine*. Paris: F. Rieder, 1926.

White, Hayden. *The Content of Form*. Baltimore: Johns Hopkins University Press, 1987.

Willet, Frank, et al. "Authenticity in African Art." *African Arts* 9.3 (1976): 6–74.

Williams, Elizabeth. "Art and Artifact at the Trocadero." In *History of Anthropology: Objects and Others*, ed. George W. Stocking. Madison: University of Wisconsin Press, 1985. 3:145–66.

Wilson, Edmund. *The Shores of Light*. New York: Farrar, Strauss and Young, 1952.

Wright, Gwendolyn. *The Politics of Design in French Colonial Urbanism*. Chicago: University of Chicago Press, 1991.

Yeager, Jack A. *The Vietnamese Novel in French. A Literary Response to Colonialism.* Hanover: University of New Hampshire Press, 1987.

Filmography

Annaud, Jean-Jacques. *The Lover.* 103 min. 1992.

Jeudy, Patrick. *Récits d'Indochine: Chronique des journées de la bataille de Dien Bien Phu.* 60 min. 1992.

Rémy, Yves, and Ada Rémy. *La Mémoire et l'oubli.* 60 min. 1992.

Schoendoerffer, Pierre. *Dien Bien Phu.* 140 min. 1992.

Wargnier, Régis. *Indochine.* 152 min. 1991.

INDEX

Panivong Norindr is Associate Professor in
the Department of French and Comparative Literature, University
of Wisconsin at Milwaukee.

Library of Congress Cataloging-in-Publication Data

Norindr, Panivong
Phantasmatic Indochina : French colonial ideology in architecture,
film, and literature / Panivong Norindr.
p. cm. — (Asia-Pacific)
Includes bibliographical references and index.
ISBN 0-8223-1778-8 (cl : alk. paper). — ISBN 0-8223-1787-7 (pa :
alk. paper)
1. Arts, French. 2. Arts, Modern—20th century—France.
3. Indochina in art. I. Title. II. Series.
NX549.A1N66 1996
700—dc20 95-50856 CIP